# making Waves

## NAVY WOMEN OF WORLD WAR II

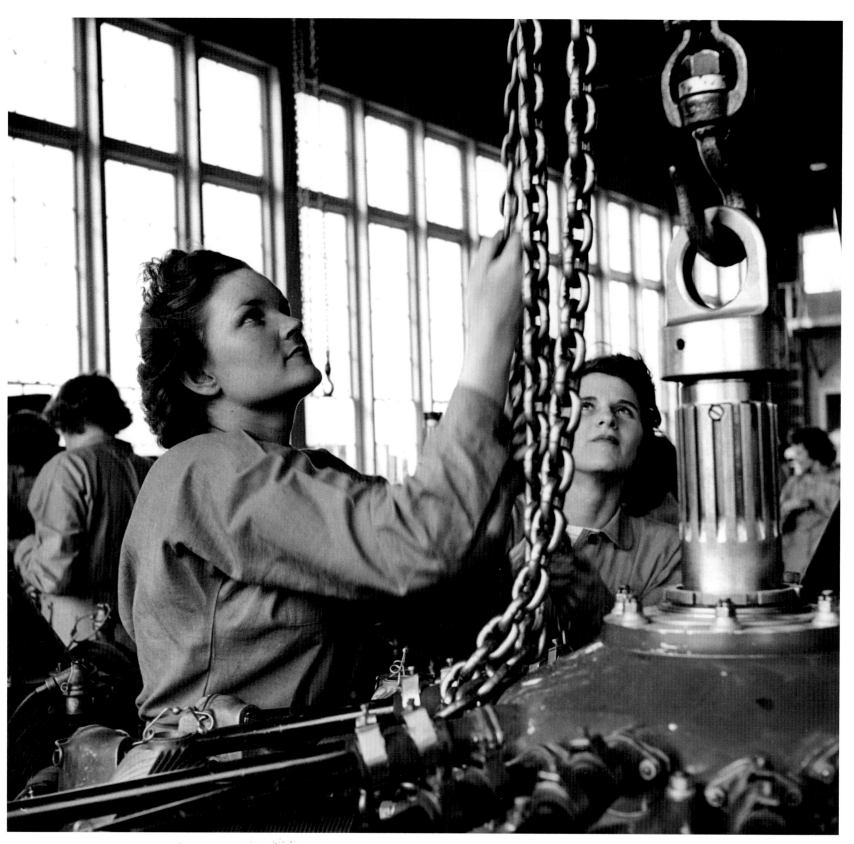

# *making* Waves

## NAVY WOMEN OF WORLD WAR II

EVAN BACHNER

Abrams, New York

*For my mother and in*
*memory of my aunt Pearl*

A NOTE ABOUT THE CAPTIONS

The captions used in this book are derived from the original captions assigned during World War II. They list the original title assigned to each photograph, the date the image was logged in, the location where the photograph was taken, the name of the photographer, and the photograph number later assigned to each image by the National Archives. The titles are quoted verbatim for the sake of historical interest. These photographs were found in Records Group 80-G, General Records of the Department of the Navy, 1804–1958. All are housed in the Still Pictures Records LICON, Special Media Archives Services Division at the National Archives in College Park, Maryland.

Frontis photo: "WAVE trainees at Naval Air Technical Training Center, Norman, Oklahoma: Lucille Henderson, AMM, and shipmate on business end of a machine shop hoist." March 1943; Norman, Okla.; PH2 Howard Liberman; 80-G-471681

As with the two previous collections in this series, *At Ease: Navy Men of World War II* and *Men of World War II: Fighting Men at Ease*, the images in this volume are drawn from a subset of the Navy record group at the Still Picture Branch of the National Archives and Records Administration in Greenbelt, Maryland. The photographs are the work of a group of some of the finest photographers of their day, or any day. How I found them, where they've been, who was responsible for creating them, and what they tell us about the tenor of the times is a fascinating story.

In 1997, at the Brooklyn Museum of Art, I saw one photograph in an exhibit of new acquisitions. The work was recognizably from World War II, of a man standing in the blister of an airplane. It was heroic and iconic in that 1940s way, but unlike anything I had seen before. I wanted to find out more, so I noted the title, "PBY Blister Gunner, 1944", and the photographer, Horace Bristol, on a scrap of paper. I thought it would be easy to track down the photographer and his work during the war. That turned out to be only partially true.

It turned out to be relatively simple to find out who the photographer was. Horace Bristol was a significant force in Depression-era photography. He was one of the first photographers hired by *Life* magazine. As I was familiar with a used bookshop that had a complete collection of *Life*, I went through all of the issues from the inception of the magazine up through the end of the war. Bristol contributed several covers and articles during the first years of publication. In 1938, working on a *Fortune* magazine assignment with John Steinbeck, he took the portraits we think of as some of the definitive images of the Depression. The migrant farm workers he documented were later used in *Life* and as the models for the Joad family in the movie version of *The Grapes of Wrath*.

Soon after the war began, magazine images credited to Horace Bristol stopped, and did not reappear until after the war. I did find several images of Navy life in his distinctive style, attributed to him, with no copyright. I assumed he was in the military, and set out to find out more. I wrote to the Navy museum in Washington, D.C. and they referred me to the National Archives. An archivist in the Still Picture Branch wrote back to me with the information that Horace Bristol had been part of the "Naval Aviation Photographic Unit" headed by Edward Steichen.

The archives had all the images taken by the unit, including the one I had seen in Brooklyn. Each image was carefully labeled with an index number. Simple, except there were two catches: the images were mixed in with about 786,000 other Navy photographs, and they were only spottily cataloged. Luckily, there was a cross reference, at least giving the short number ranges that corresponded with the unit's work. I could find them, if I went through every single one of hundreds of boxes, looking for the relevant images among the 200 prints in every box. Determined researchers, given time and patience, could find these "hidden" images.

When I did come across a photograph from Steichen's unit, it was immediately apparent. The New Realism movement in photography, which dominated Depression-era photography and *Life* magazine, informed every image. Far more interesting than the surrounding static images of ships, admirals, and airplanes, every one of them jumped out at me. They were far beyond the typical military documentation and visual inventory. They ably conveyed the story of the human condition during the war years, on pristine fifty-five-year-old prints. Characteristically, while there are many battle photographs among them, the photographers sought out people engaged in the activities of everyday life, but in a far different context.

Spending thirty-five days over an eight year period, I gradually built a catalog, connecting the index number with the image and the caption. I started with a film camera and a copying machine and ended with a scanner and a database. The result was a catalog of over 1,000 images

on subjects as diverse as combat, rest and relaxation, Italian war orphans, African-Americans, Franklin Delano Roosevelt's funeral, WAVES, and women workers at an aircraft plant in California.

With the exception of the combat photographs, most of these images had never been published. Those that were published during the war were of low production quality and were never credited to the photographer. Instead they were billed as being an "Official U.S. Navy Photograph", which probably contributed to their postwar obscurity. It wasn't until the mid-1960s, when the prints were transferred from the Navy to the National Archives, that the real credits were visible. Since then, several books have reproduced the high quality images necessary to truly appreciate the work. *At Ease* and *Men of World War II* were the first books to publish the full index data on the featured photographs.

In addition to Edward Steichen and Horace Bristol, the photographers of the Naval Aviation Photographic Unit included: Wayne F. Miller, Charles Fenno Jacobs, Charles Kerlee, Victor Jorgensen, Dwight Long, John Swope, Thomas Binford, Charles Steinheimer, Barrett Gallagher, Howard Liberman, and several others.

The primary purpose of the photographic unit was to visually describe the war to the American people. They were selectively released by the Navy and the Office of War Information in order to support the war effort. They were patriotic, heroic, and reassuring, all at the same time. That they were taken in a style that was immediately compelling was no accident. The realistic photographic vernacular that came to predominate during the Depression and the war was heavily influenced by Steichen and practiced by Horace Bristol and Charles Fenno Jacobs in *Life* magazine before the war.

The work was divided into two distinct types of activity. Initially, the photographers concentrated on domestic preparations for the war: the draft and recruiting, training, military manufacturing, the home front, etc. They

then were "embedded" with the servicemen, onboard ship and in naval airplanes, documenting life during and between battles.

The images in this volume of women in the Navy (WAVES) and of women factory workers were all taken in the United States. They had to be. The deployment of the WAVES was limited by Congress, which specified that they perform their duties within the confines of the United States and territories for the purpose of freeing male servicemen for combat duty. Eventually, 86,000 women volunteered for the WAVES. My aunt, Pearl Nadel, was one of them. She reported for training to Hunter College in the Bronx, New York, which became the single point for WAVE training in February, 1943.

Unfortunately, African-American women were not permitted to enlist in the WAVES until October, 1944, and fewer than 100 served before the war ended. The photographs in this book were all taken before that time.

WAVES stands for Women Accepted for Voluntary Emergency Service. It is easy, from our twenty-first century viewpoint, to glean some irony from the name, but it was not lost on the former director of the WAVES, as well as the President of Wellesley College, Mildred McAffee Horton. On April 30, 1947, during a speech given to the women's luncheon at the U.S. Chamber of Commerce, she stated:

"Now it is delightful to be appreciated. It is gratifying to be received graciously when one asks the opportunity to serve one's nation, it is perhaps pleasant to be allowed to feel that it is uniquely patriotic to participate in a war effort in which men are expected to serve and women are permitted to. On the whole, however, that experience represents a position of women which is something less than that of a full-fledged citizen."

When I first approached this project, and began to go through the pictures of the women's war effort, I expected them to reflect the status described above. Surprisingly, the photographs were just as patriotic, heroic, and reassuring as those of men in battle and at rest. There is no sense of

limits being placed on the women in the images. In this sense, the all-male photographic unit was far ahead of its time in depicting women as full non-compartmentalized contributors to society, as far as the limits placed on their activity allowed.

There are four categories of WAVE images: training, transportation, work, and relaxation. In a comparison with images of men, they were portrayed roughly the same way, by turns serious and playful. The images are never used to ridicule the women engaged in "traditional" male occupations. There is not one photograph in the collection where the caption could or did broadcast the notion that the women were out of their depth or an object of fun. In fact the opposite was the case. Each image showcases the capabilities of women, in training, in work, and in play. You see women instructing naval officers in their responsibilities, being telegraph officers and stenographers, undergoing rigorous physical training, marching, working, firing weapons, etc., perhaps in different job categories than men, but with exactly the same seriousness of purpose.

Taken in isolation, some of the images look like they were meant to objectify the women, in a modern sense. However, if you look closely at the photos of the women in this volume and the sailors in the two previous volumes, the ones of women appear fairly reserved by comparison. In a subject by subject comparison, the same techniques were used for men and women, including shots taken from behind, grooming, hair care, wrestling, calisthenics, swimming, etc. In the case of the women, at least, they are always clothed. Playful imagery was the way the Naval Aviation Photographic Unit told part of the story, but never disrespectfully.

This is even more apparent in the section of the book devoted to workers at the Consolidated Vultee aircraft plant in California, where even the playfulness is gone. These are workers devoted to the war effort, competently doing their jobs in 1943. Rosie the Riveter may have been a fictional character, but what she represented was certainly reflected in the vital work documented by the photographers. It isn't

certain that a photographer in 2007 would approach the same subject with similar respect.

I would like to add one final note about this project, which has produced this book and the two previous ones. The adventure in research I've undertaken over the past 10 years would be very different if I were to begin again. In 1997, I mailed a physical letter to the National Archives asking about their holdings. An archivist responded by letter with photocopies of a few images. I spent many days over eight years exploring the photographs box by box. On my first visit to Maryland, I photographed the original photographs. Now, I'm on my third scanner and fourth laptop computer. I have a database with scans of the images and the attached captions.

In the late 1990s, the National Archives had an experimental database with a relatively small amount of material available online. They have now undertaken a major project to digitize their holdings. The Still Pictures branch has 8,000,000 images in their collection, 786,000 of them are from the Navy. Of all their images, 58,000 are available online, with a searchable index. I wouldn't doubt that in a few years, all their photographs will be digitized. A researcher will just have to enter the name of the photographer or subject, and all the images in all three books will be at their fingertips. In *At Ease* I used a quote about Edward Steichen's Navy work taken from *The New Yorker* magazine. I found it using *The Reader's Guide to Periodical Literature*. I copied it from microfilm, an older technology. Every issue of *The New Yorker* from its first publication is now available on one searchable disk.

This nascent universal availability of information is a boon for research of any kind, but it kind of takes the fun out of it. My personal adventure of exploration and research, the feeling of holding what may be the only definitive print of a fifty-five-year-old masterwork, being the only person with a catalog entry for many of the images, all will be pretty much out of reach in a few years. I'm very satisfied I was able to do this now.

# making Waves

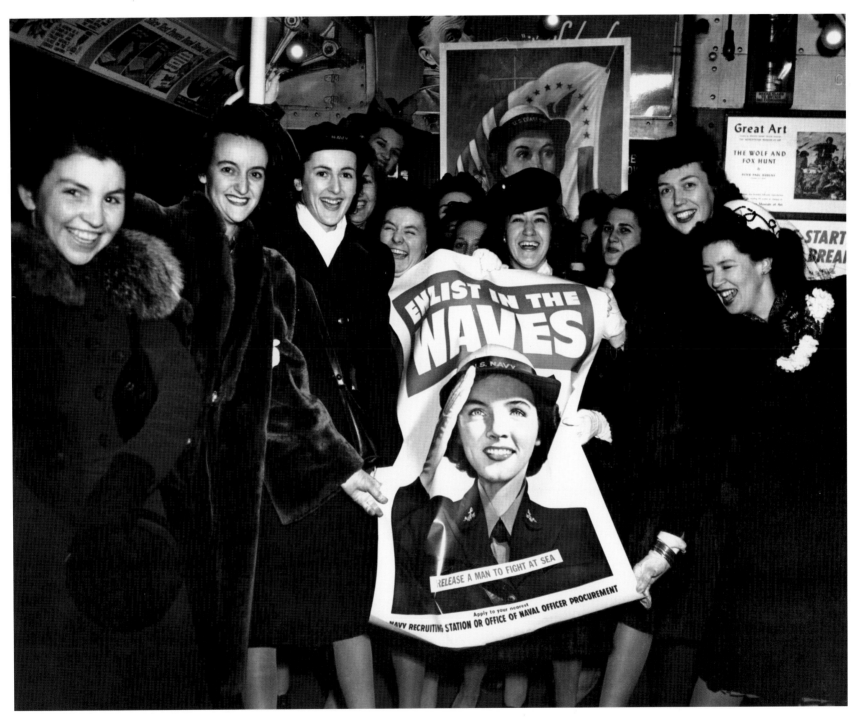

"WAVES and SPARS travel by special subway train from New York City Hall, where 418 inductees have just been sworn in, to commissioning ceremonies at Hunter College, Bronx, New York." February 1943; New York City, NY; photograph unattributed; 80-G-23751

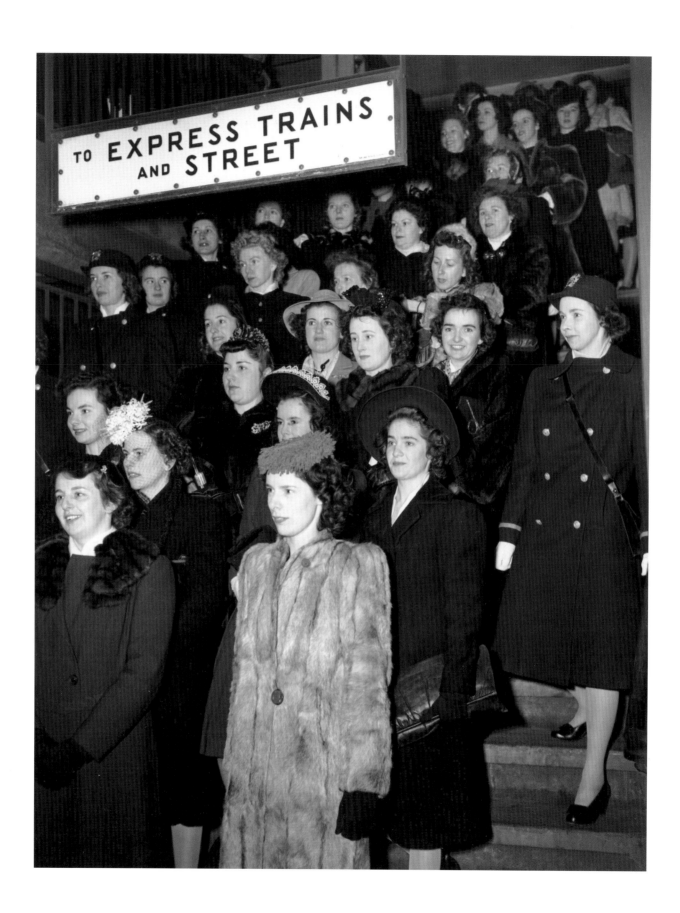

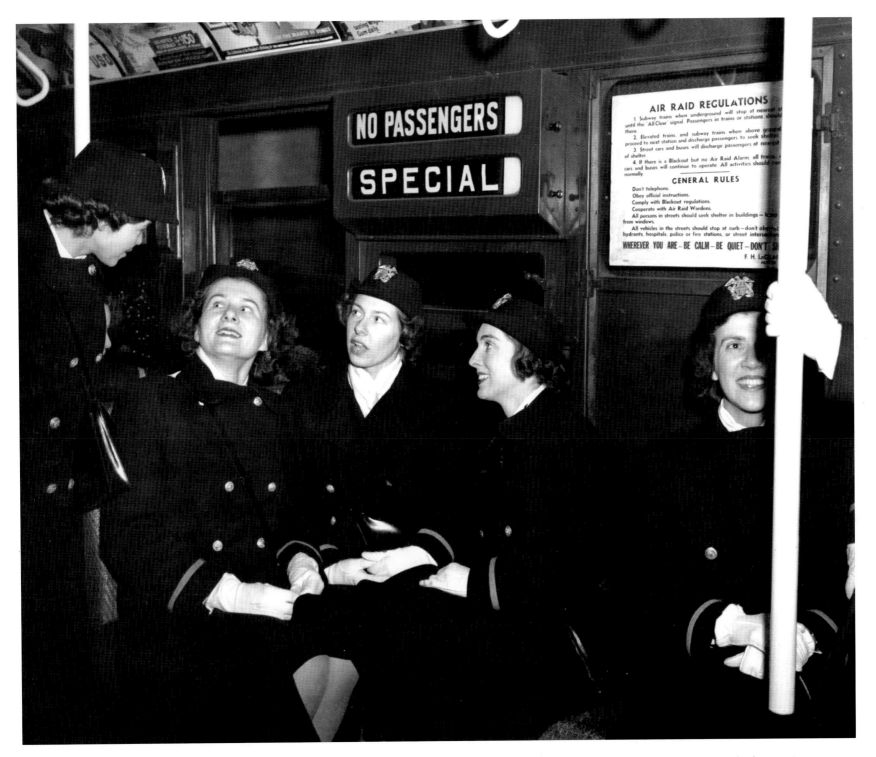

"WAVE and SPAR inductees, part of a group of 418 women sworn in at a mass ceremony at the City Hall, New York City, about to board a special subway train to attend commissioning ceremonies at Hunter college." February 1943; New York City, NY; photograph unattributed; 80-G-23749

"WAVES and SPARS travel by special subway train from New York City Hall, where 418 inductees have just been sworn in at commissioning ceremonies at Hunter College, Bronx, New York." February 1943; New York City, NY; photograph unattributed; 80-G-23750

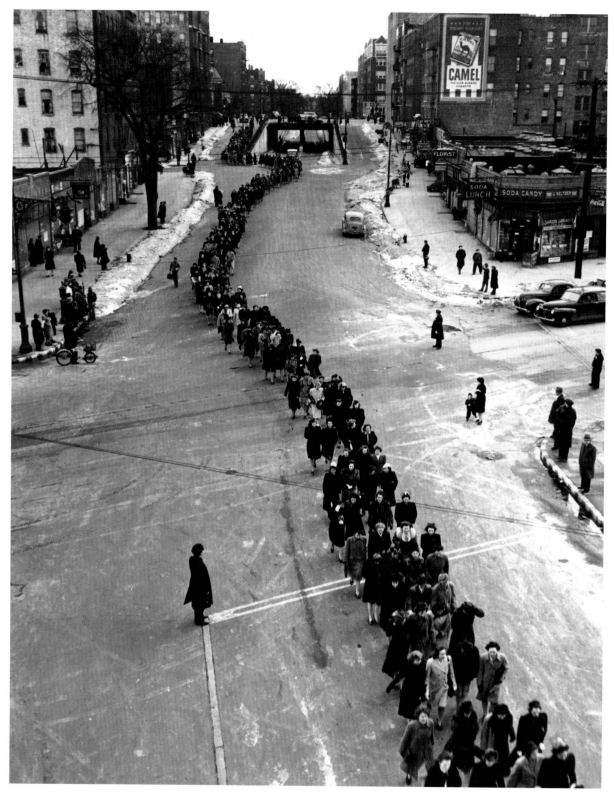

"Inductees in the WAVES and SPARS enroute to commissioning ceremonies at Hunter College, Bronx. They have just been sworn in at the City Hall, New York City." February 1943; New York City, NY; photograph unattributed; 80-G-23752

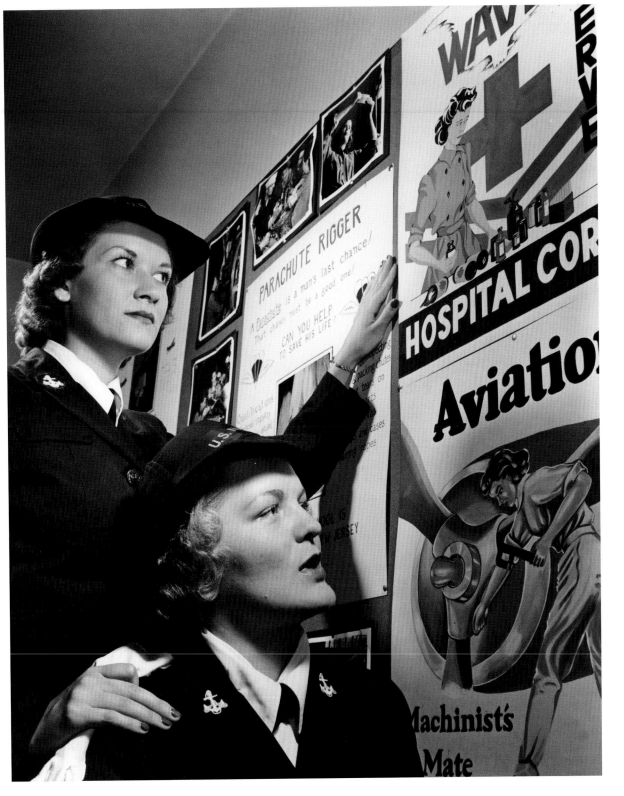

"WAVES at Hunter College Training School, New York City: Selecting from among offered WAVE vocations." November 1943; New York City, NY; photograph unattributed; 80-G-102998

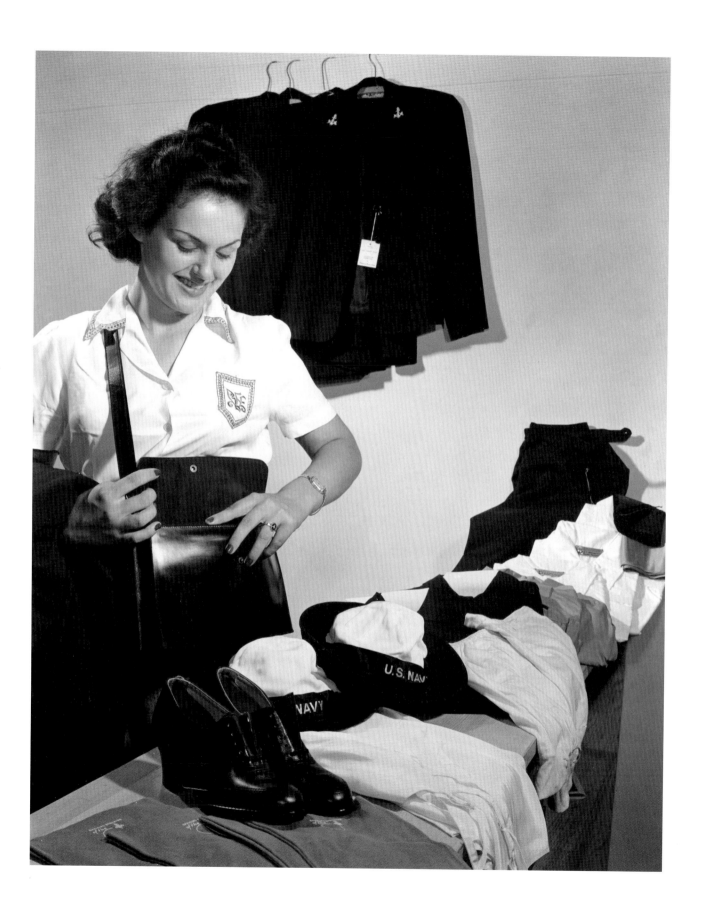

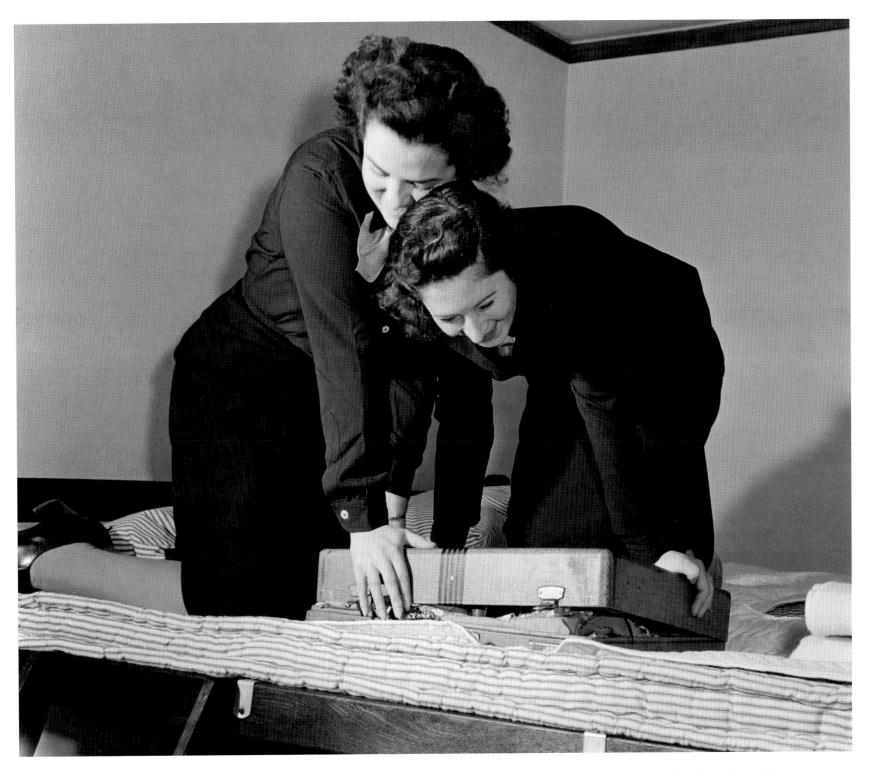

"WAVES at Hunter College Training School, New York City: Newly enlisted WAVE receiving issue of WAVE clothing at Hunter College." November 1943; New York City, NY; photograph unattributed; 80-G-102974

"WAVES at boot camp, Cedar Falls, Iowa: Ruth Clark (right), and Ruby Spiliotis, have lots to pack before leaving." March 1943; Cedar Falls, Iowa; PH2 Howard Liberman; 80-G-471661

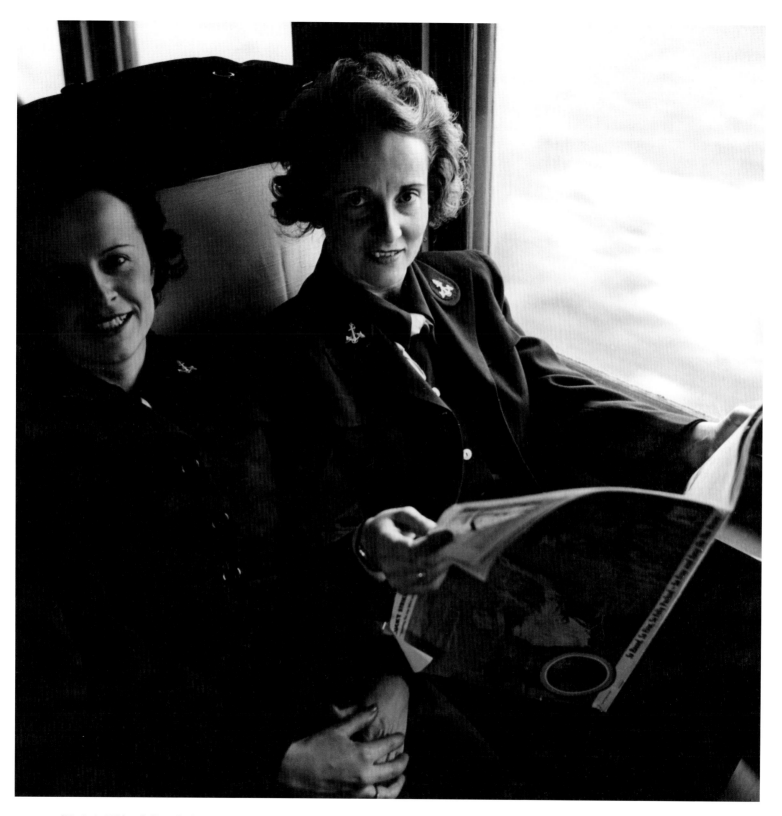

"Marjorie Hiblen (left) and Edna Brown (right), having completed their training at Cedar Falls, Iowa, leave by train for their new assignments."
February 1943; location unknown; Lt. Wayne Miller; 80-G-471553

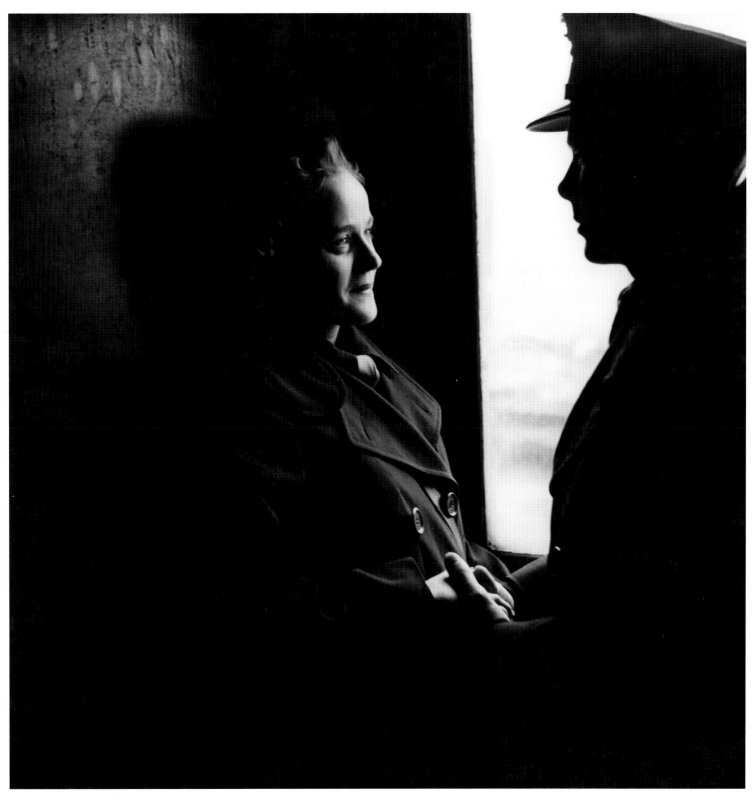

"WAVE Lee Chamberlain says good bye at train time to Chief Bulkley at Cedar Falls, Iowa. She is off to her new billet." February 1943;
Cedar Falls, Iowa; Lt. Wayne Miller; 80-G-471552

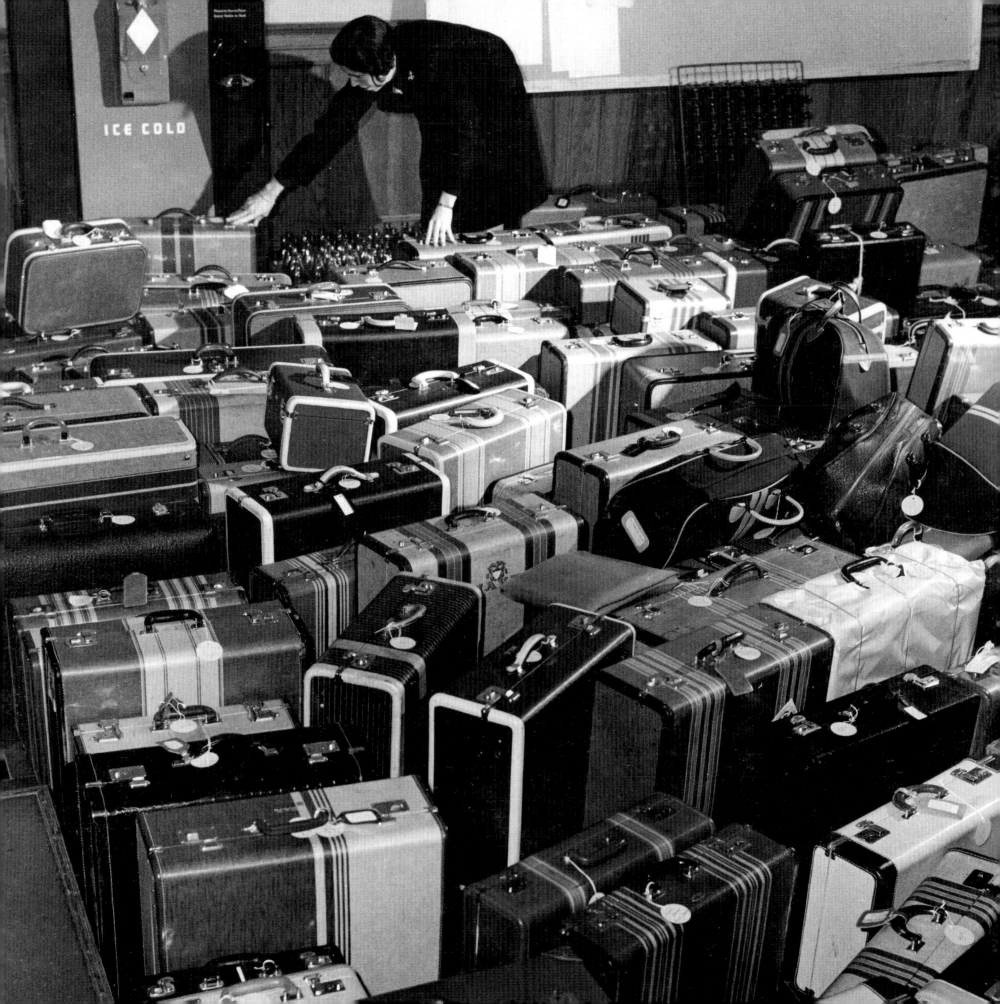

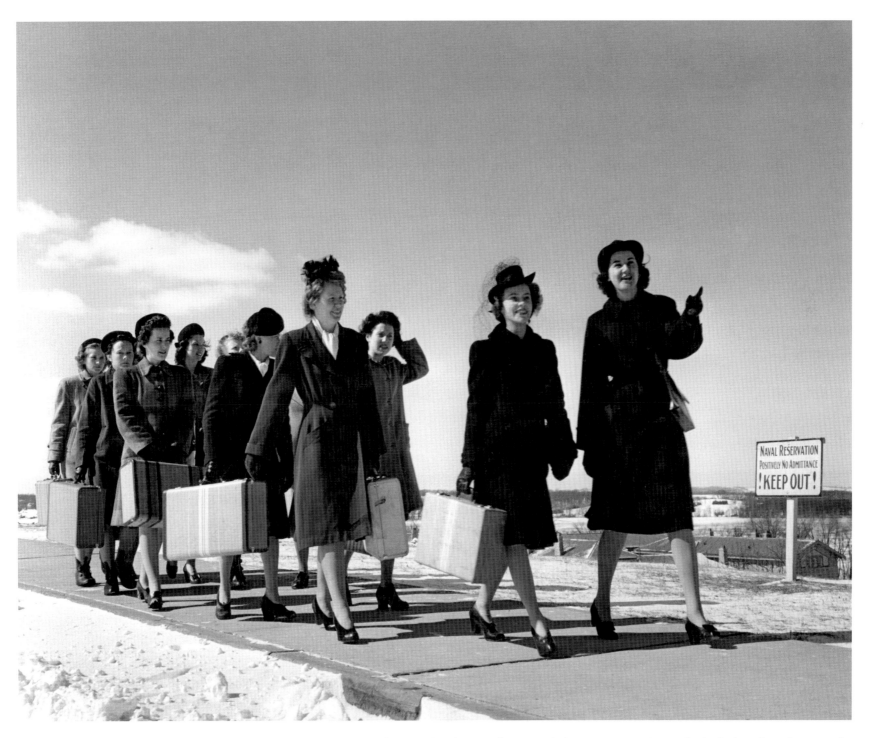

"Graduation day at WAVE boot camp, Cedar Falls, Iowa: Luggage of all sizes, shapes, and qualities, ready to go with their owners to stations and schools throughout the country."
March 1943; Cedar Falls, Iowa; photograph unattributed; 80-G-471660

"WAVES at Radio School, Madison, Wisconsin: Recruits arrive for boot training." March 1943; Madison, Wisc.; Sp (P) 2 Howard Liberman; 80-G-471659

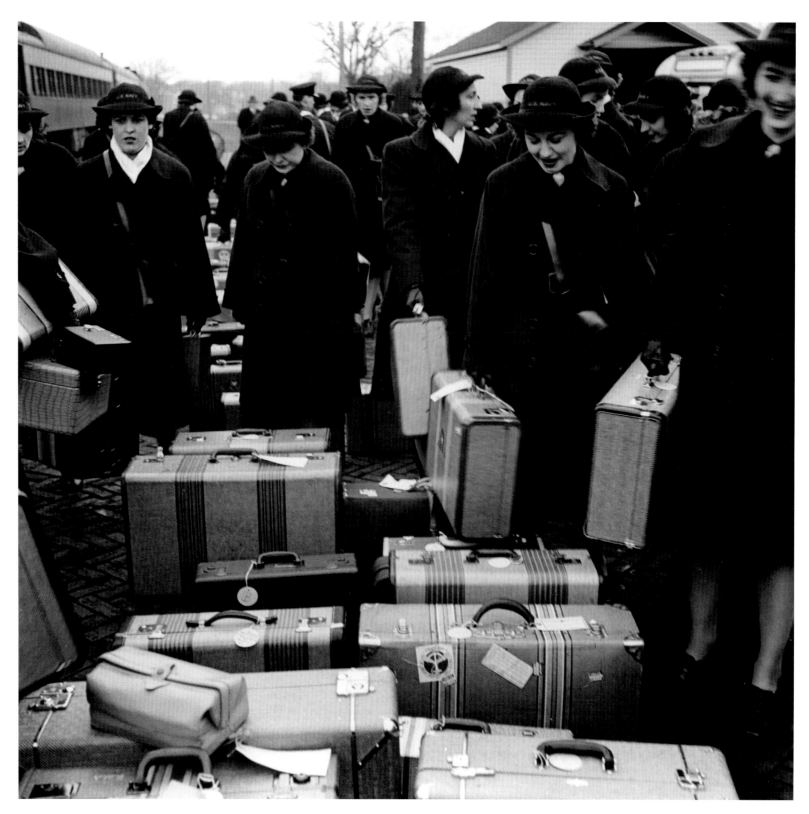

"WAVES boarding trains at Cedar Falls, Iowa for new places of instruction." February 1943; Cedar Falls, Iowa; Lt. Wayne Miller; 80-G-471528

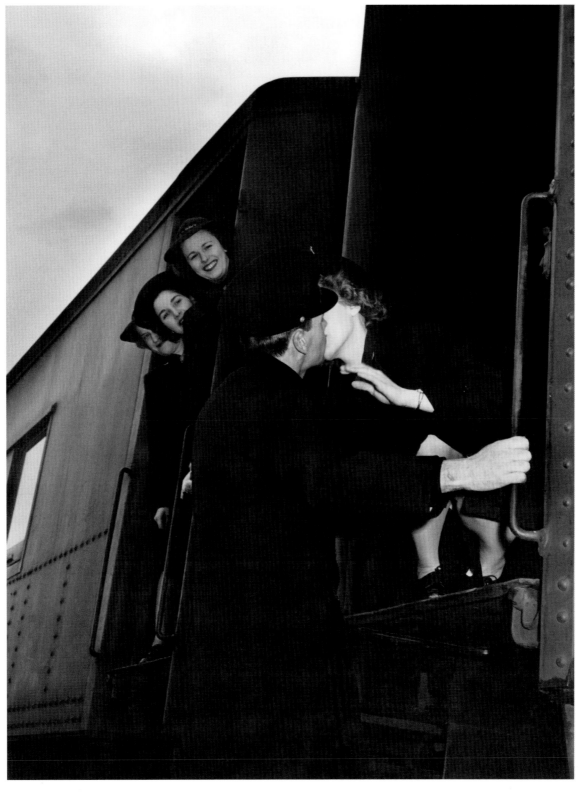

"WAVES leaving Cedar Falls, Iowa by special train for Chicago, Illinois: Chief Bulkley kisses Lee Chamberlain good-bye."
February 1943; Cedar Falls, IA; Lt. Wayne Miller; 80-G-471481

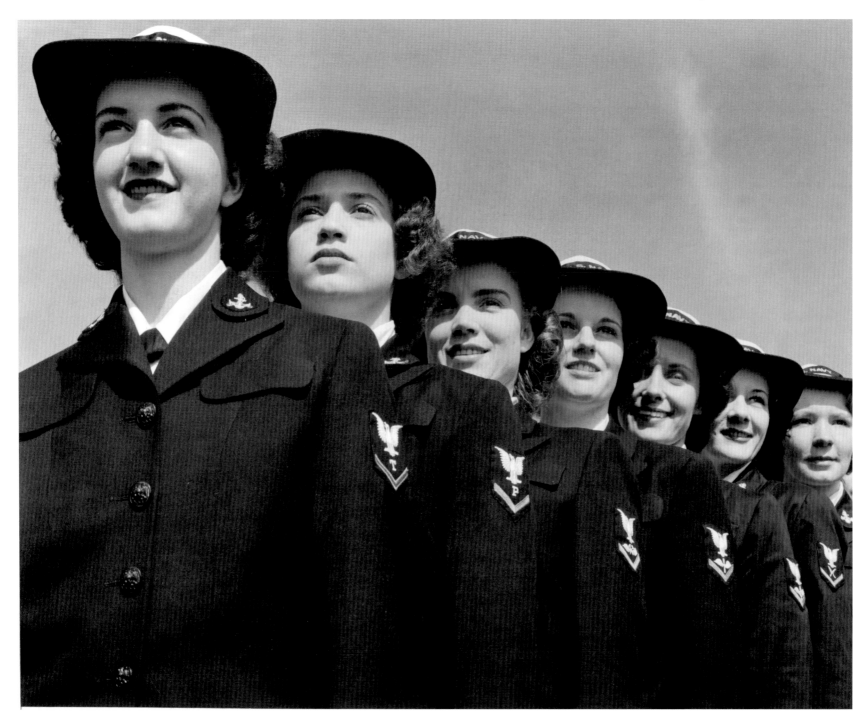

24

"WAVE Petty Officers-rates are awarded after specialized training." November 1943; photograph unattributed; 80-G-102975

"Captains inspection at Cedar Falls, Iowa: Waves "at ease." February 1943; Cedar Falls, Iowa; Lt. Wayne Miller; 80-G-471530

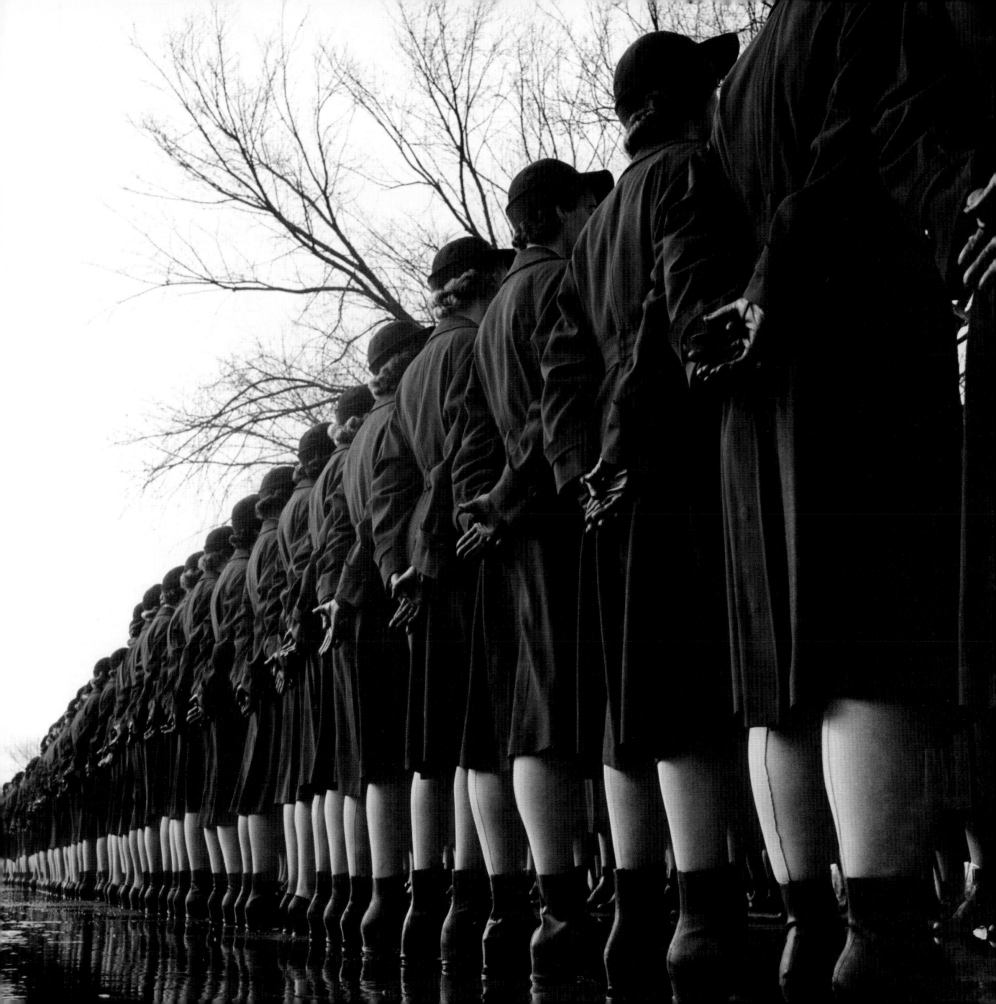

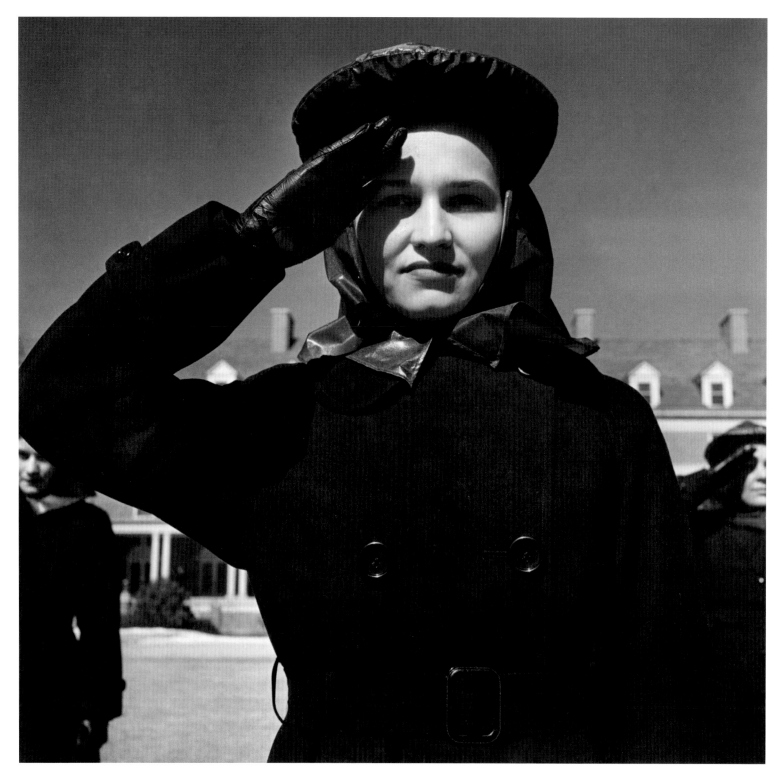

"WAVE saluting at Stillwater, Oklahoma." February 1943; Stillwater, Okla.; Lt. Wayne Miller; 80-G-471547

"WAVES at boot camp, Cedar Falls, Iowa: March to chow." March 1943; Cedar Falls, Iowa; PH2 Howard Liberman; 80-G-471650

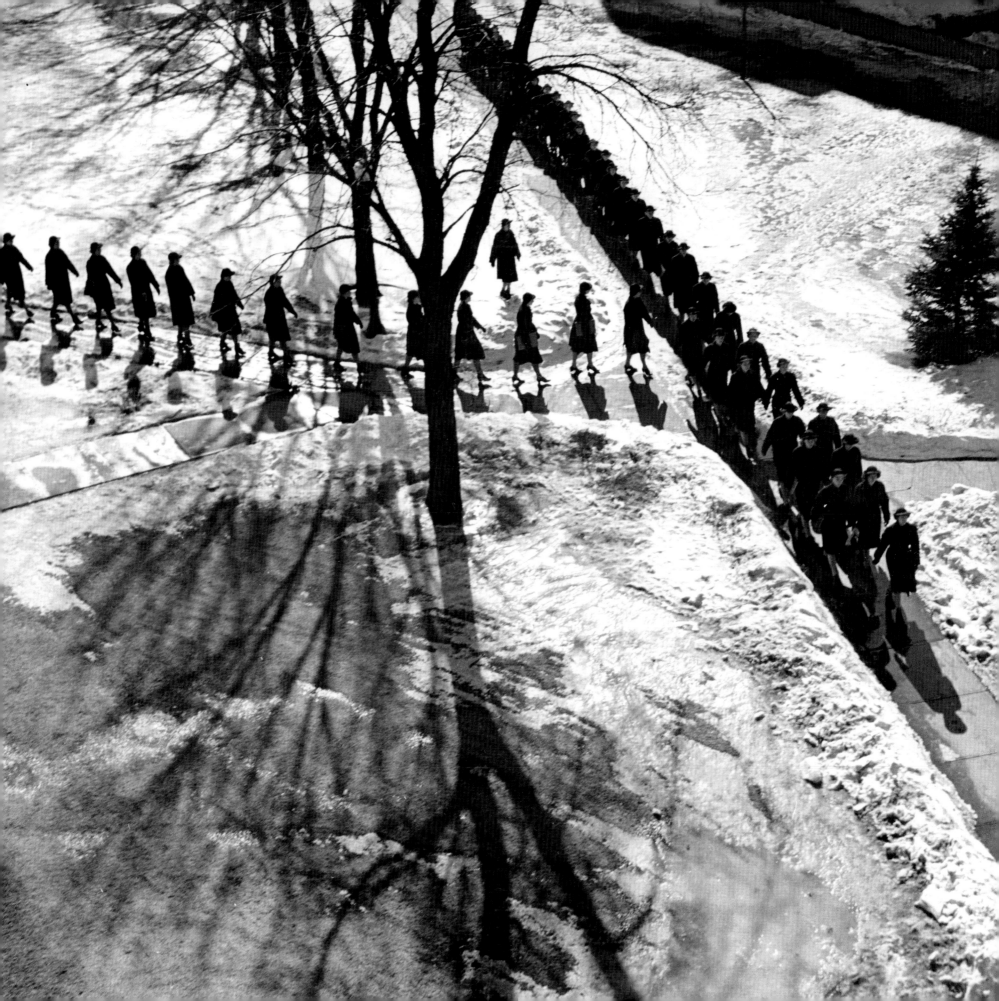

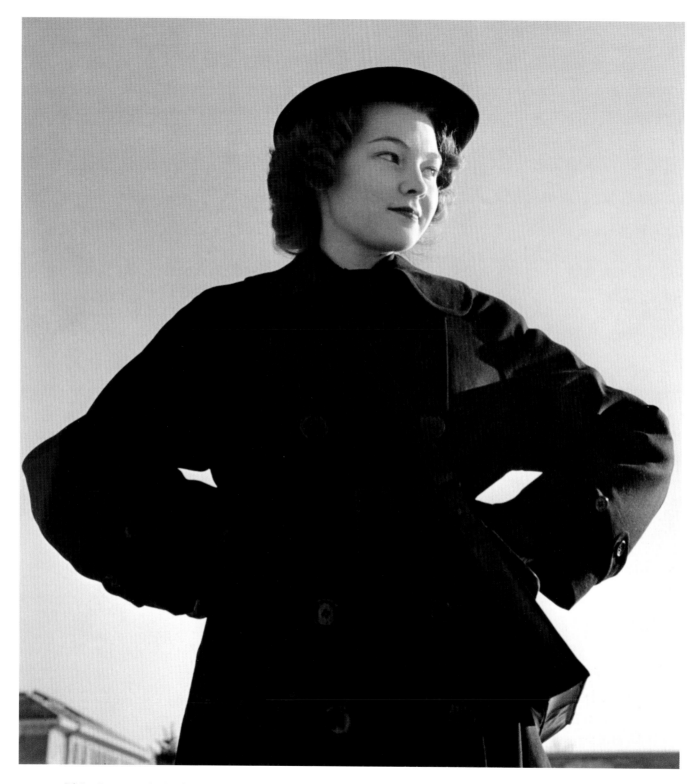

"Elaine Davenport (YN) at boot camp, Cedar Falls, Iowa." March 1943; Cedar Falls, Iowa; PH3 Howard Liberman; 80-G-471639

"WAVES at Radio School, Madison, Wisconsin: March at Radio School." March 1943; Madison, Wisc.; PH2 Howard Liberman; 80-G-471678

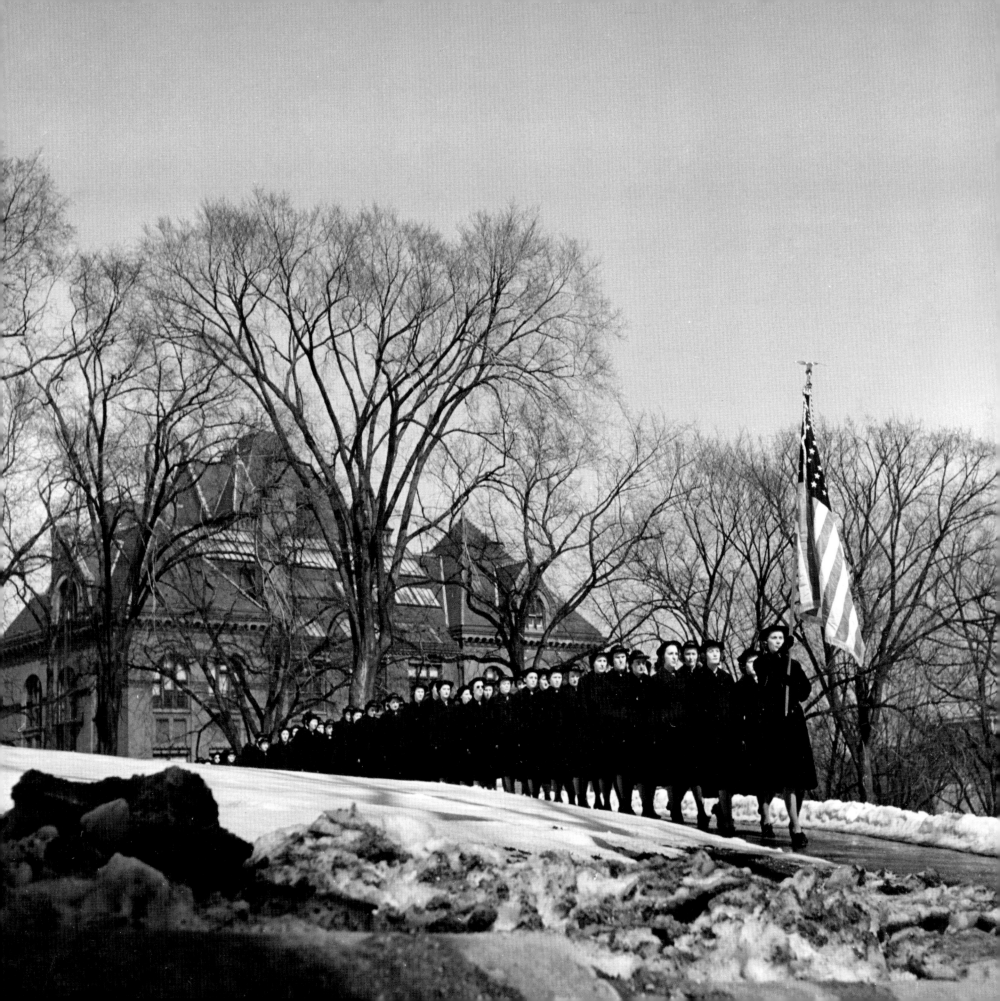

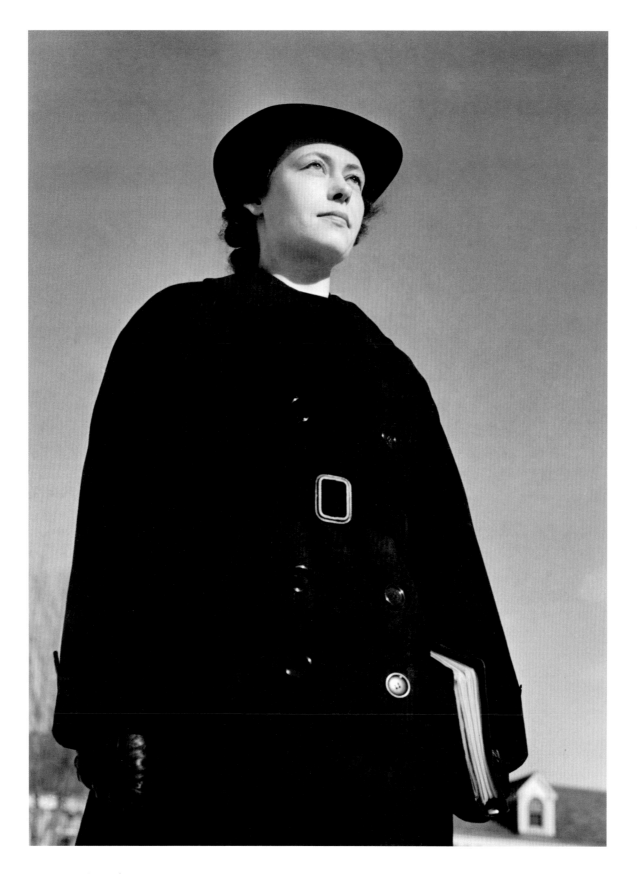

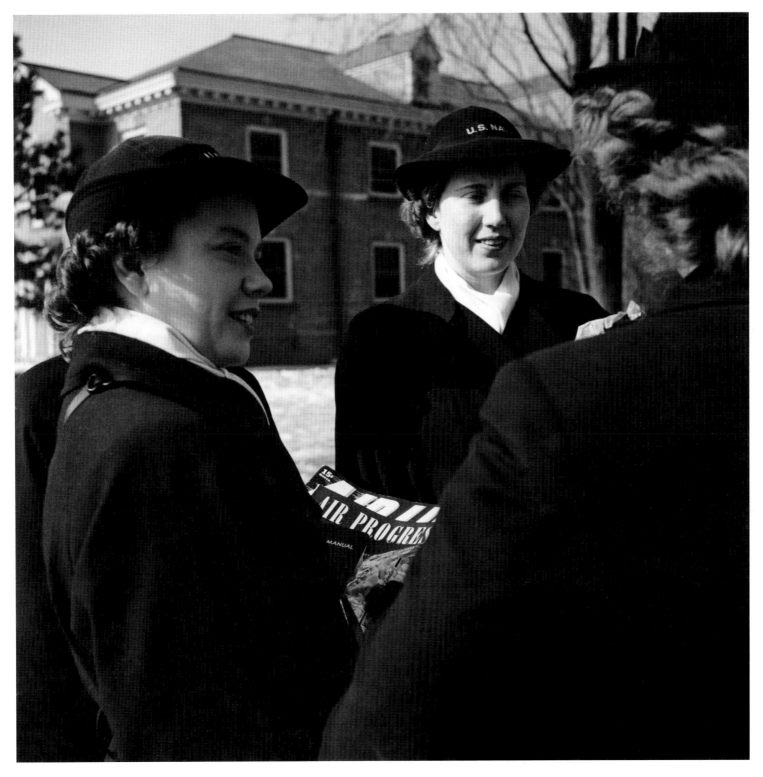

"Millicent Polley, Platoon Leader, at Radio School of University of Wisconsin, Madison, Wisconsin." March 1943; Madison, Wisc..; PH3 Howard Liberman; 80-G-471628

"WAVES at boot camp, Cedar Falls, Iowa, rival the men in aviation interests." February 1943; Cedar Falls, Iowa; Lt. Wayne Miller; 80-G-471589

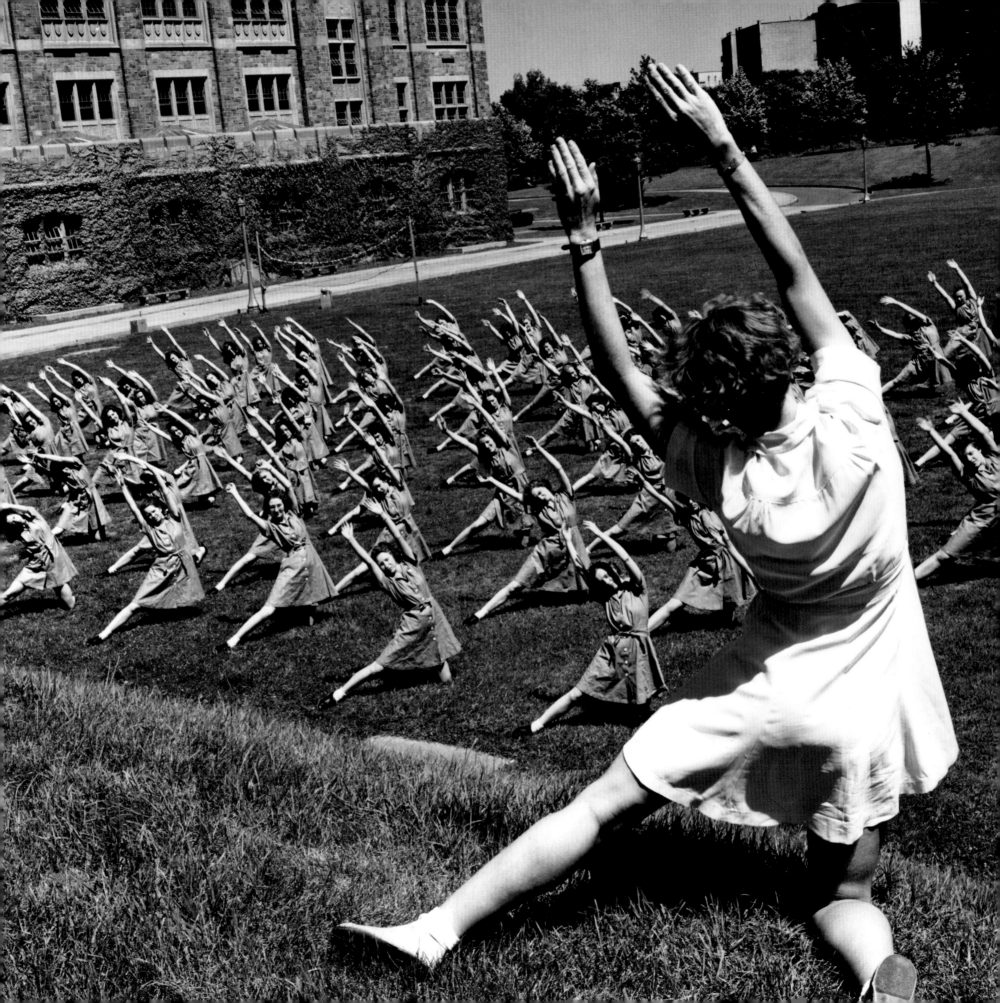

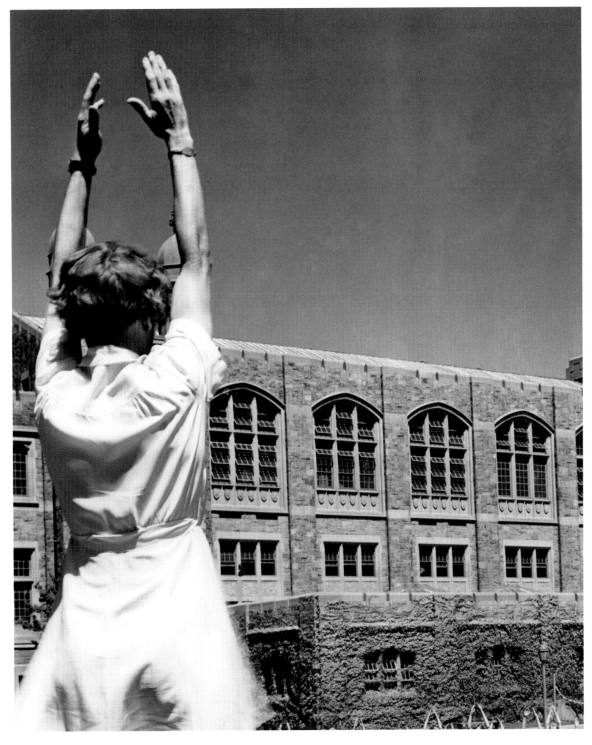

"WAVES at Hunter College Training School, New York City: Taking exercise drill." November 1943; New York City, NY; photograph unattributed; 80-G-102976

"WAVES at Hunter College Training School, New York City: WAVE Officers leading calisthenics." November 1943; New York City, NY; photograph unattributed; 80-G-102971

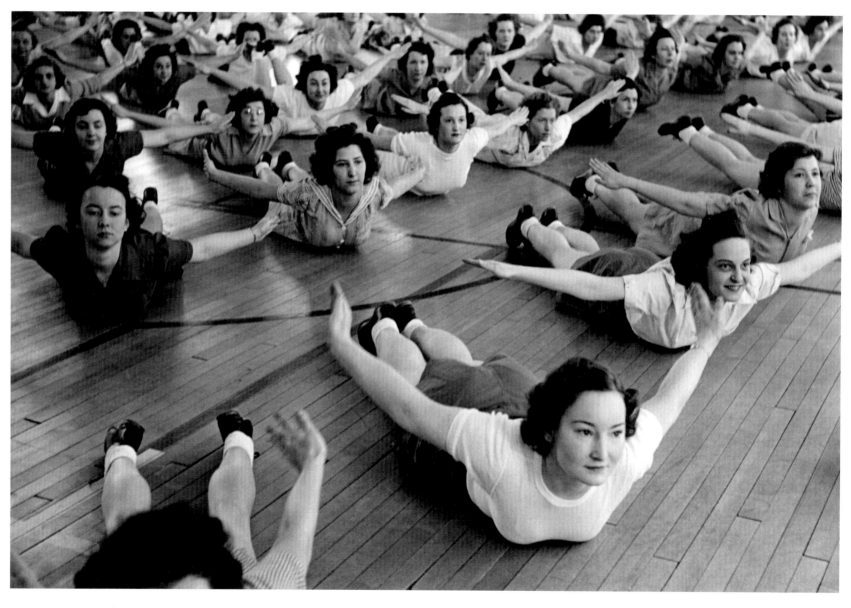

"Physical training is a daily part of WAVES at "boot" camp, Cedar Falls, Iowa." February 1943; Cedar Falls, Iowa; Lt. Wayne Miller; 80-G-471591

"WAVES having calisthenics outdoors at NATTC, Norman, Oklahoma." February 1943; NATTC, Norman, Okla.; Lt. Wayne Miller; 80-G-471568

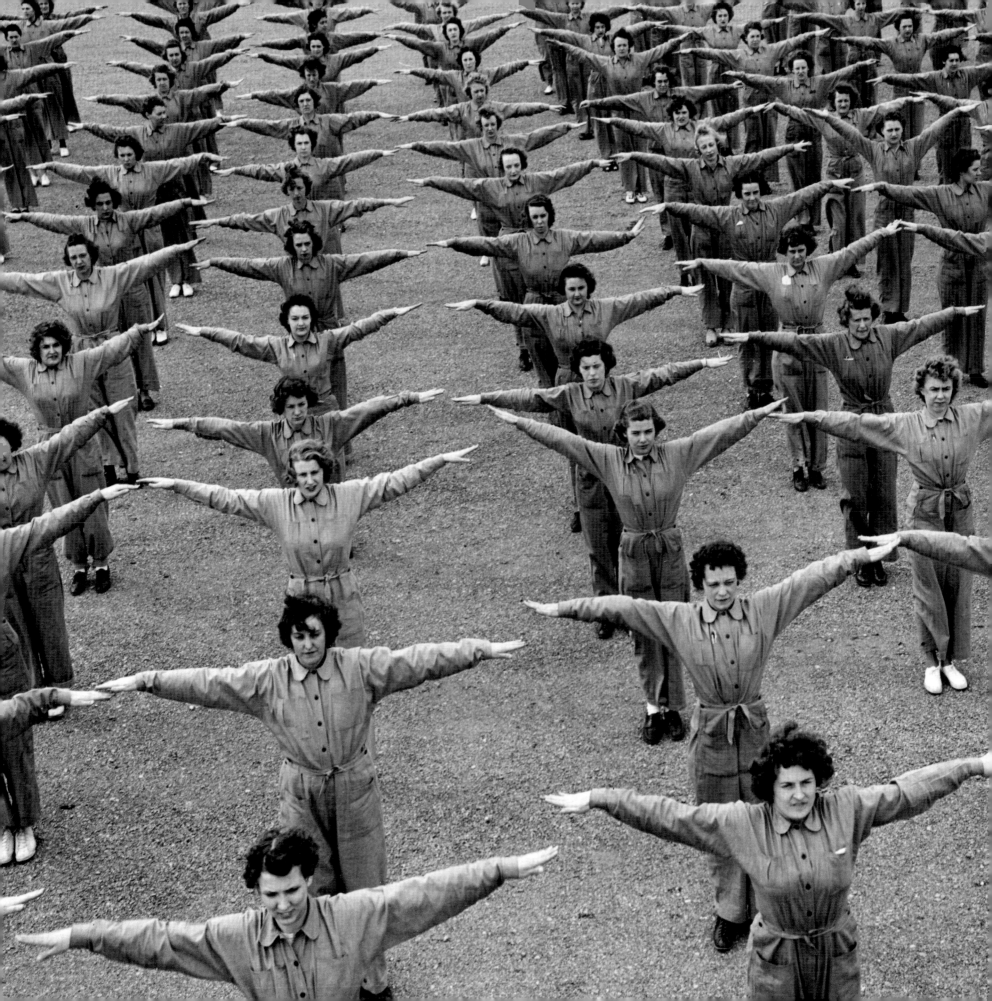

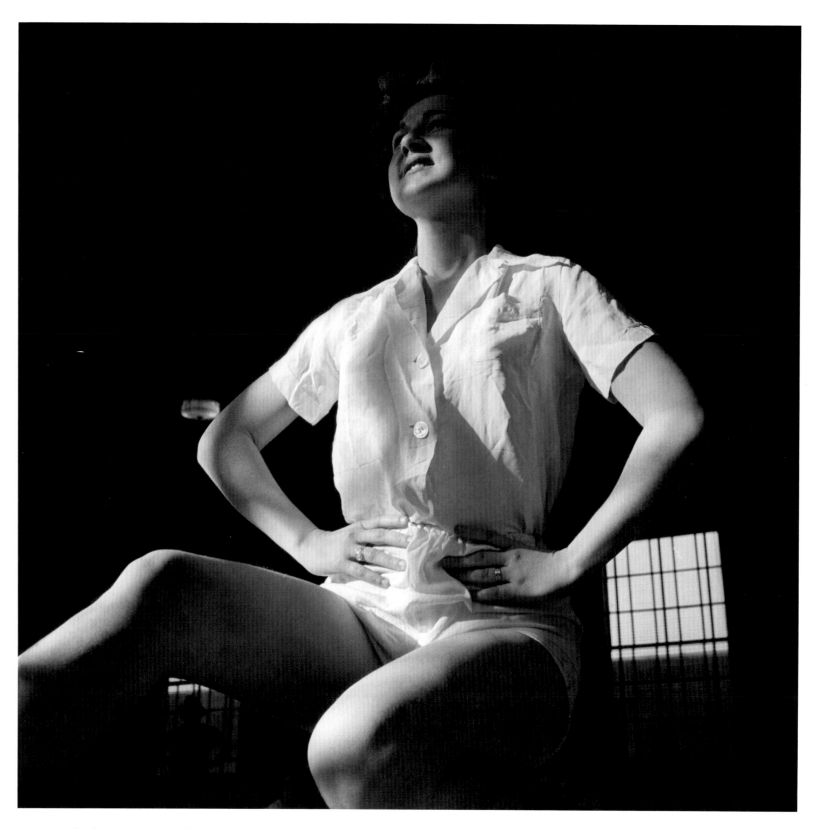

"Daily gym instructions keeps WAVES shipshape at boot camp, Cedar Falls, Iowa." February 1943; Cedar Falls, Iowa; Lt. Wayne Miller; 80-G-471574

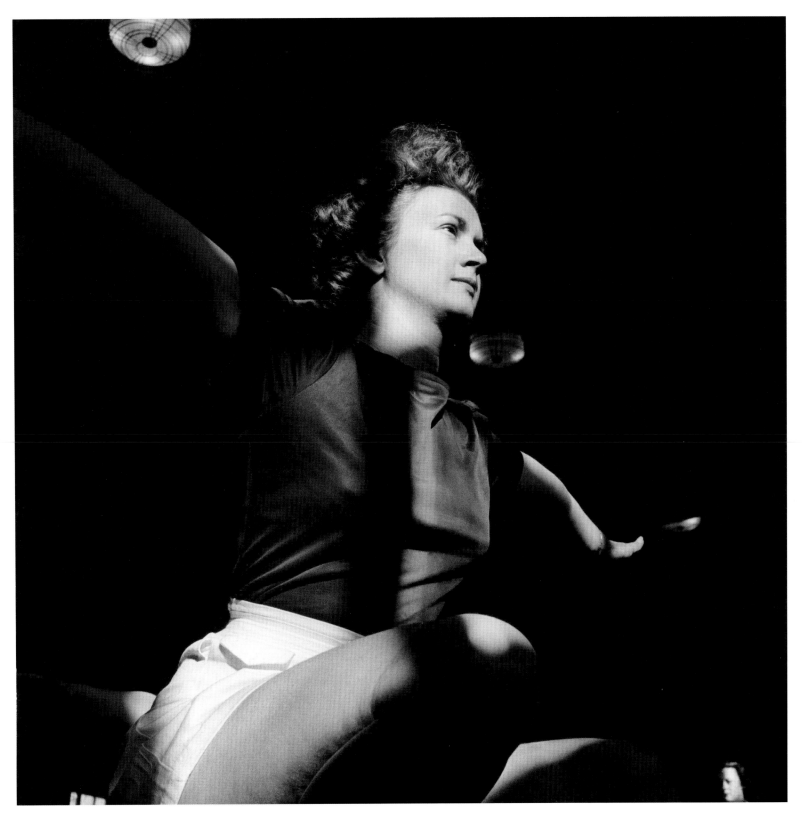

"Daily gym instructions keeps WAVES shipshape at boot camp, Cedar Falls, Iowa." February 1943; Cedar Falls, Iowa; Lt. Wayne Miller; 80-G-471575

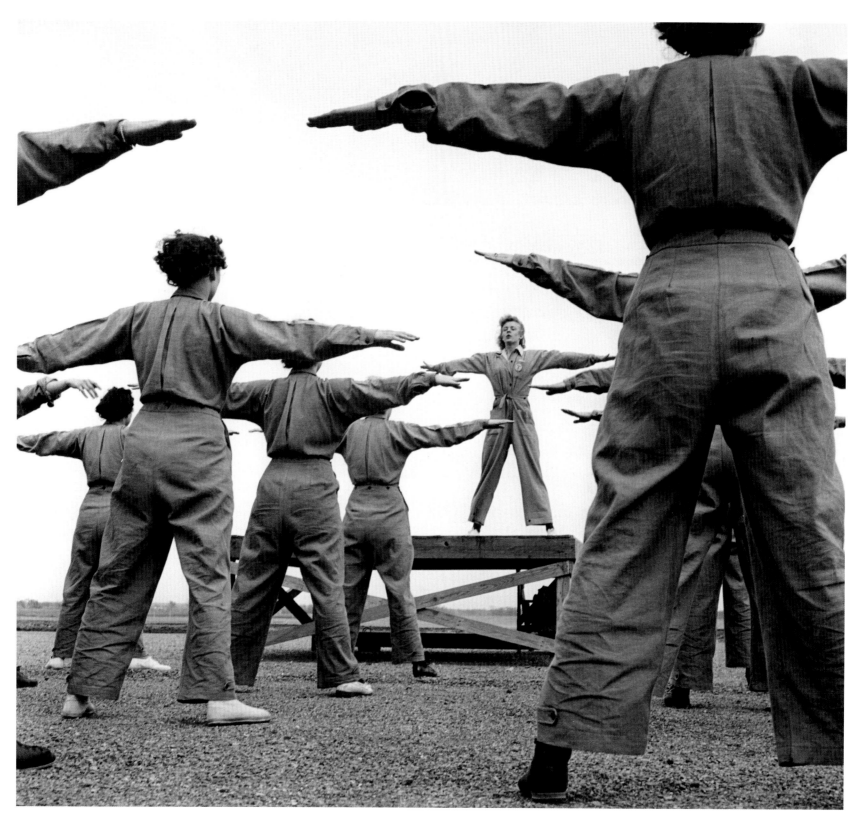

"WAVES having calisthenics at NATTC, Norman, Oklahoma." February 1943; Norman, Okla.; Lt. Wayne Miller; 80-G-471592

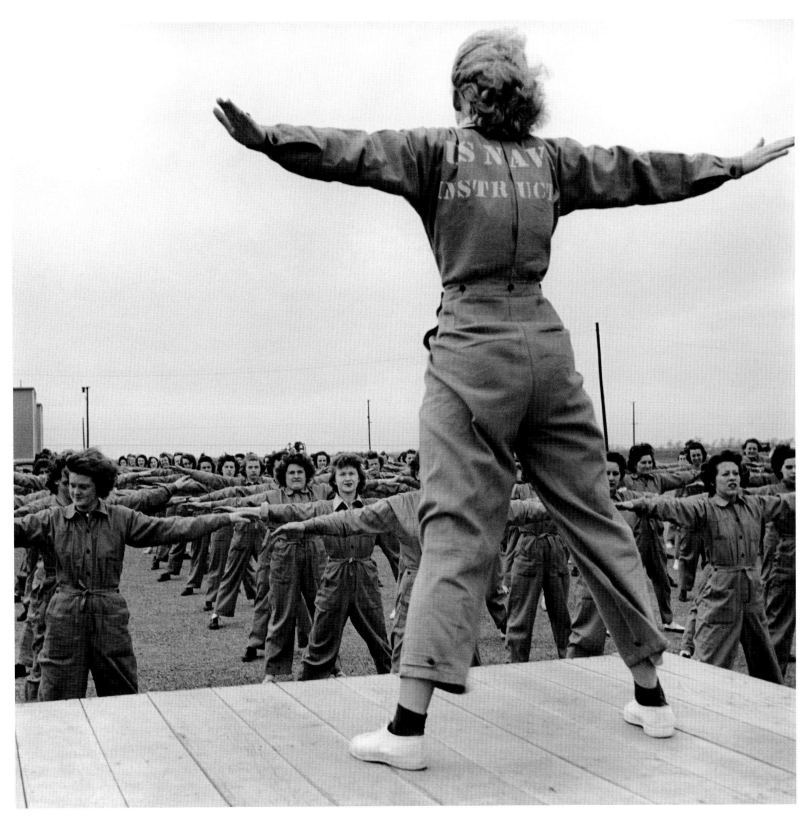

"WAVES having calisthenics at NATTC, Norman, Oklahoma." February 1943; Norman, Okla.; Lt. Wayne Miller; 80-G-471594

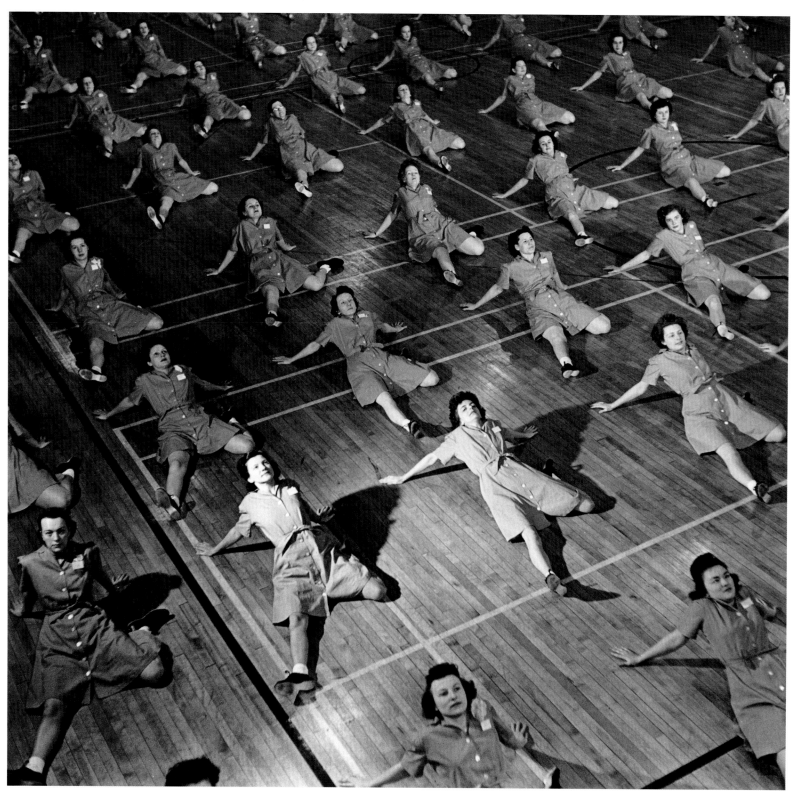

"WAVES receiving physical training at Naval Training School (Radio) University of Wisconsin, Madison, Wisconsin." February 1943;
Madison, Wisc.; PH3 Howard Liberman; 80-G-471615

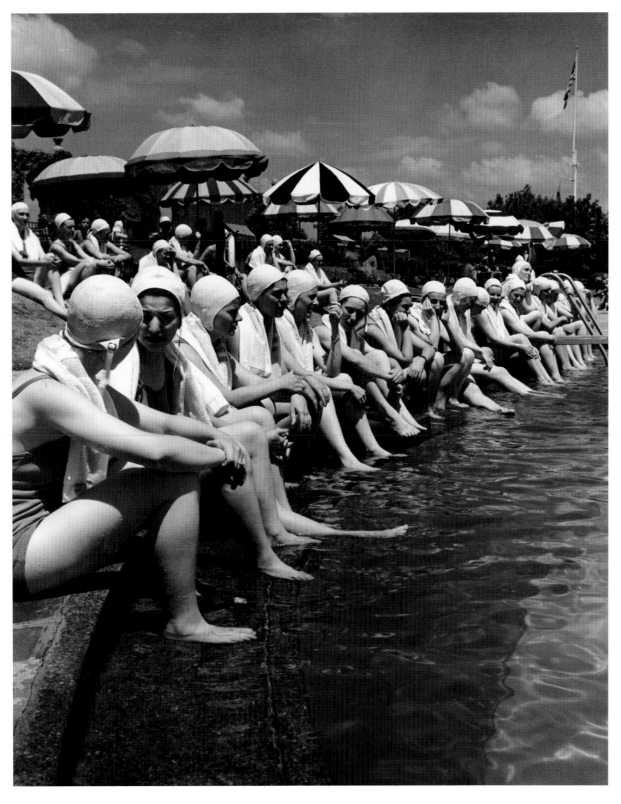

"WAVES at Hunter College Training School, New York City: WAVES in outdoor pool." November 1943; New York City, NY;
photograph unattributed; 80-G-103003

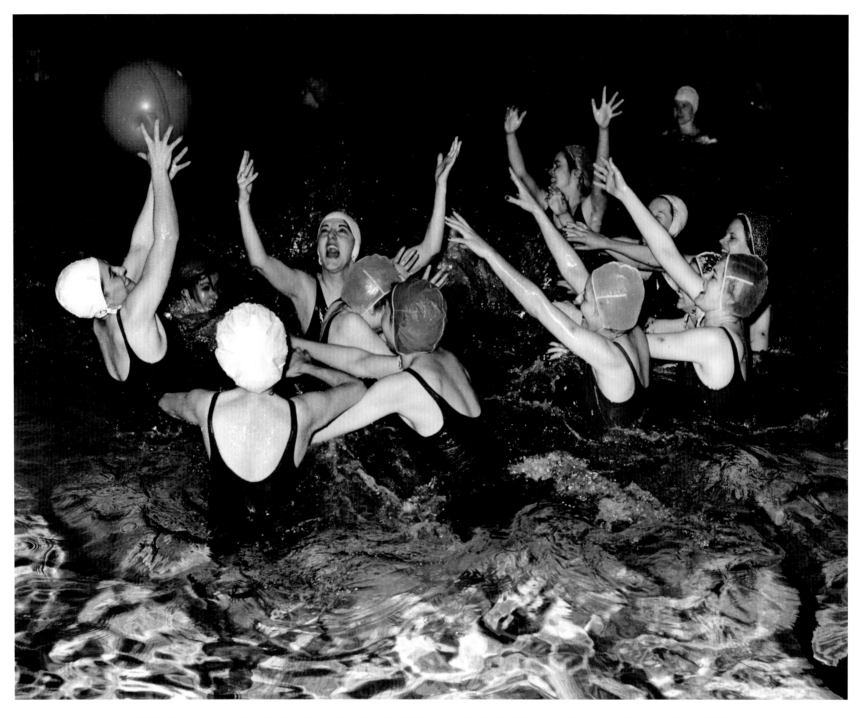

"WAVES playing water polo at boot camp, Cedar Falls, Iowa." February 1943; Cedar Falls, Iowa; PH2 Howard Liberman; 80-G-471606

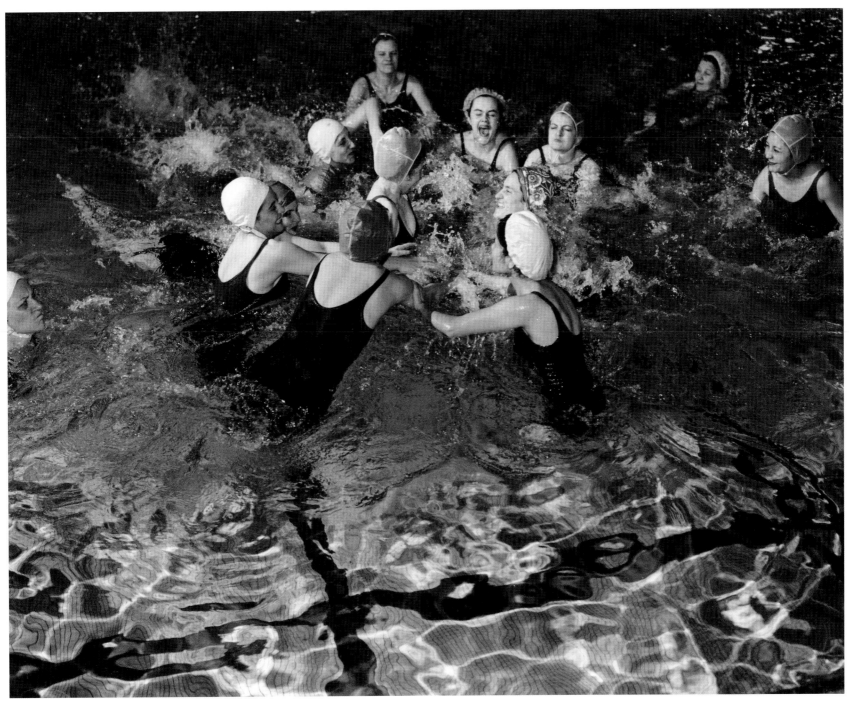

"WAVES playing water polo at boot camp, Cedar Falls, Iowa." February 1943; Cedar Falls, Iowa; PH2 Howard Liberman; 80-G-471607

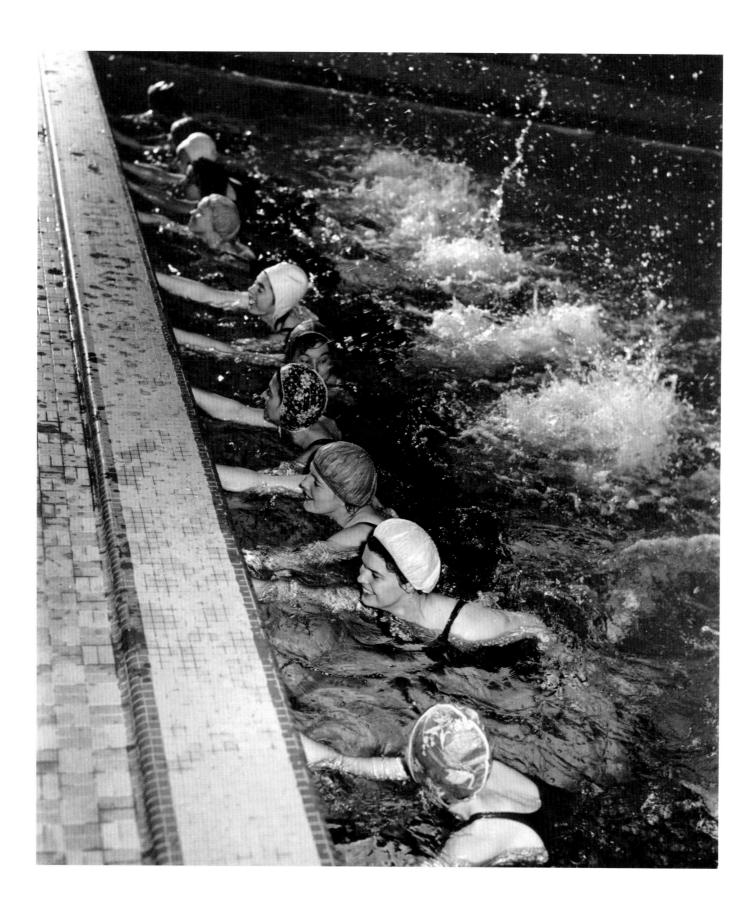

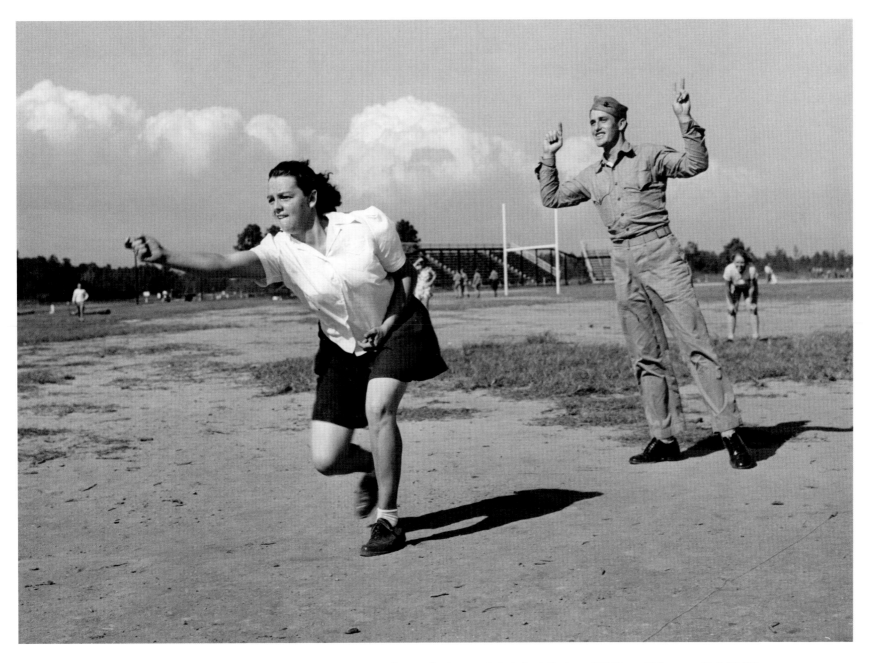

"WAVES practicing crawl kick in pool at boot camp, Cedar Falls, Iowa." February 1943; Cedar Falls, Iowa; PH3 Howard Liberman; 80-G-471632

"Women marines playing softball at Cherry Point, North Carolina." November 1943; Cherry Point, N.C.; Lt. Paul Dorsey; 80-G-471912

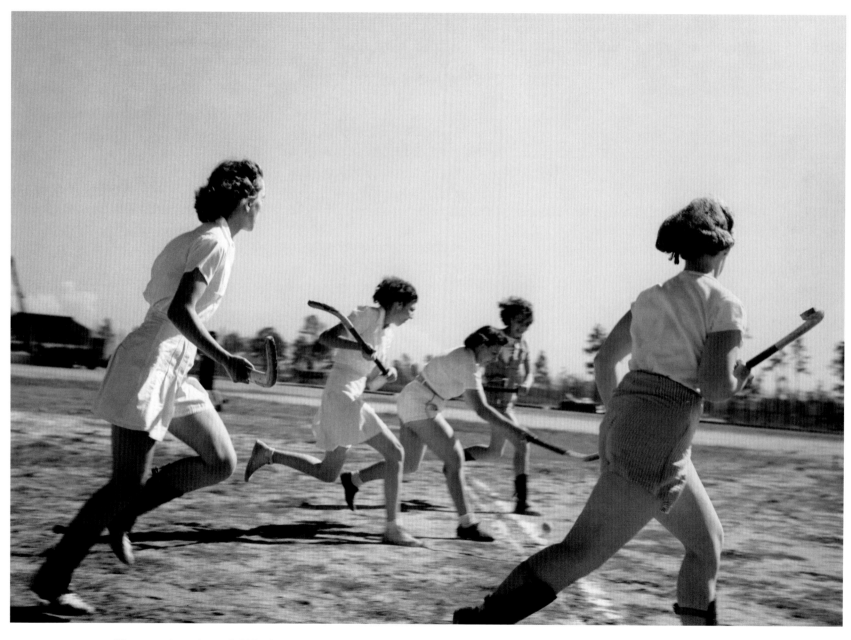

"Women marines playing field hockey at Cherry Point, North Carolina." November 1943; Cherry Point, N.C.; Lt. Paul Dorsey; 80-G-471911

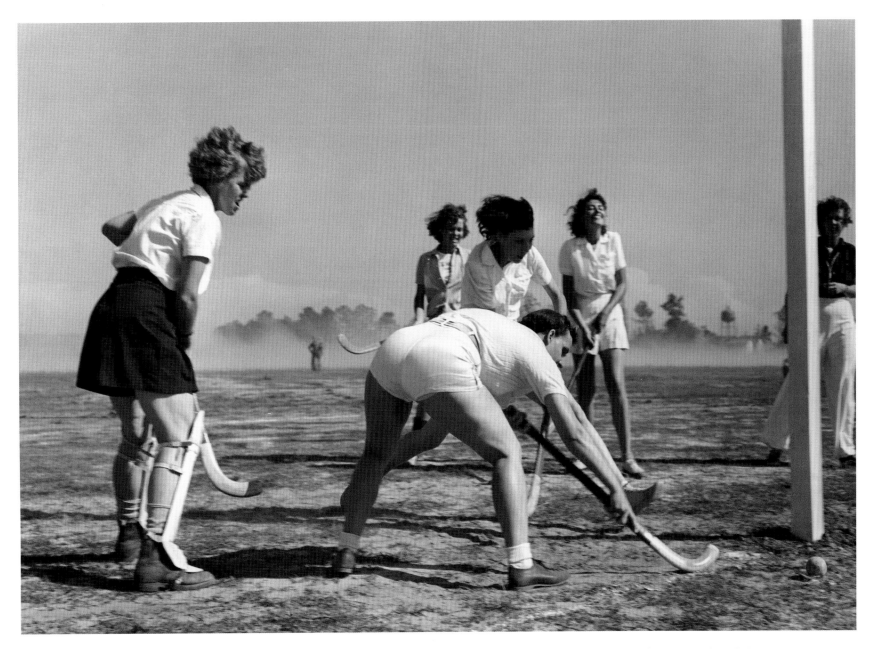

"Women marines playing field hockey at Cherry Point, North Carolina." November 1943; Cherry Point, N.C.; Lt. Paul Dorsey; 80-G-471917

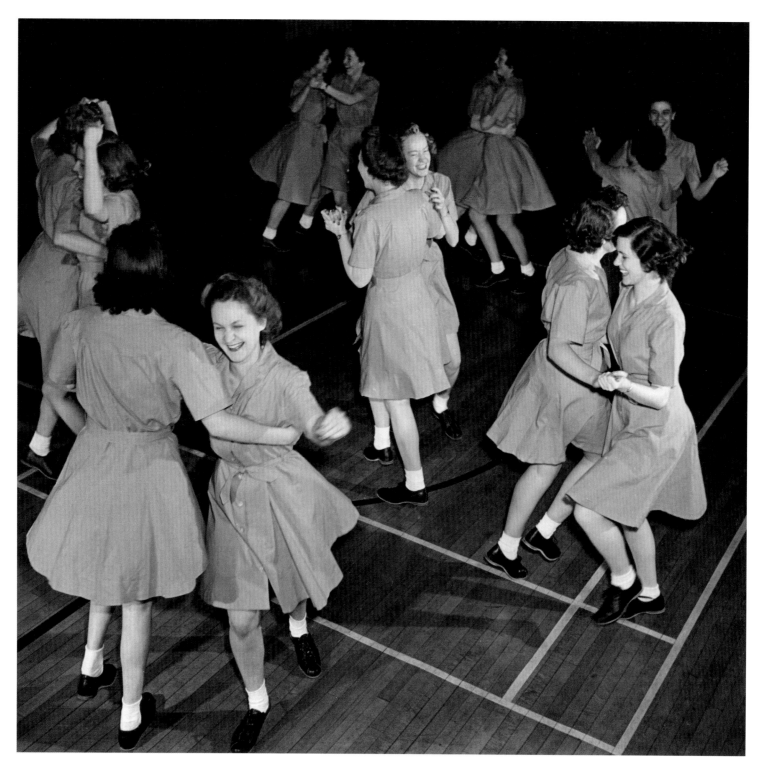

"WAVES square dancing of Radio School at University of Wisconsin, Madison, Wisconsin." March 1943; Madison, Wisc.; photograph unattributed; 80-G-471640

"Couple won jitterbug contest at the "open house" given by WAVES, Radio School at University of Wisconsin, Madison, Wisc." February 1943; Madison, Wisc.; PH2 Howard Liberman; 80-G-471611

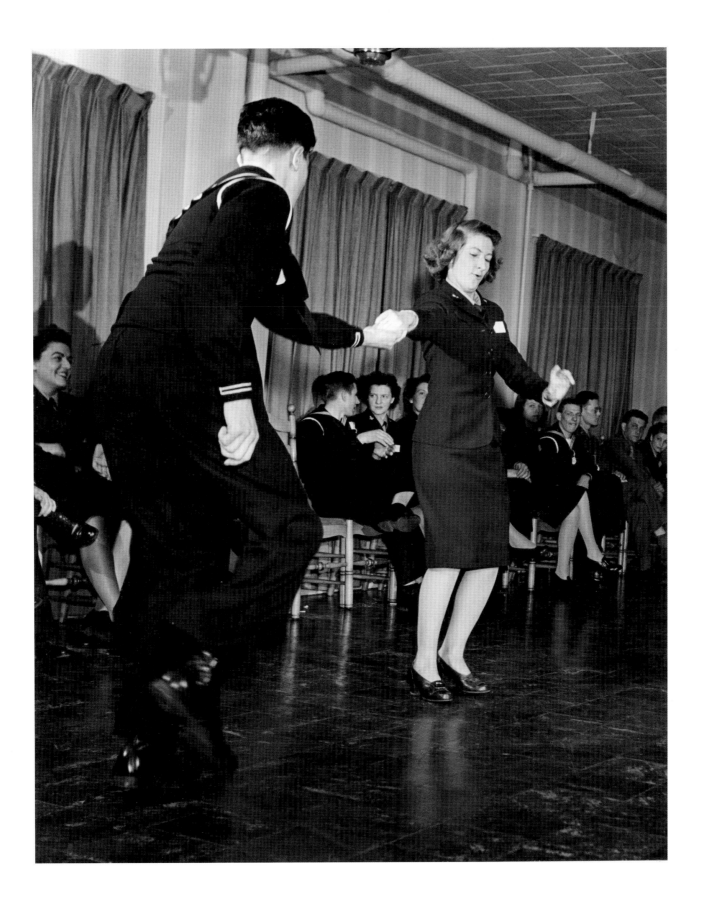

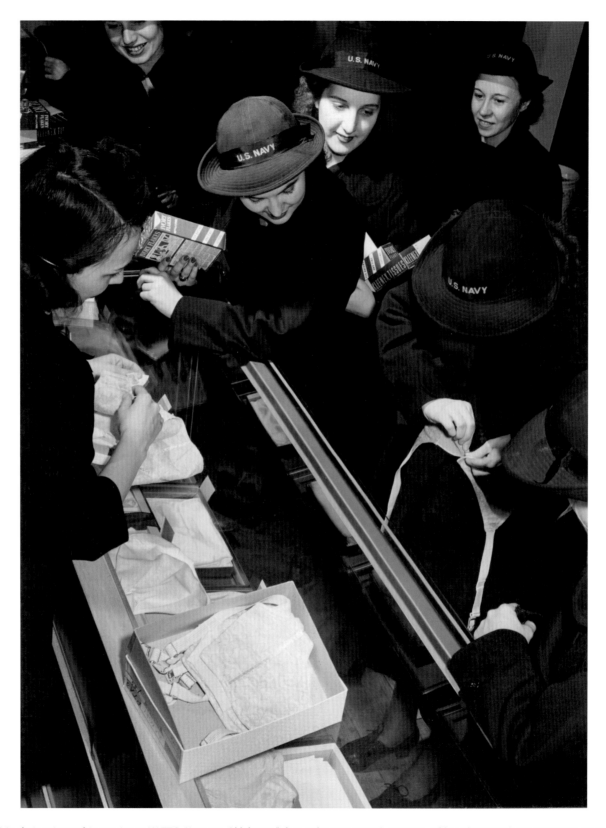

"WAVES in their private ship service at NATTC, Norman, Oklahoma." date unknown; NATTC, Norman, Okla.; photograph unattributed; 80-G-471556

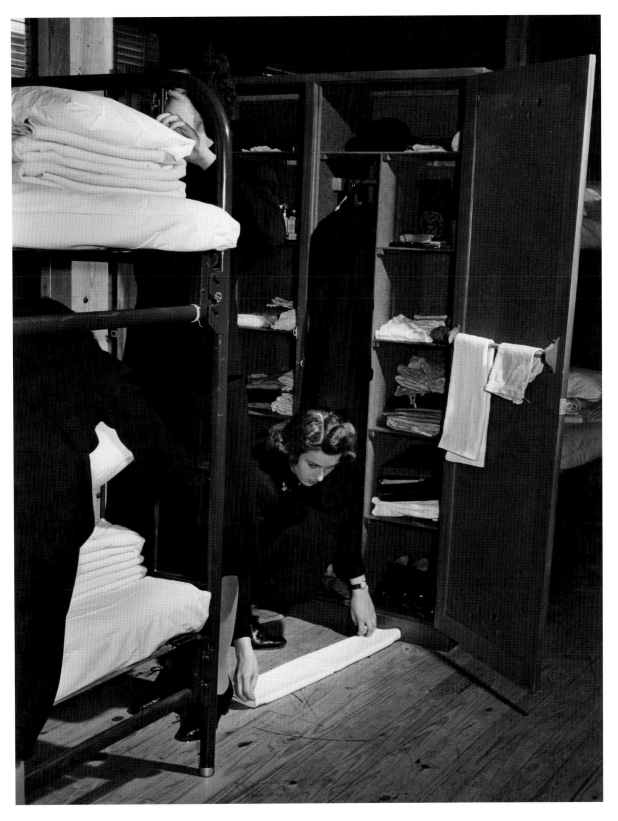

"Living quarters of WAVES at NATTC, Norman, Oklahoma." February 1943; NATTC, Norman, Okla.; photograph unattributed; 80-G-471554

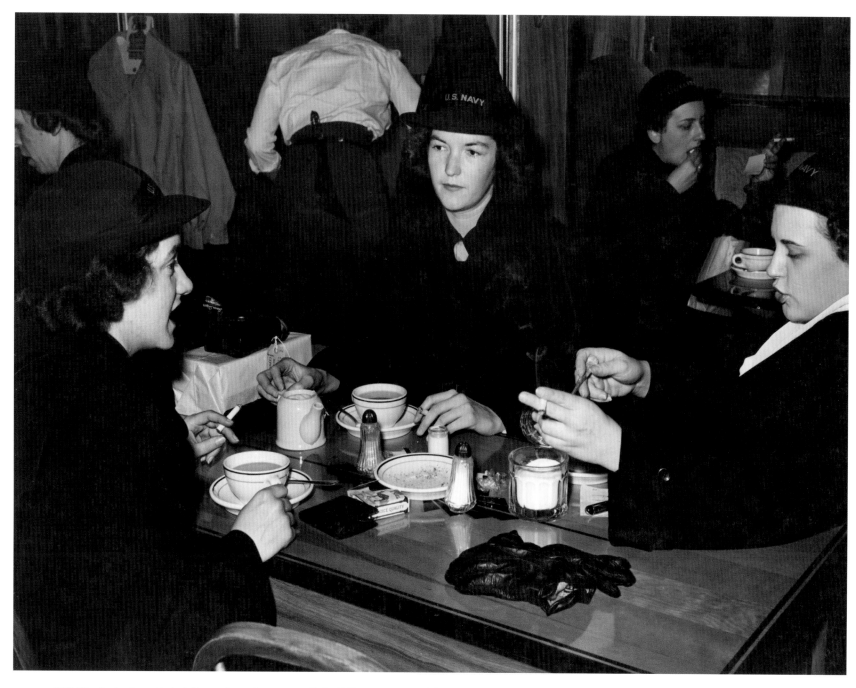

"WAVES relaxing from their daily routine at boot camp, Cedar Falls, Iowa: L-R, Kathleen Leahey, Katherine Van Wyck, and Phyllis Wright enjoy Cokes and cigarettes."
February 1943; Cedar Falls, Iowa; Lt. Wayne Miller; 80-G-471565

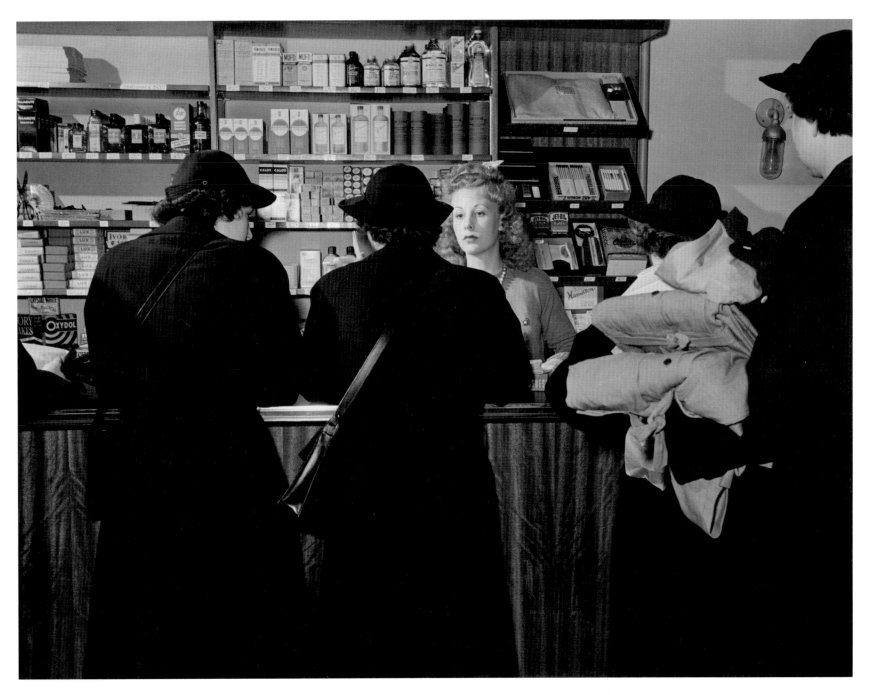

53

"Ship service exclusively for the WAVES at NATTC, Norman, Oklahoma." February 1943; NATTC, Norman, Okla.; photograph unattributed; 80-G-471602

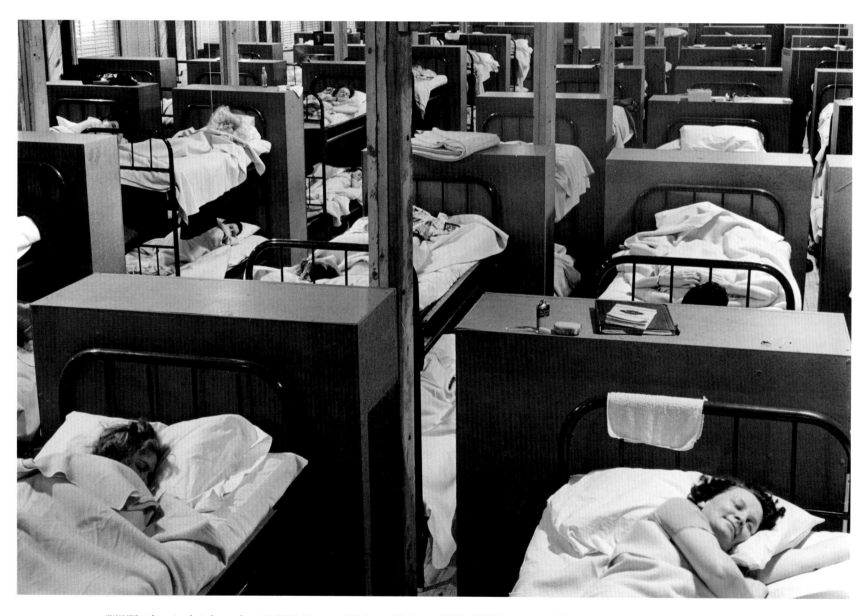

"WAVES asleep in their barracks at NATTC, Norman, Oklahoma." February 1943; NATTC, Norman, Okla.; photograph unattributed; 80-G-471534

"L-R, Jane Rosenbaum, June Davis, and Thelma Stretch do their laundry and write letters at night in their room, Yeoman School, Stillwater, Oklahoma."
February 1943; Stillwater, Okla.; Lt. Wayne Miller; 80-G-471582

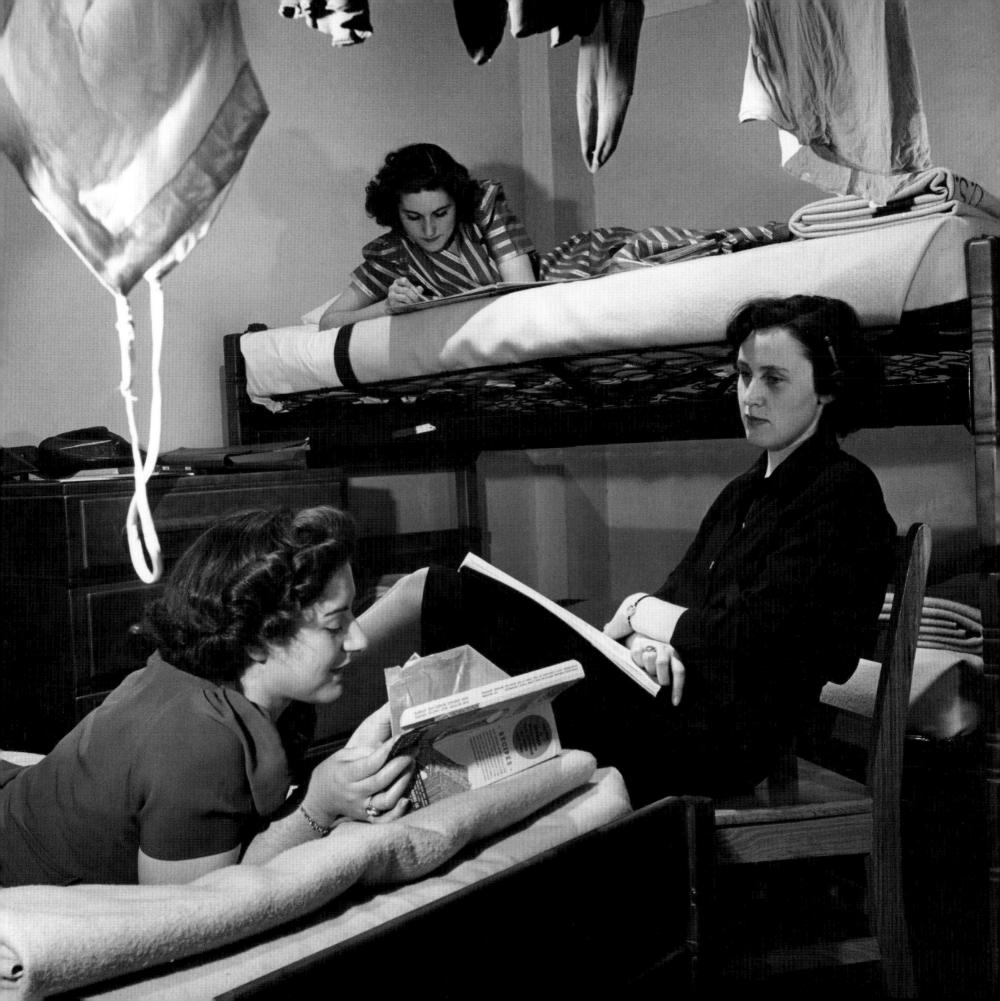

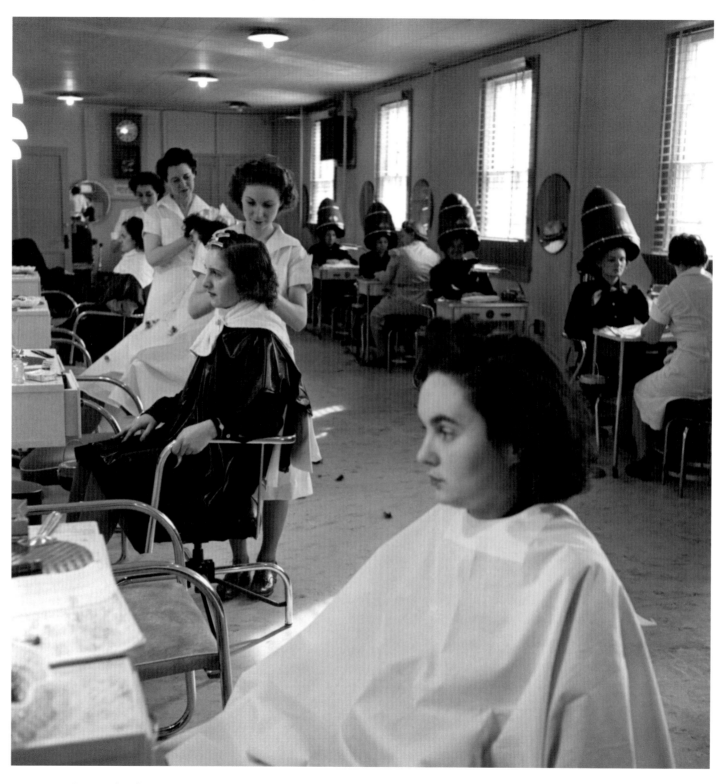

"Beauty shop for WAVES at NATTC, Norman Oklahoma." February 1943; NATTC, Norman, Okla.; Lt. Wayne Miller; 80-G-471541

"Beauty shop for WAVES at NATTC, Norman Oklahoma." February 1943; NATTC, Norman, Okla.; Lt. Wayne Miller; 80-G-471539

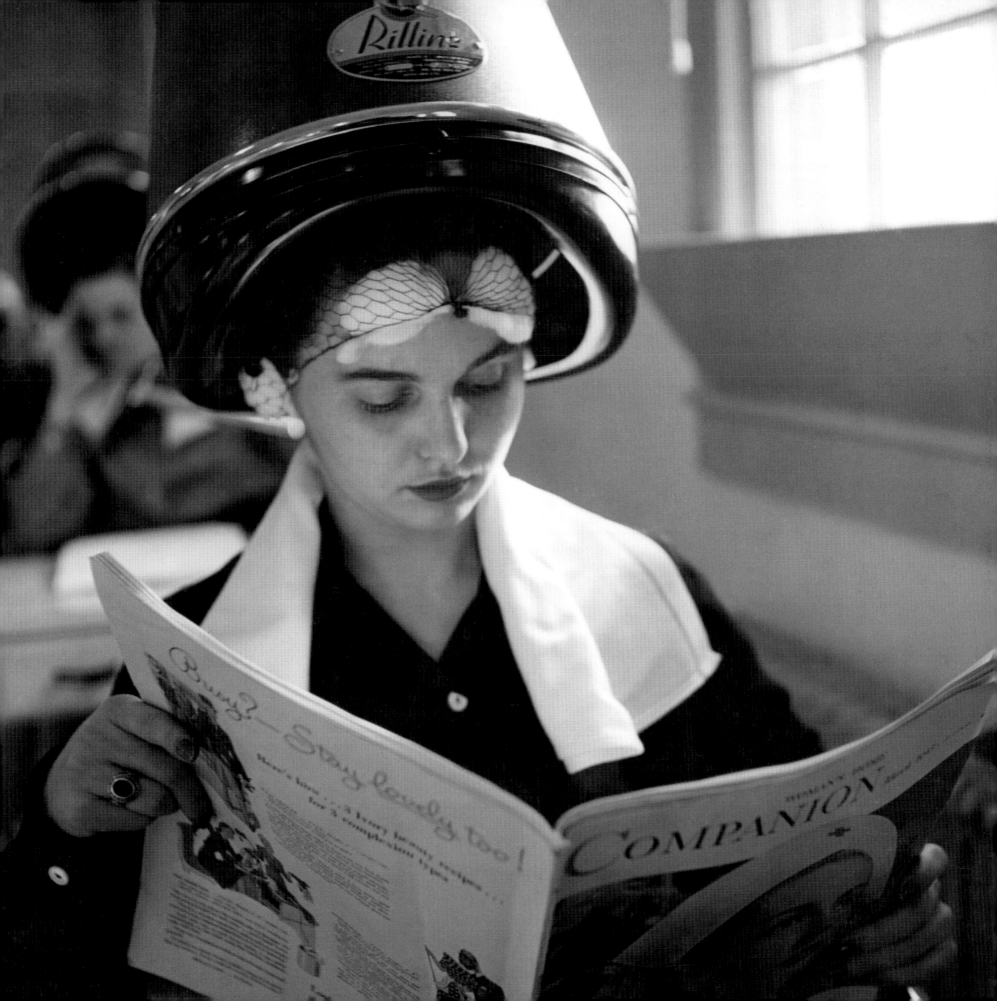

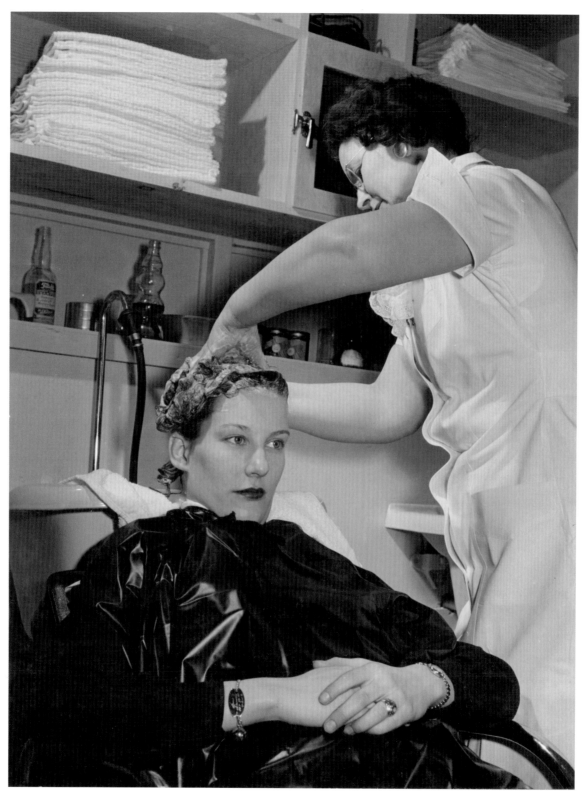

"Ann Daniels receives a shampoo from Mrs. Pearl Hazelton in beauty shop at NATTC, Norman, Oklahoma." February 1943;
NATTC, Norman, Okla.; Lt. Wayne Miller; 80-G-471491

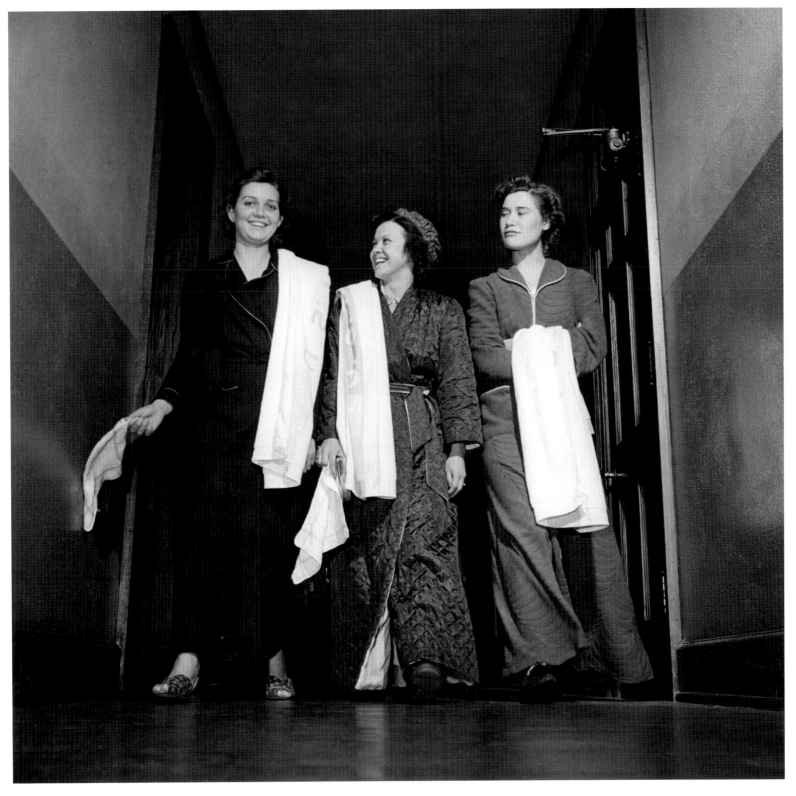

"L-R, Joy Shrader, Winifred Smith, and Estelle Slominski going for shower at bedtime, boot camp, Cedar Falls, Iowa."
February 1943; Cedar Falls, Iowa; Lt. Wayne Miller; 80-G-471573

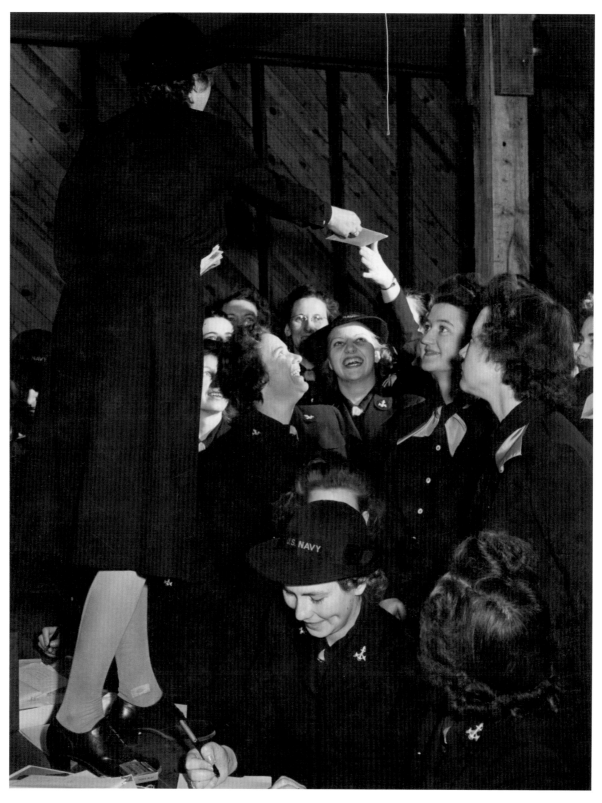

"Incoming mail is highlight of day for WAVES at NATTC, Norman, Oklahoma." February 1943;
NATTC, Norman, Okla.; Lt. Wayne Miller; 80-G-471601

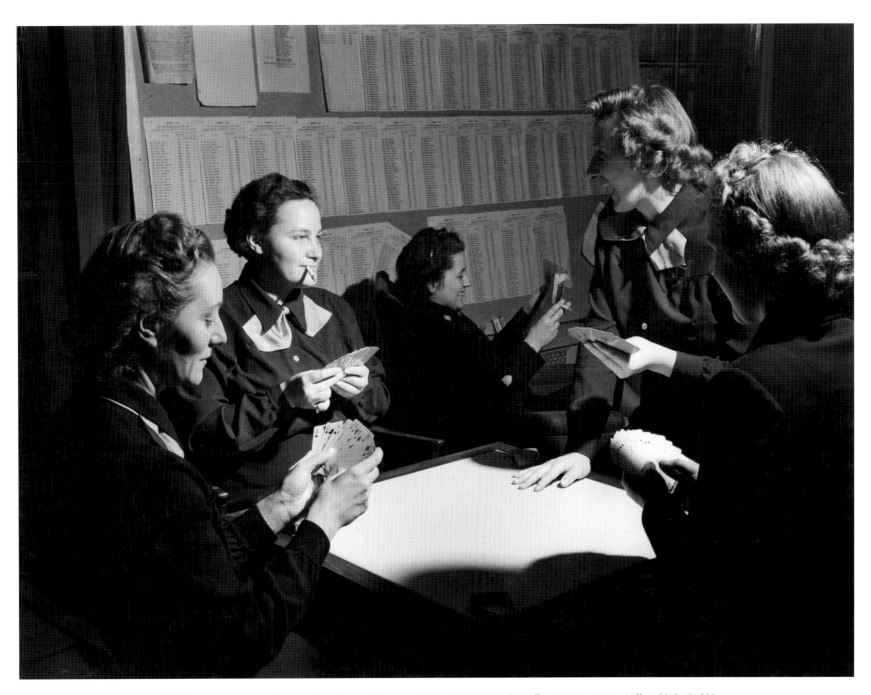

"WAVES playing bridge at Bartlett Hall, Cedar Falls, Iowa." February 1943; Cedar Falls, Iowa; Lt. Wayne Miller; 80-G-471600

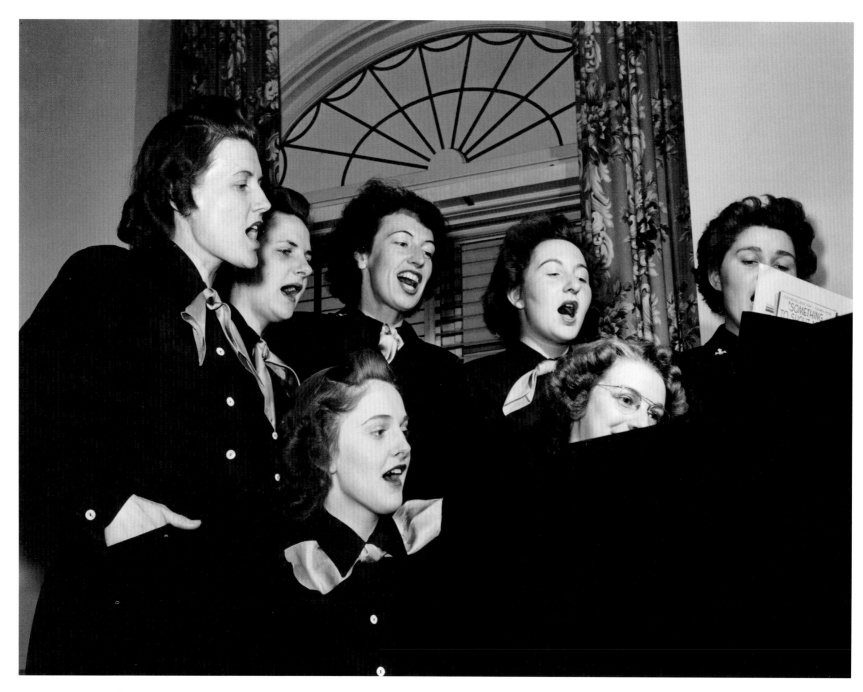

"WAVES attending Yeoman School at Stillwater, Oklahoma: Singing old songs for relaxation." September 1943; Stillwater, Okla.; photograph unattributed; 80-G-471900

"Sylvia Nathan, who will go to Washington, D.C. as an IBM operator after leaving boot camp, Cedar Falls, Iowa." February 1943; Cedar Falls, Iowa; photograph unattributed; 80-G-471604

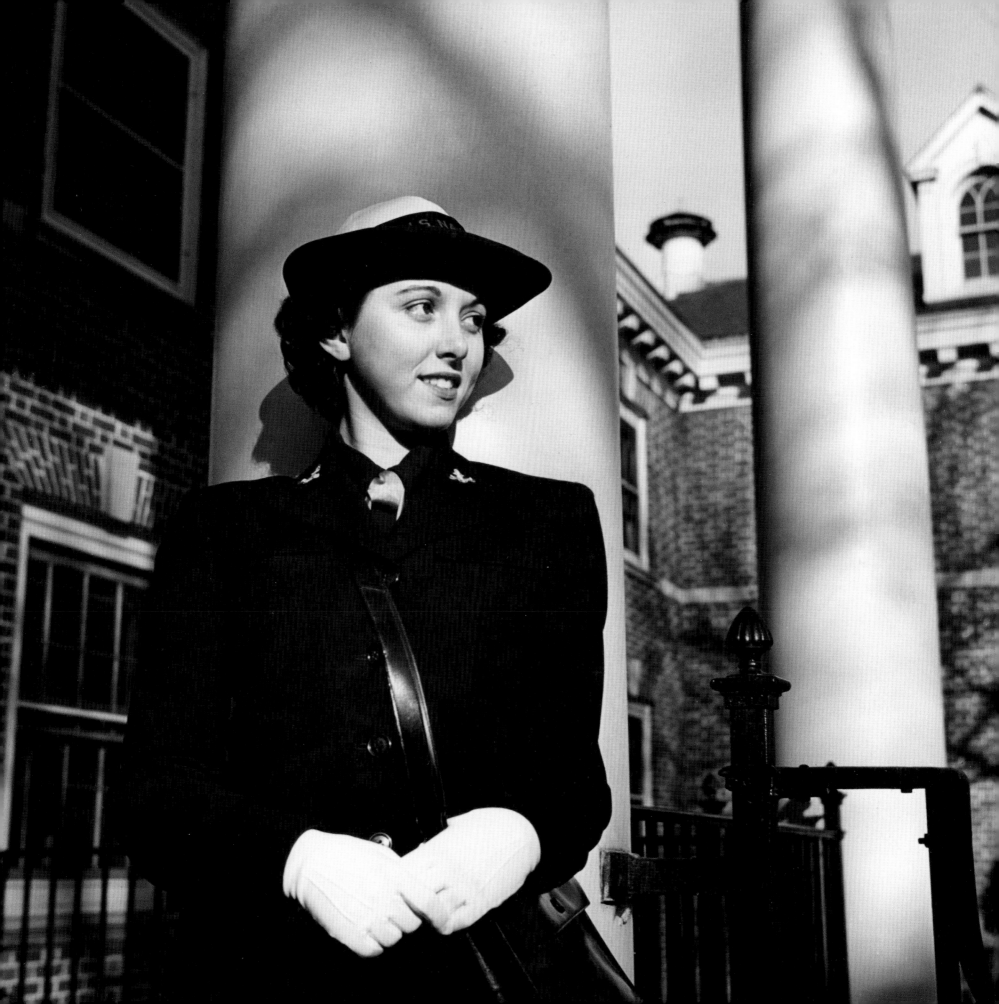

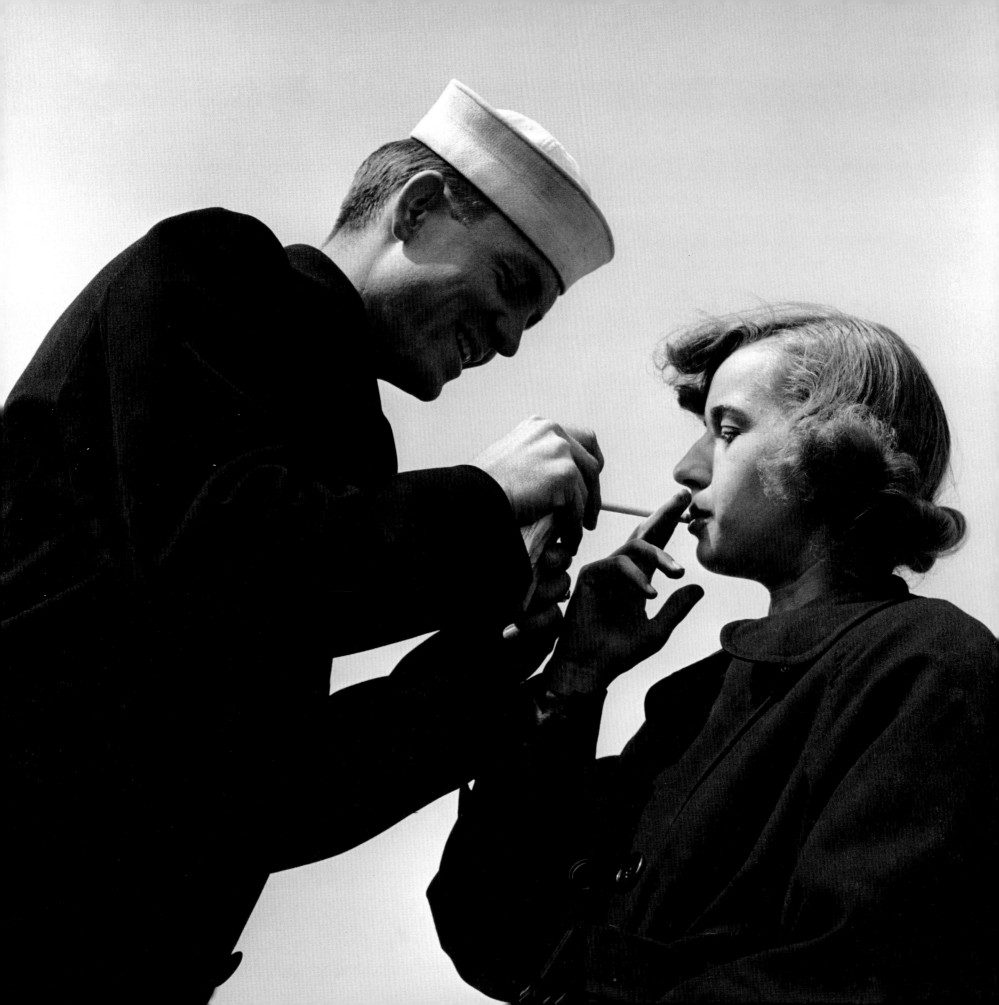

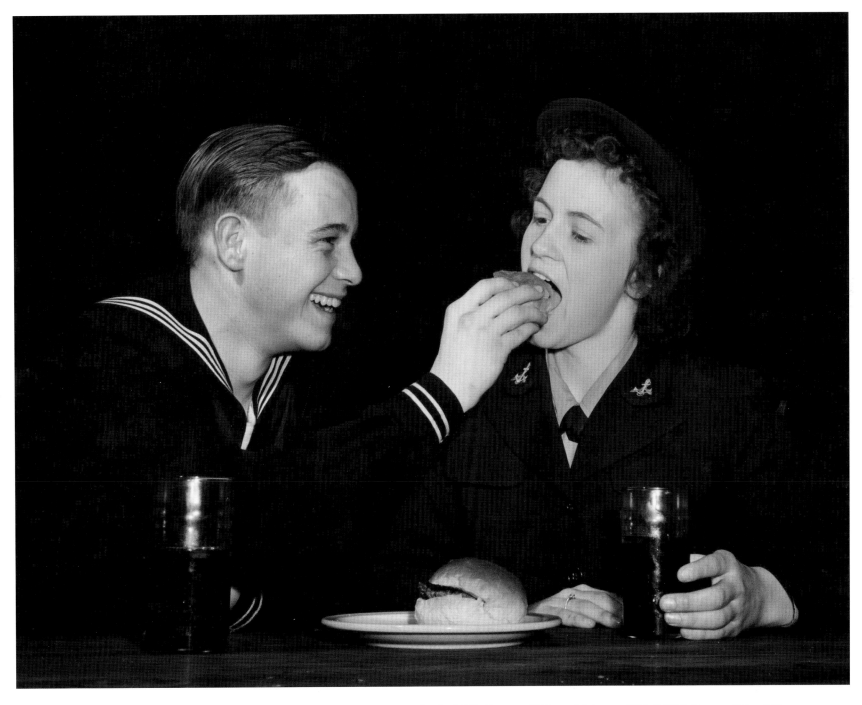

"WAVE and sailor take time out for a smoke at aviation machinist mate school, NATTC, Norman, Oklahoma." February 1943; NATTC, Norman, Okla.; PH2 Howard Liberman; 80-G-471608

"Esther Miller and George Riketts having something to eat on campus at University of Wisconsin, Madison, Wisconsin. Both are attending Radio School." March 1943; Madison, Wisc.; PH3 Howard Liberman; 80-G-471635

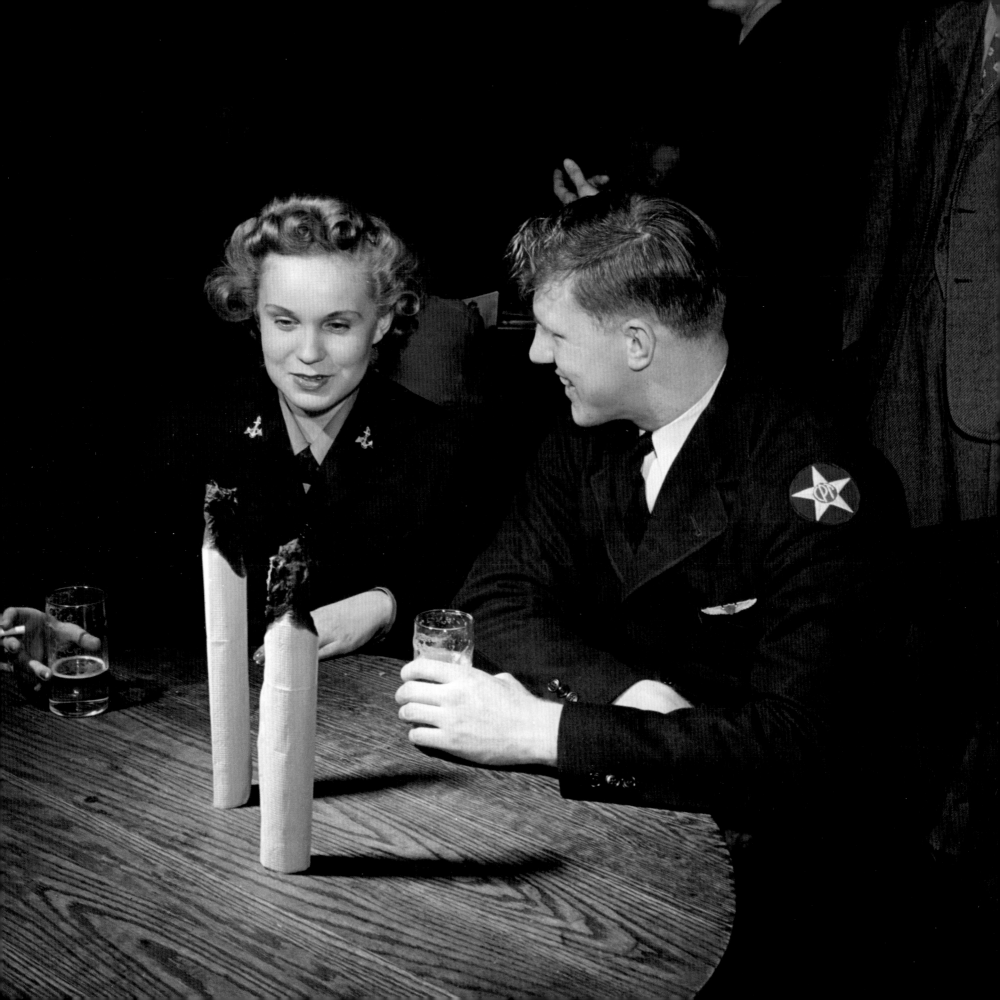

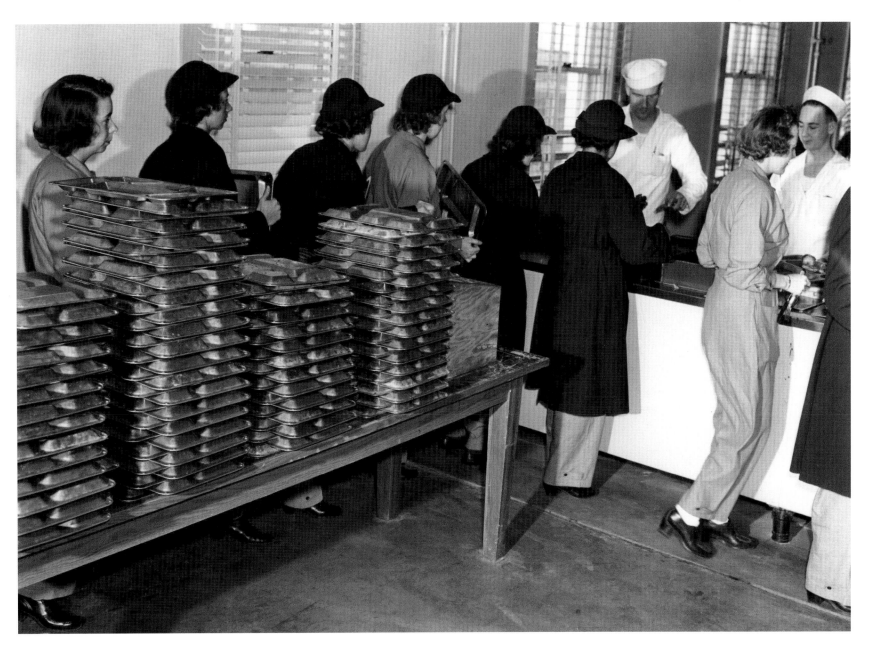

"June Dusold and John Mulaney at the Rathskeller on their first date together. Both are in training at University of Wisconsin, Madison, Wisconsin."
March 1943; Madison, Wisc.; PH3 Howard Liberman; 80-G-471627

"WAVE trainees at Naval Air Technical Training Center, Norman, Oklahoma: Chow line." March 1943; Norman, Okla.; PH2 Howard Liberman; 80-G-471668

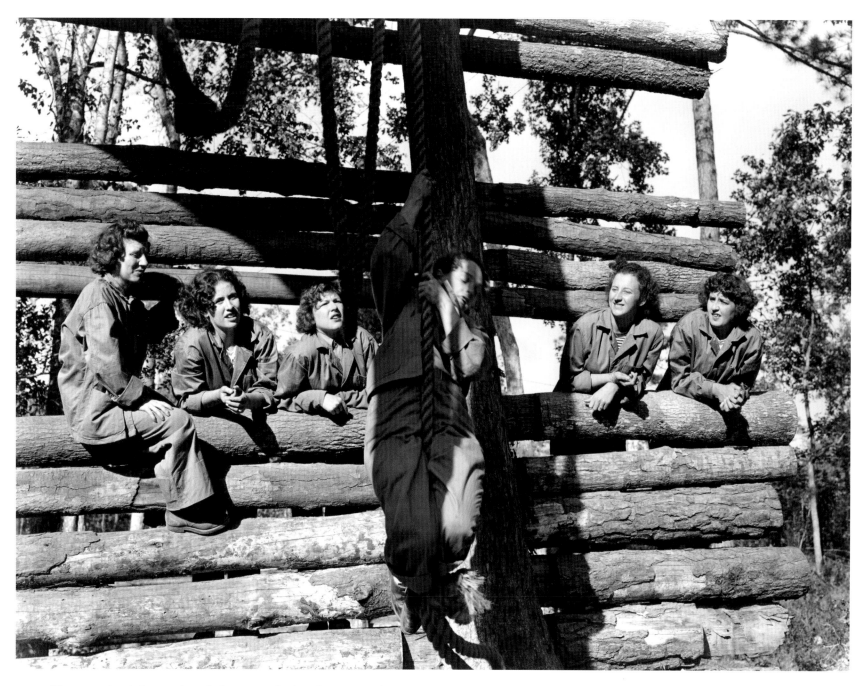

"Women marines being put through the commando obstacle course at Cherry Point, North Carolina." November 1943; Cherry Point, N.C.; Lt. Paul Dorsey; 80-G-471915

"Women marines being put through the commando obstacle course at Cherry Point, North Carolina." November 1943; Cherry Point, N.C.; Lt. Paul Dorsey; 80-G-471914

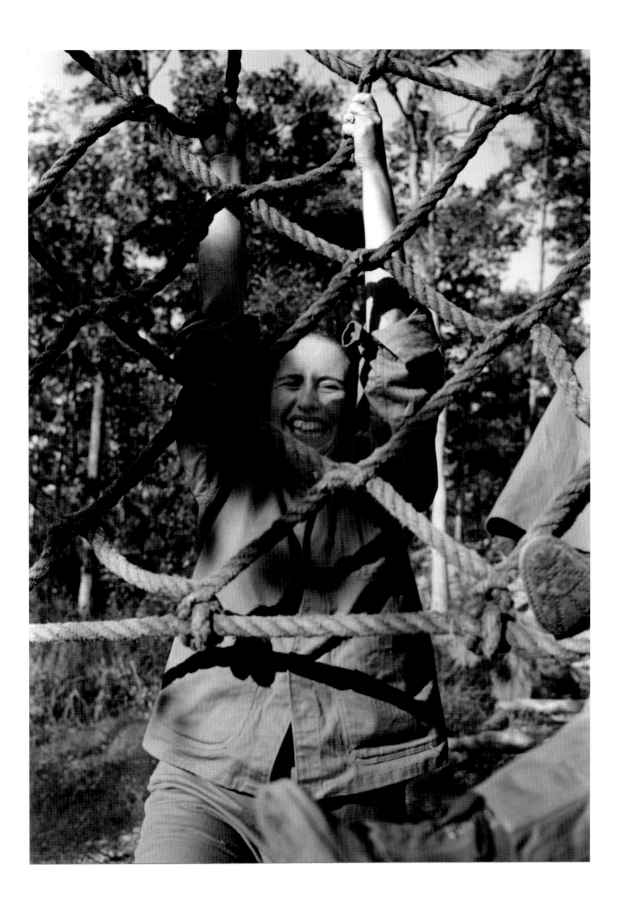

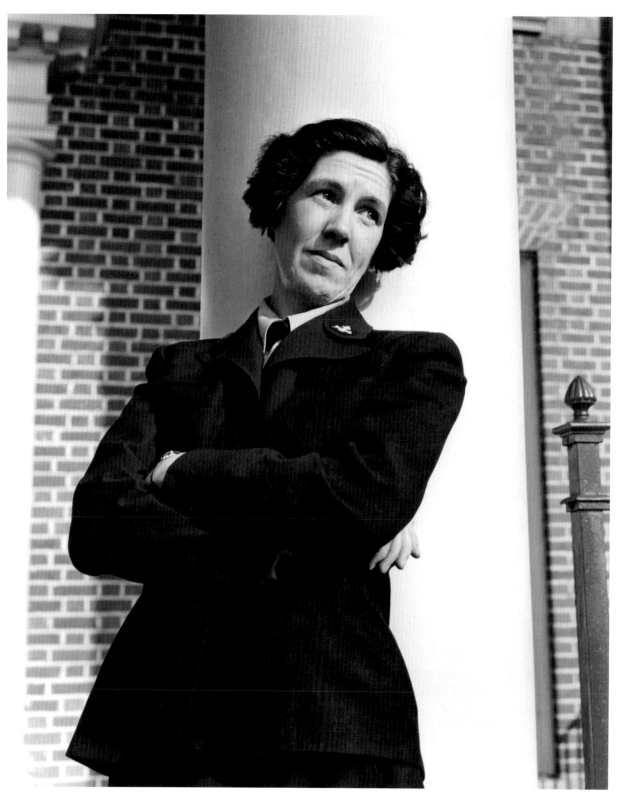

"Eileen Hunter at boot camp, Cedar Falls, Iowa: She was New England bowling champ and is registered pharmacist-graduate of Connecticut."
March 1943; Cedar Falls, Iowa; Howard Liberman; 80-G-471625

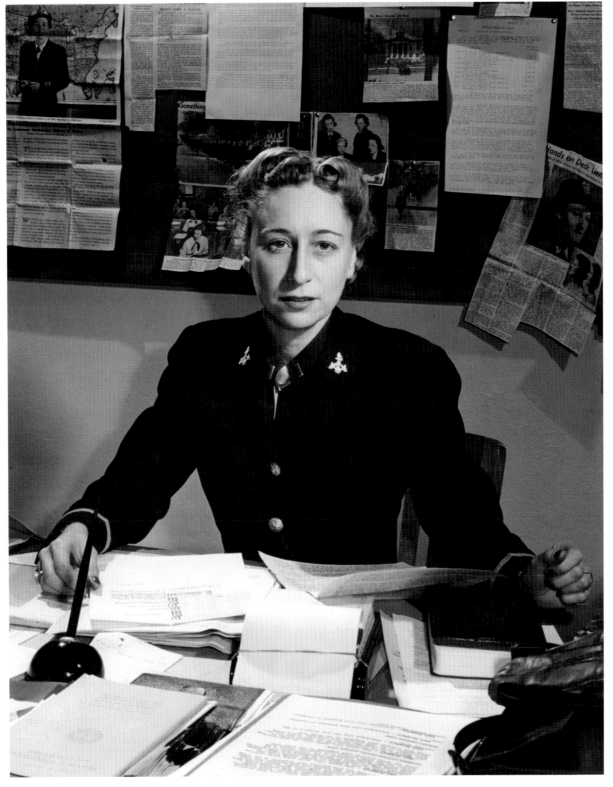

"Ens. Gladys Henderson, public relations officer at Cedar Falls, Iowa." February 1943; Cedar Falls, Iowa; Lt. Wayne Miller; 80-G-471570

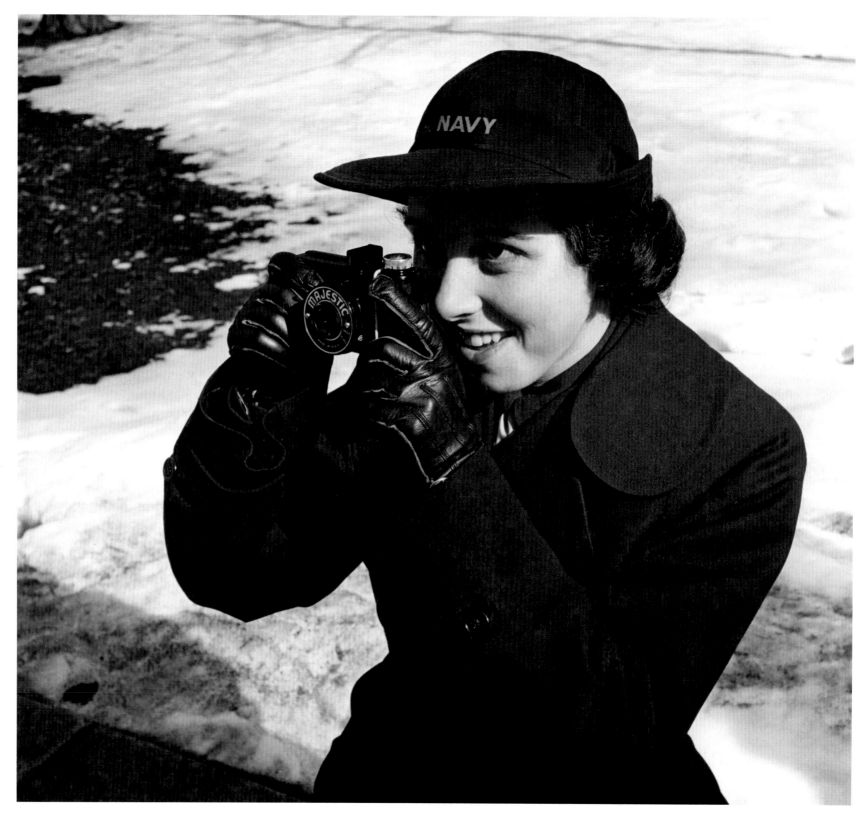

"Silvia Nathan spends considerable time taking pictures of her new shipmates at boot camp, Cedar Falls, Iowa." February 1943; Cedar Falls, Iowa; Lt. Wayne Miller; 80-G-471583

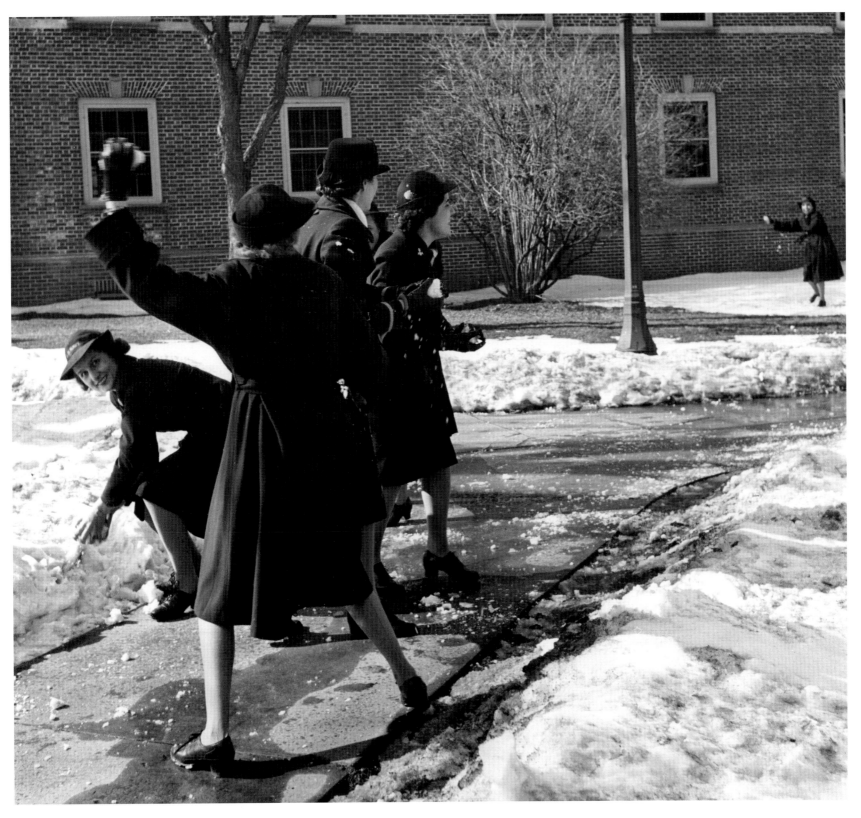

"WAVES enjoy first snow of year at boot camp, Cedar Falls, Iowa." February 1943; Cedar Falls, Iowa; Lt. Wayne Miller; 80-G-471595

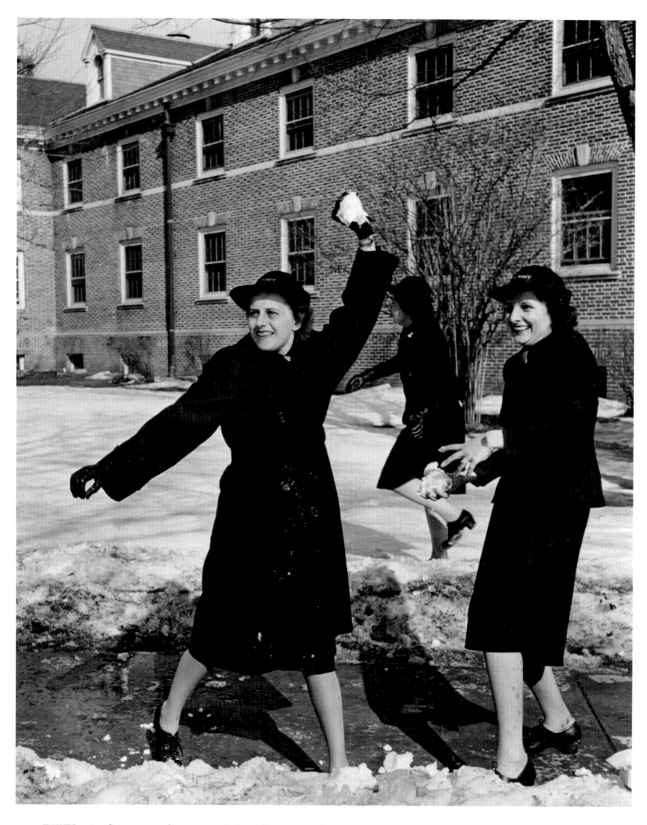

"WAVES enjoy first snow at boot camp, Cedar Falls, Iowa." February 1943; Cedar Falls, Iowa; Lt. Wayne Miller; 80-G-471584

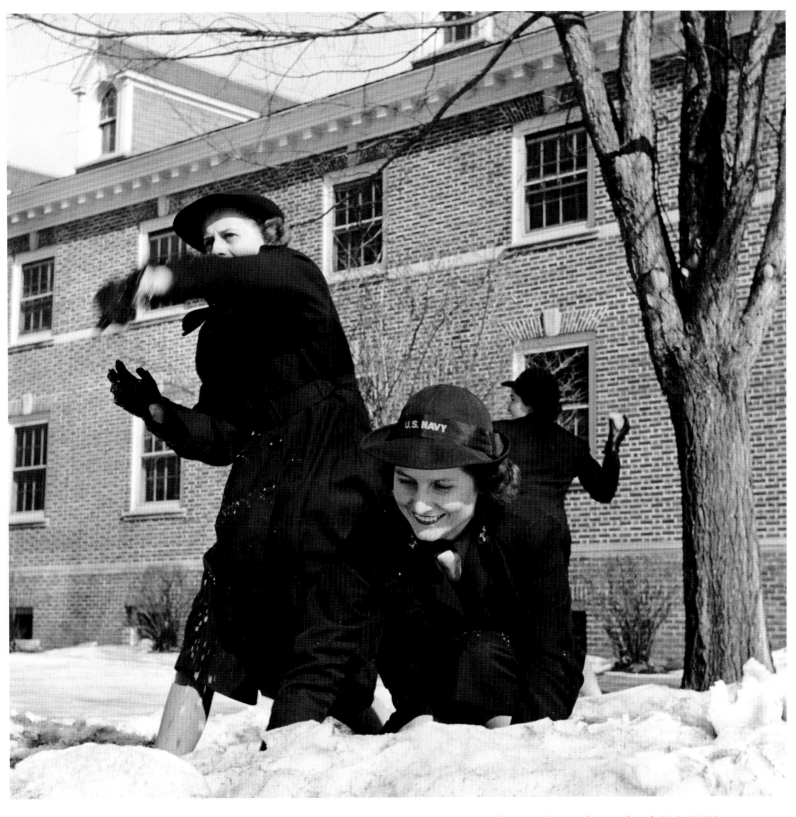

"WAVES enjoy first snow of year at boot camp, Cedar Falls, Iowa." February 1943; Cedar Falls, Iowa; photograph unattributed; 80-G-471596

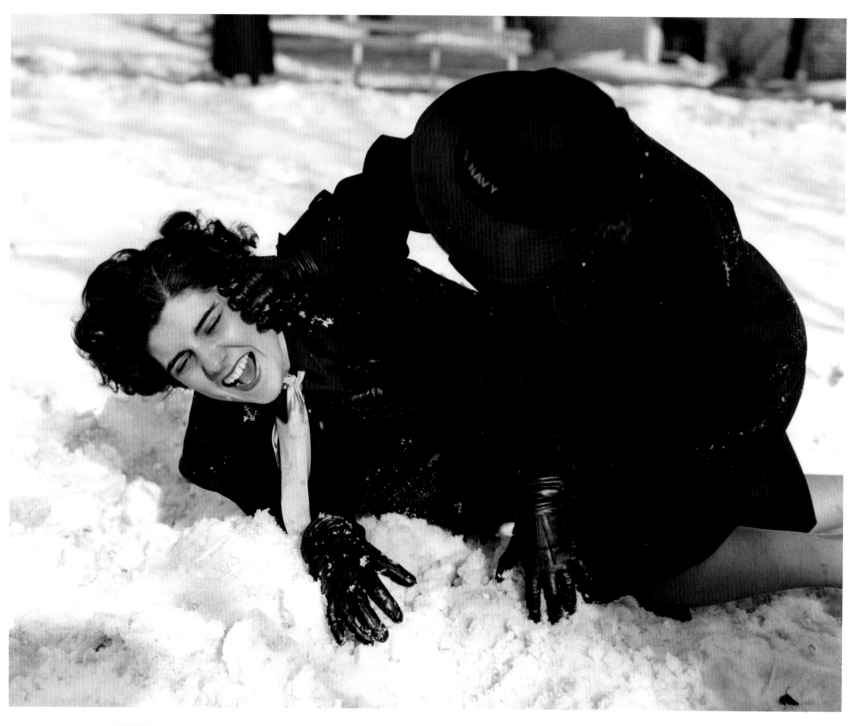

"WAVES enjoy the first snow at boot camp, Cedar Falls, Iowa." February 1943; Cedar Falls, Iowa; photograph unattributed; 80-G-471599

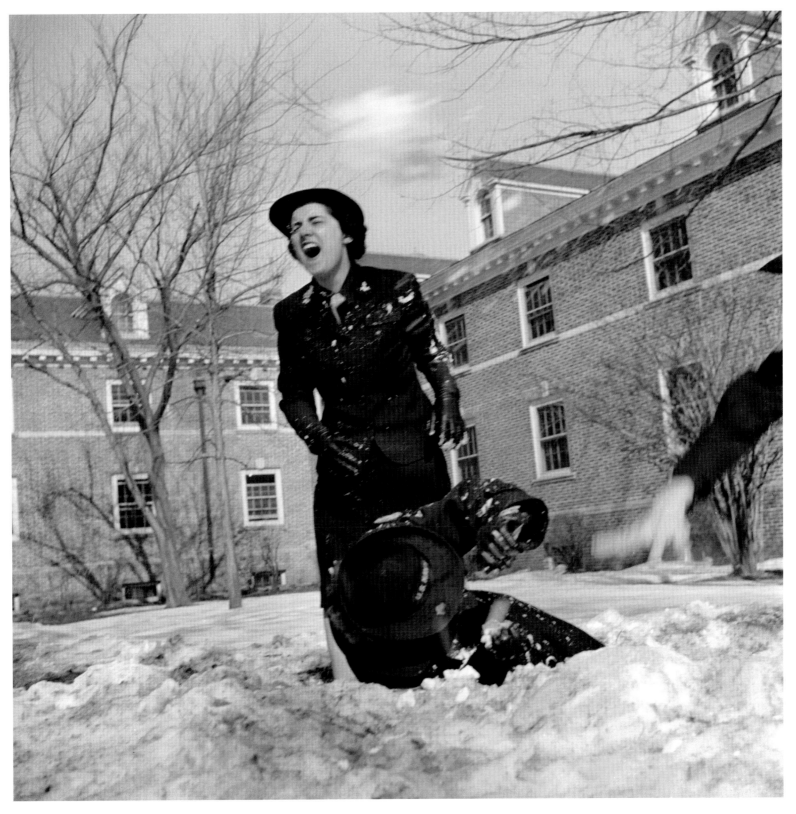

"WAVES enjoy first snow at boot camp, Cedar Falls, Iowa." February 1943; Cedar Falls, Iowa; Lt. Wayne Miller; 80-G-471585

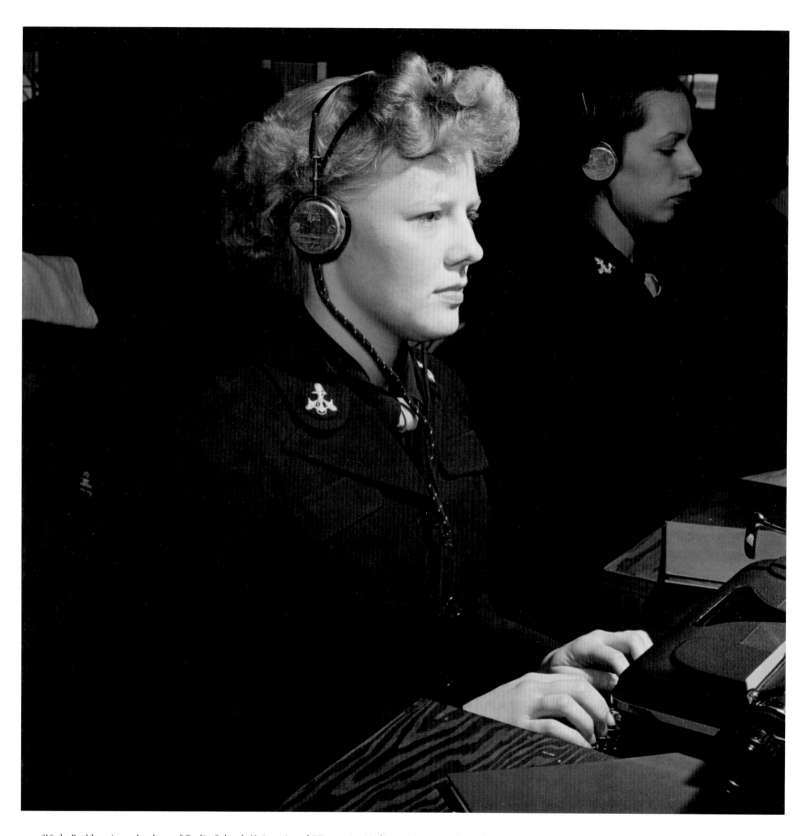

"Viola Brakker, in code class of Radio School, University of Wisconsin, Madison, Wisconsin." March 1943; Madison, Wisc.; PH3 Howard Liberman; 80-G-471617

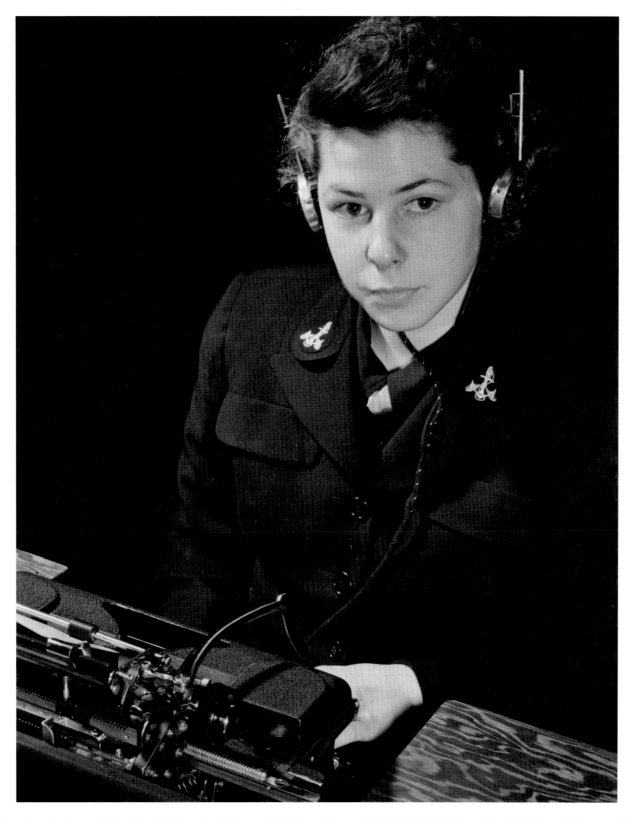

"WAVE trainee in code class at Radio School, University of Wisconsin, Madison, Wisconsin." March 1943; Madison, Wisc.; PH3 Howard Liberman; 80-G-471620

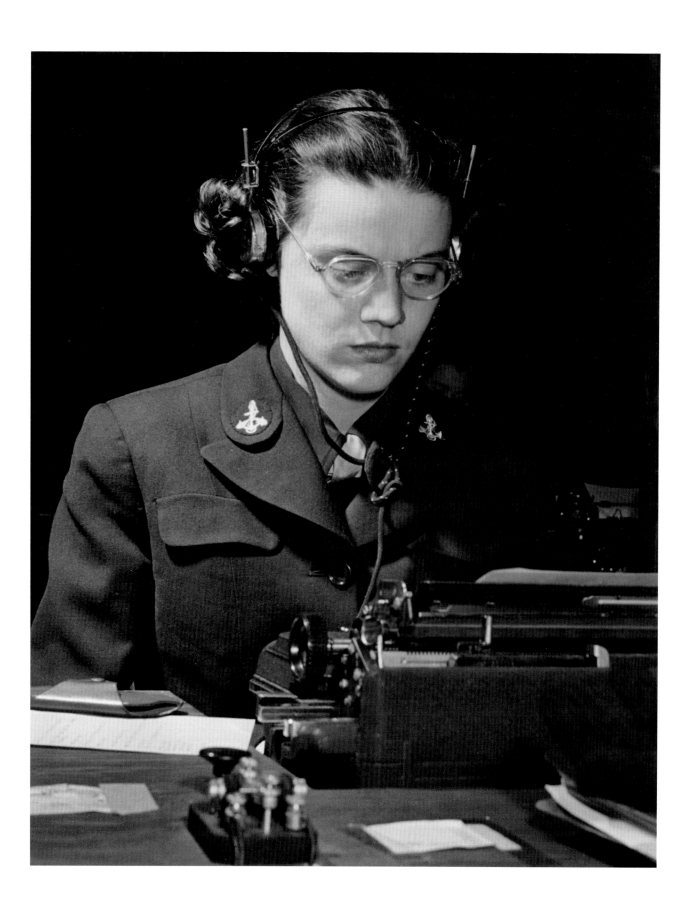

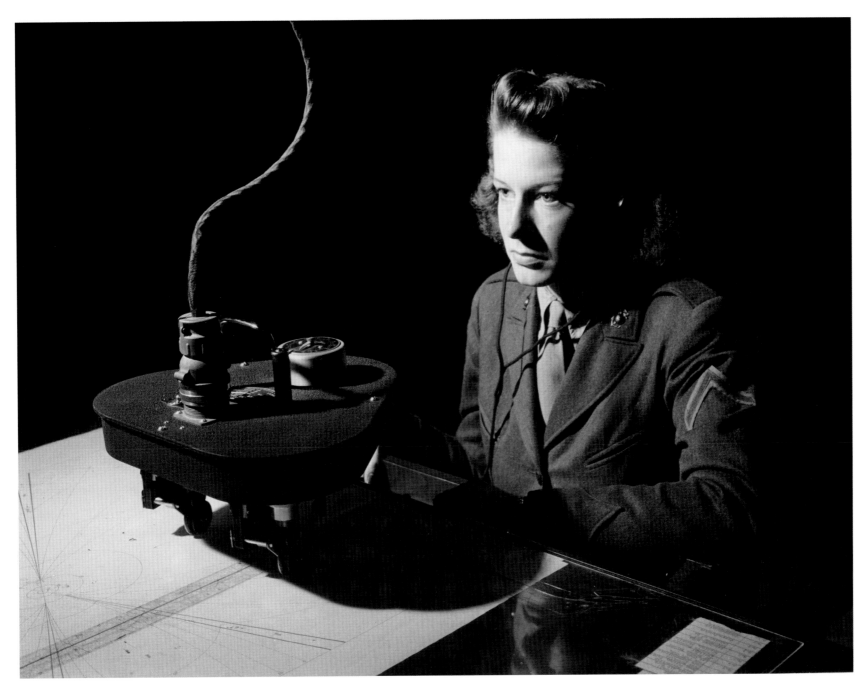

"WAVE trainee in code class at Radio School, University of Wisconsin, Madison, Wisconsin." March 1943; Madison, Wisc.; PH3 Howard Liberman; 80-G-471638

"Pfc. Cynthia Lawrence, USMCR, operating link trainer recorder at Cherry Point, North Carolina." November 1943; Cherry Point, N.C.; Lt. Paul Dorsey; 80-G-471909

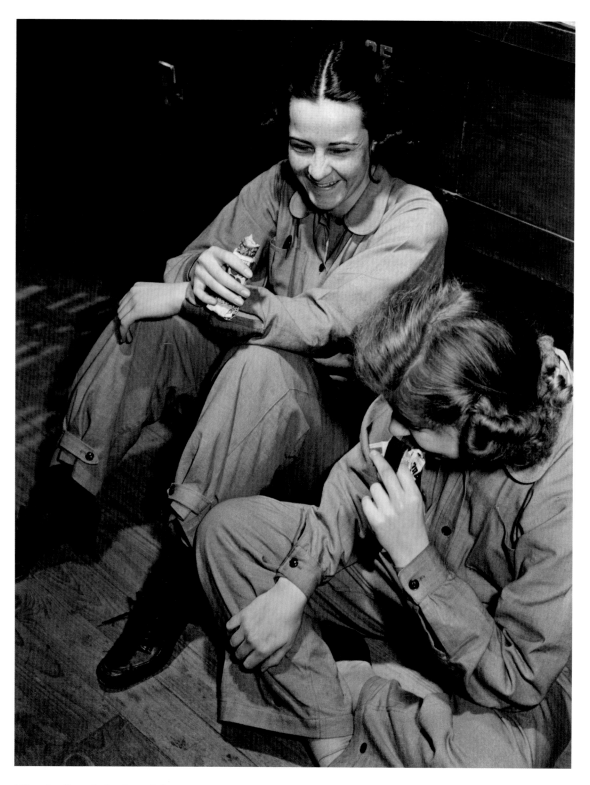

"Jane Carlisle (left) and Mary Bradley relaxing from daily routine at NATTC, Norman, Oklahoma." date unknown; NATTC, Norman, Okla.; Lt. Wayne Miller; 80-G-471566

"WAVES relax awhile during aviation machinist mate training at NATTC, Norman, Oklahoma." February 1943; Norman, Okla.; Lt. Wayne Miller; 80-G-471588

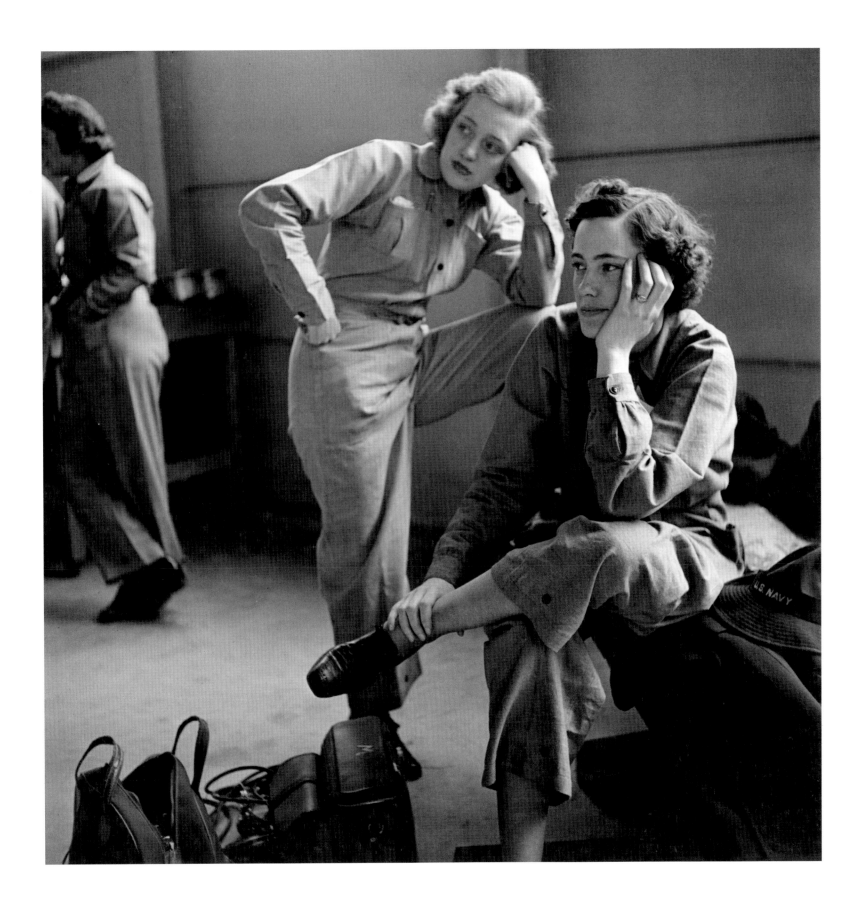

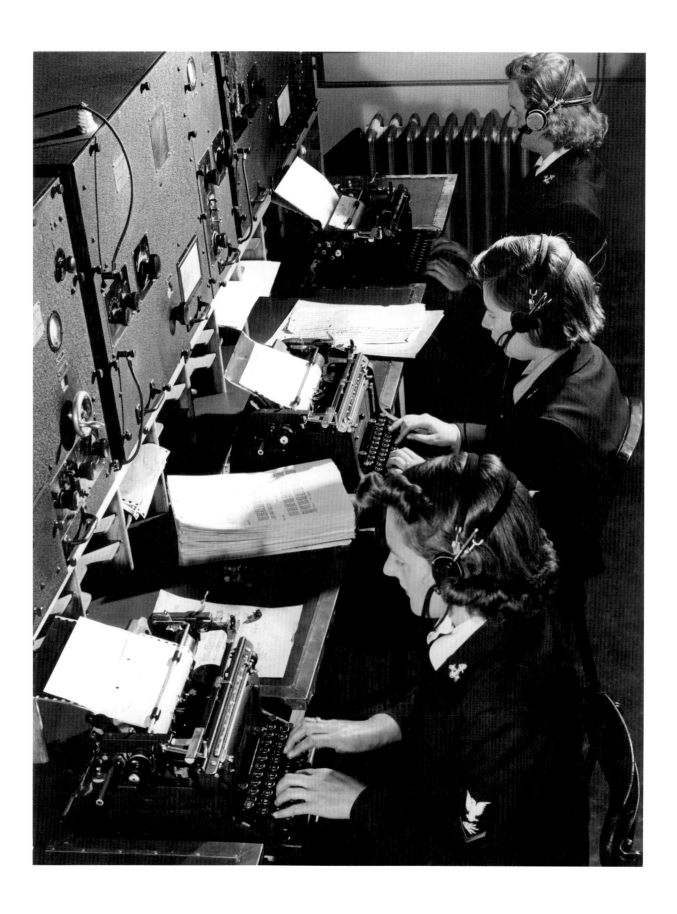

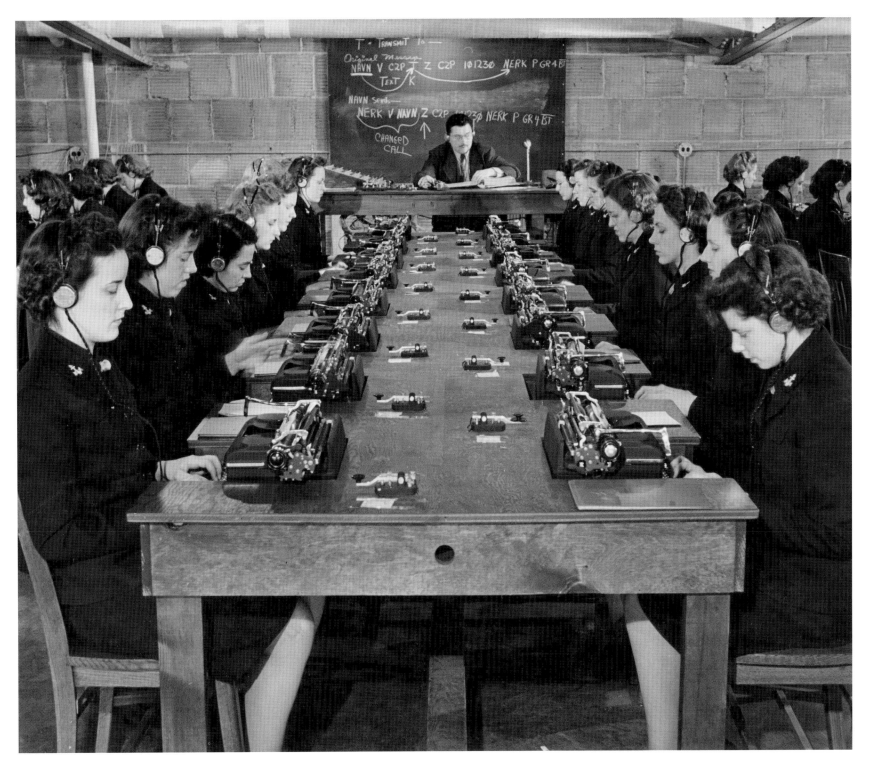

"WAVE radiomen at work at San Diego, California." May 1943; San Diego, Calif.; LCdr. Charles Jacobs; 80-G-471614

"Code class in session at Radio School of University of Wisconsin, Madison, Wisconsin: Instructor in background." March 1943; Madison, Wisc.; PH3 Howard Liberman; 80-G-471642

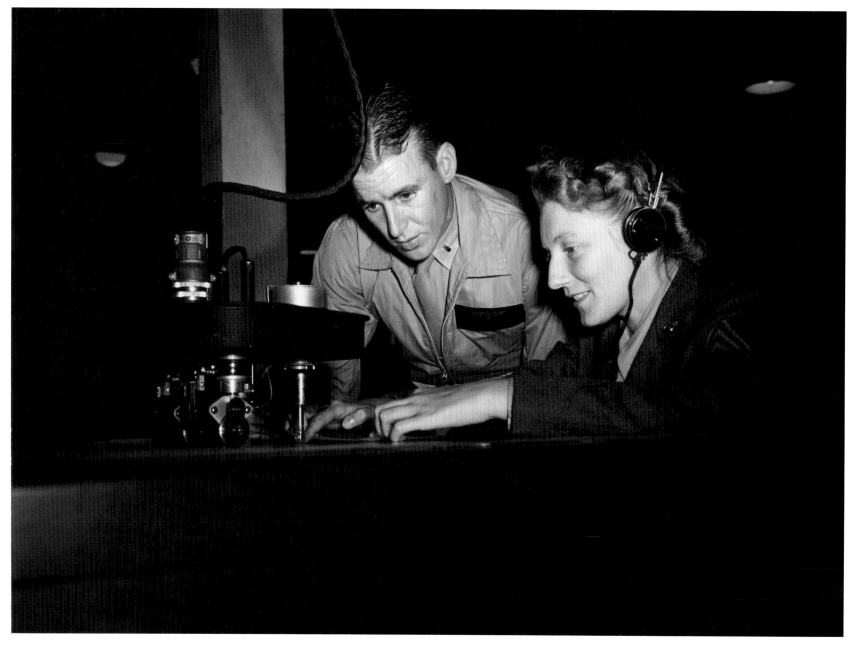

"Cpl. Frances Parker, USMCR, explaining the operation of link trainer to 2nd Lt. B.C. Saunders, USMC, at Cherry Point, North Carolina."
November 1943; Cherry Point, N.C.; Lt. Paul Dorsey; 80-G-471908

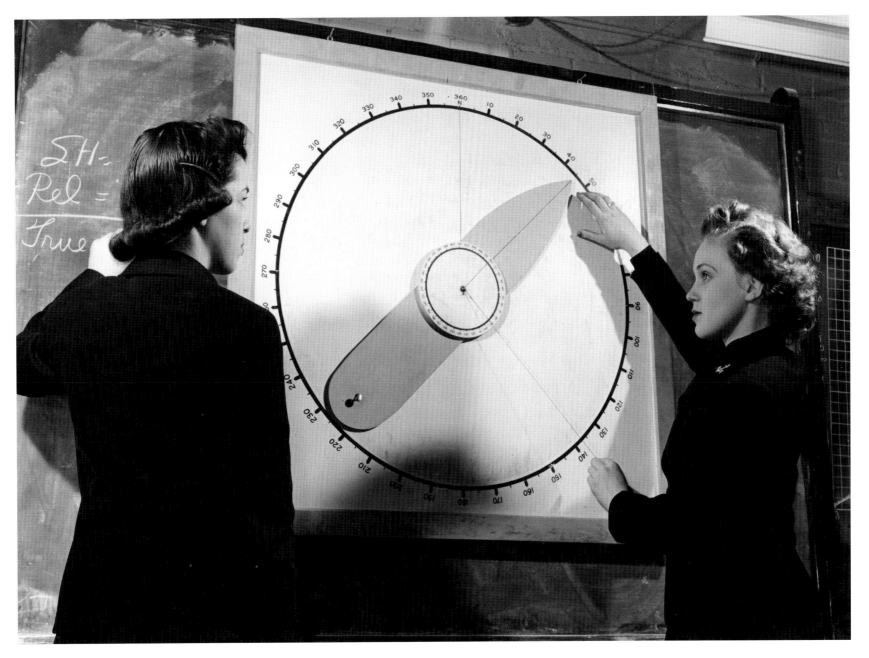

"Jean Dusold, SN (right) helping a shipmate work out a problem in compass bearings at the Radio School, University of Wisconsin, Madison, Wisconsin."
March 1943; Madison, Wisc.; PH3 Howard Liberman; 80-G-471621

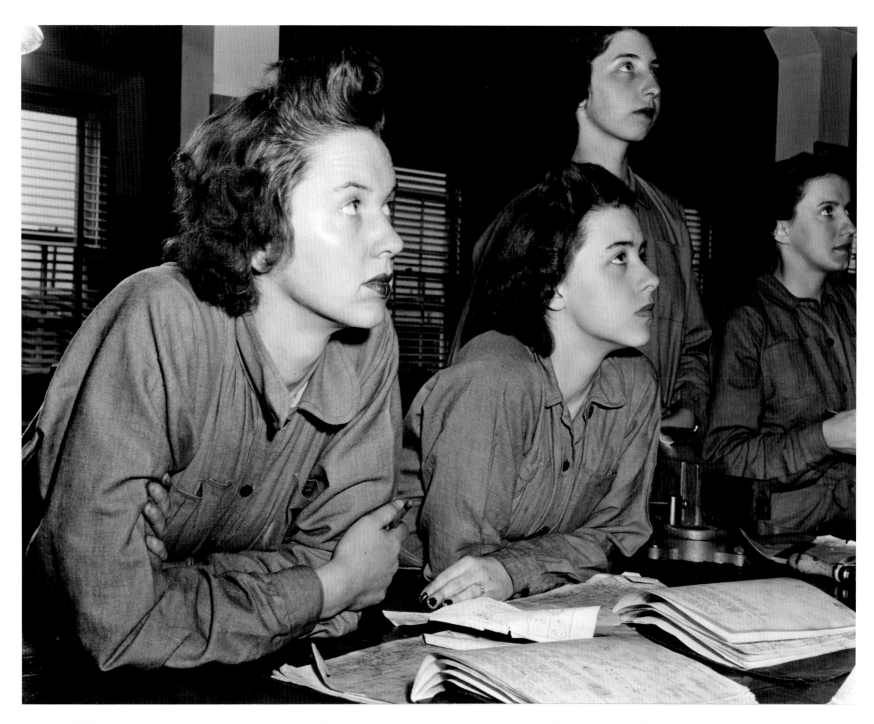

"WAVE trainees at Naval Air Technical Center, Norman, Oklahoma: Students listen to instructor." March 1943; Norman, Okla.; PH2 Howard Liberman; 80-G-471658

"WAVE trainees at Naval Air Technical Training Center, Norman, Oklahoma: Elsie Saak, AMM, studies." March 1943; Norman, Okla.; PH2 Howard Liberman; 80-G-471664

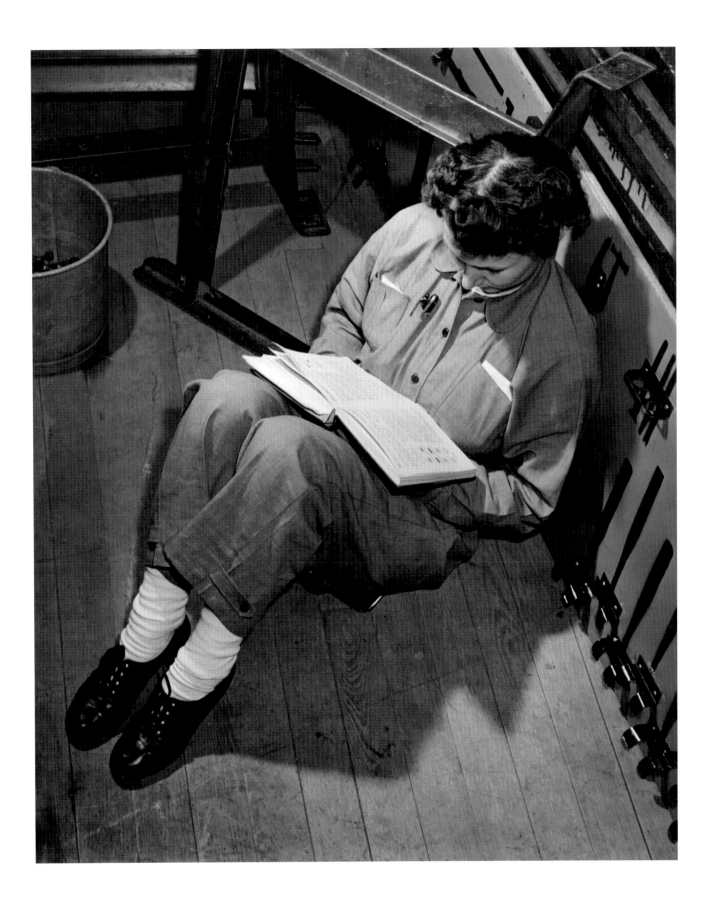

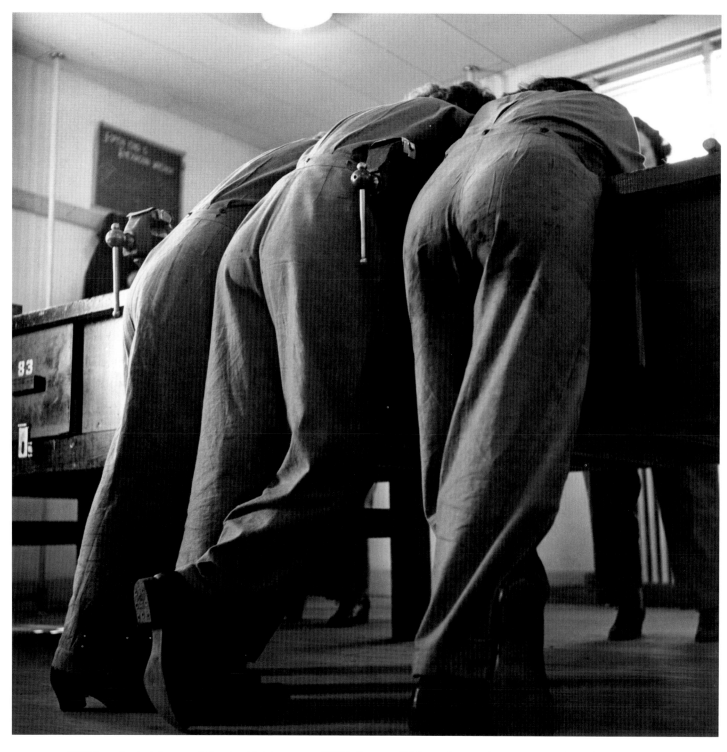

"WAVES receive training as aviation machinist mates at NATTC, Norman, Oklahoma: In consultation over tough machinist problem."
February 1943; NATTC, Norman, Okla.; Lt. Wayne Miller; 80-G-471512

"WAVES receive instruction as aviation machinist mates at NATTC, Norman, Oklahoma." February 1943;
NATTC, Norman, Okla.; PH2 Howard Liberman; 80-G-471559

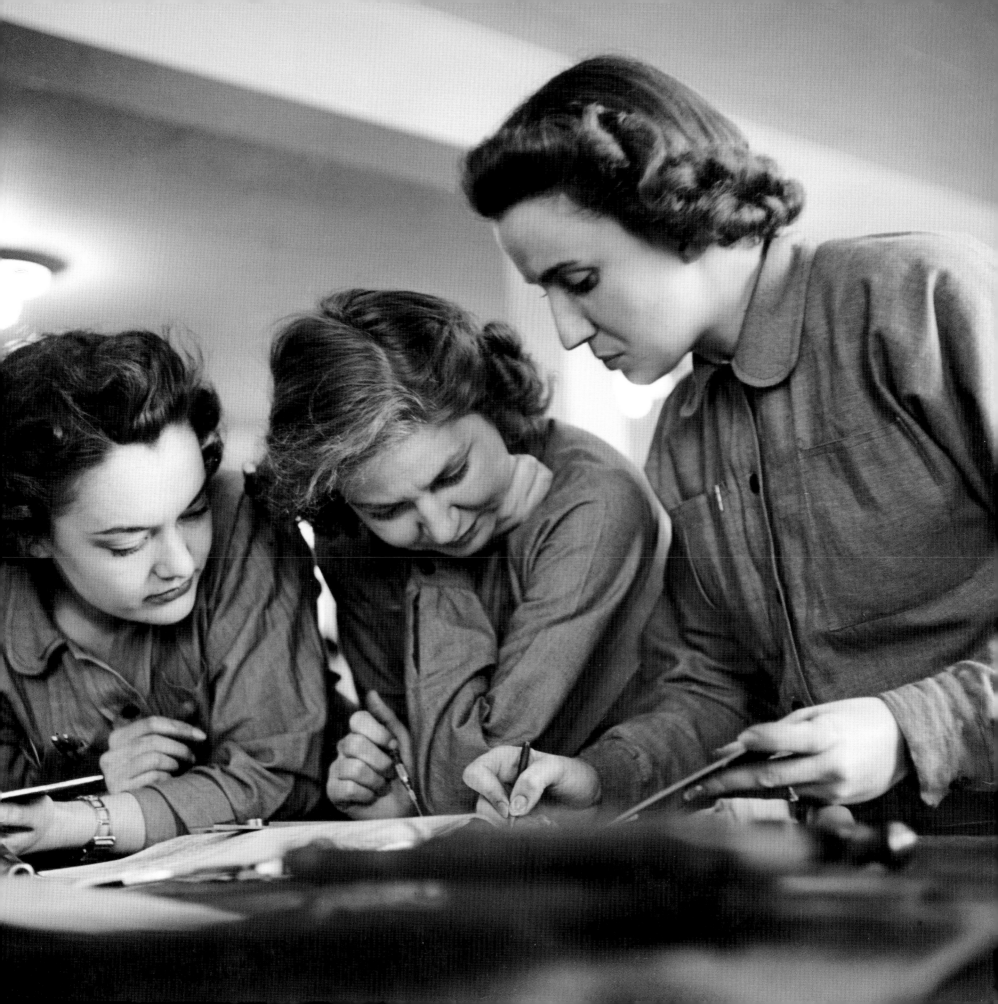

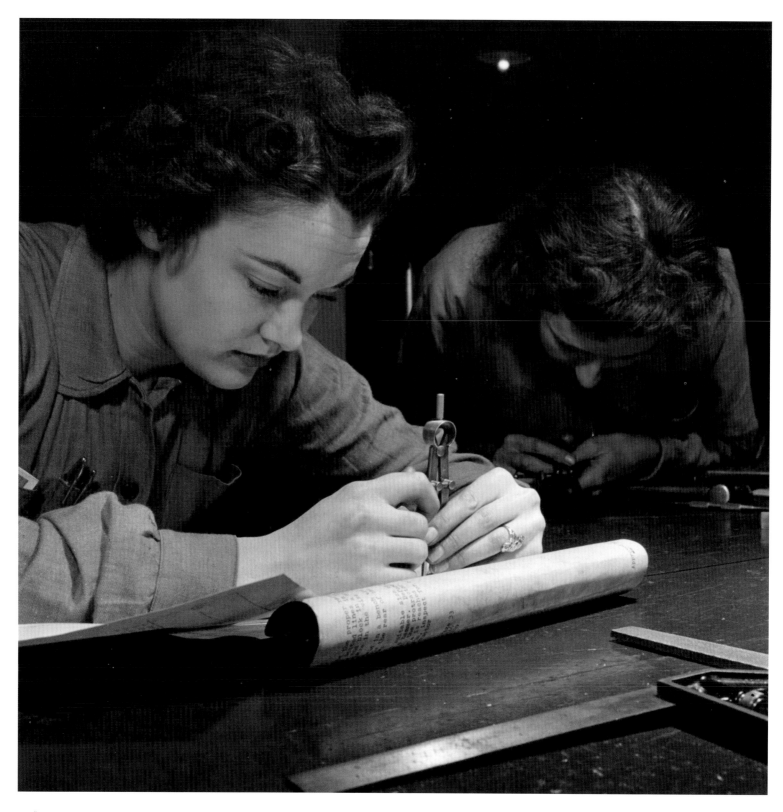

"WAVES receive training as aviation machinist mates at NATTC, Norman, Oklahoma: Virginia Bounds and Dorothy Bouidelais working on "hinge fitting plate"."
February 1943; NATTC, Norman, Okla.; Lt. Wayne Miller; 80-G-471513

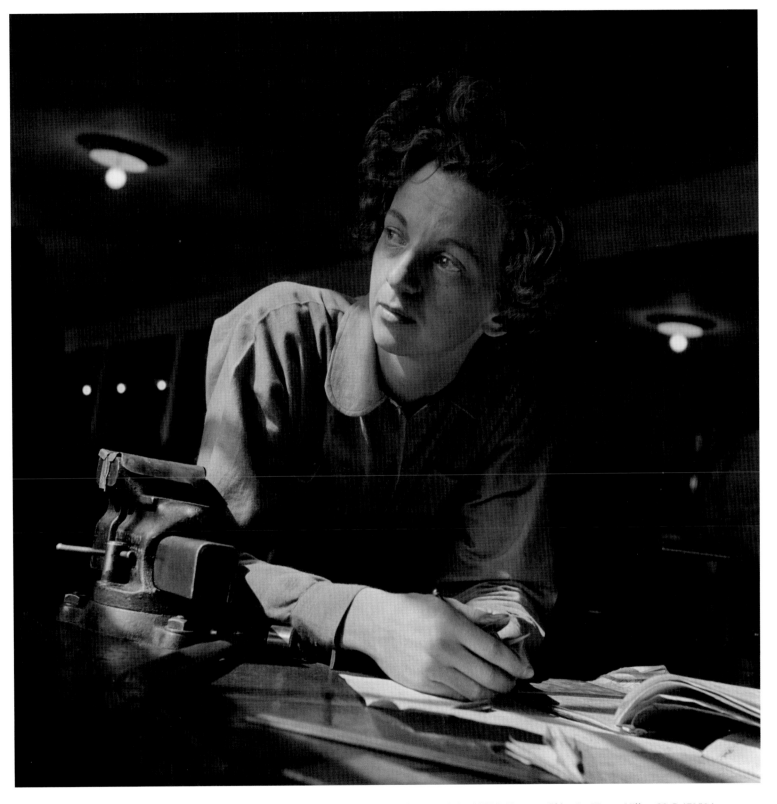

"WAVE at work in aviation machine shop at NATTC, Norman, Oklahoma." February 1943; NATTC, Norman, Okla.; Lt. Wayne Miller; 80-G-471514

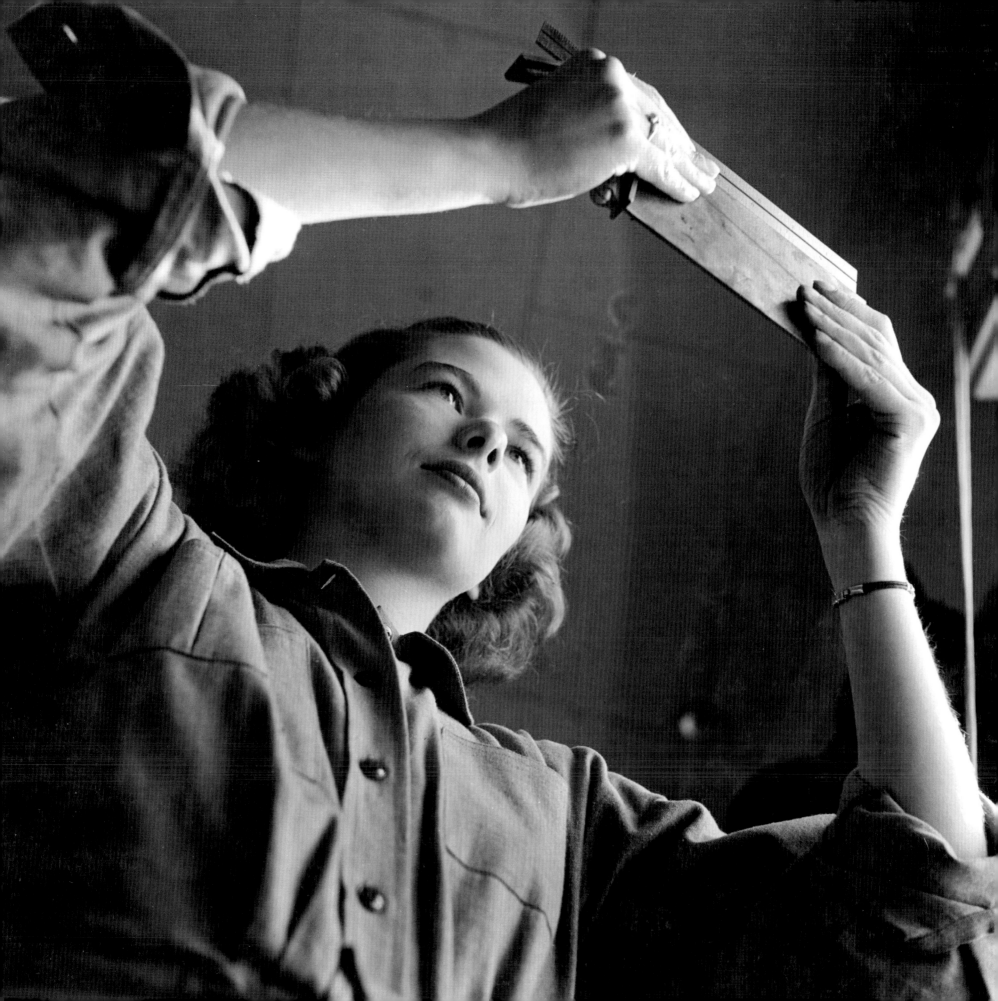

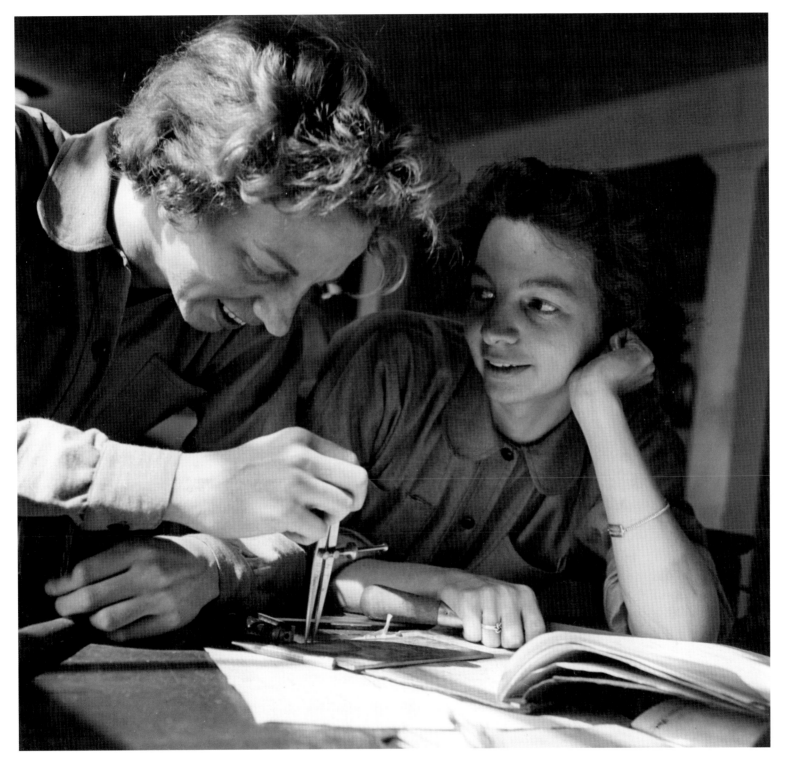

"WAVE trainees at Naval Air Technical Training Center, Norman, Oklahoma: Irma Dedolph, AMM." March 1943; Norman, Okla.; PH2 Howard Liberman; 80-G-471674

"WAVES receive training as aviation machinist mates at NATTC, Norman, Oklahoma: Working on "hinge fitting plate"." February 1943; NATTC, Norman, Okla.; Lt. Wayne Miller; 80-G-471511

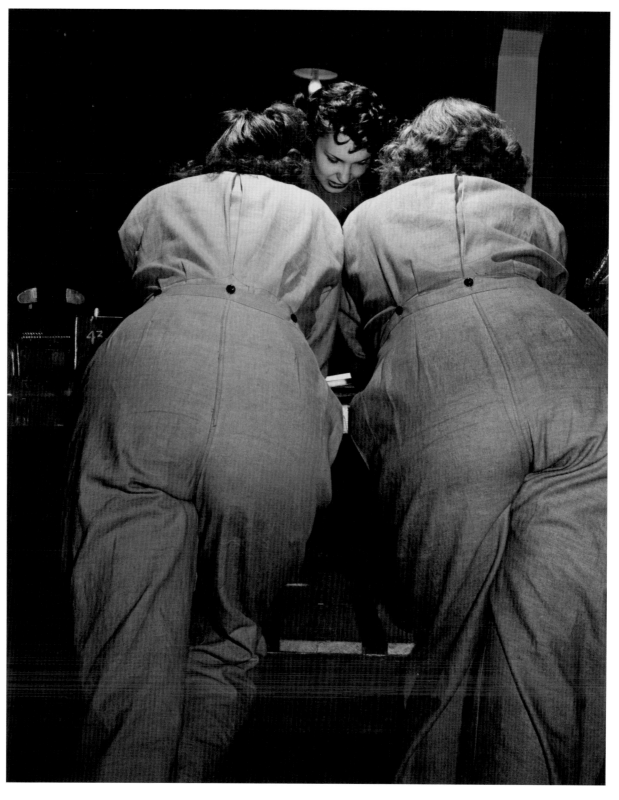

"Cecilea Weber and two other WAVES talking over tough problem at NATTC, Norman Oklahoma." February 1943; NATTC, Norman, Okla.; Lt. Wayne Miller; 80-G-471488

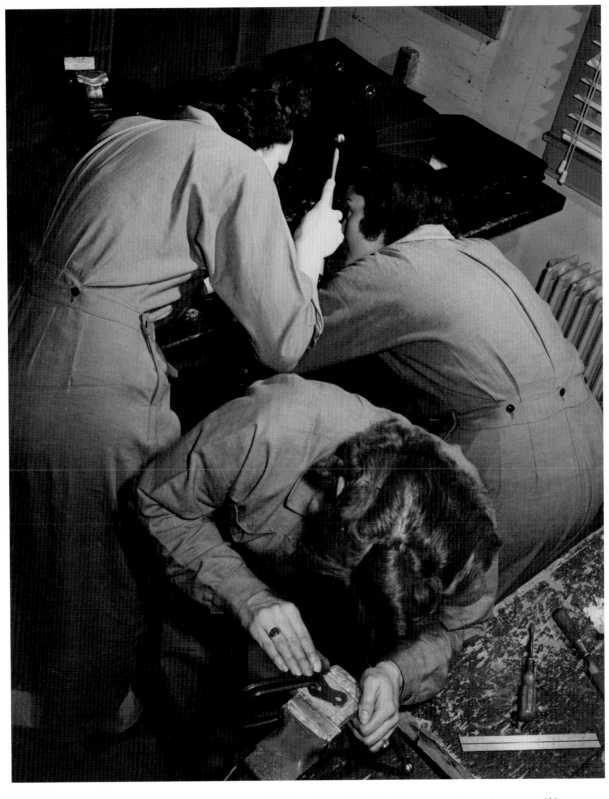

"Aviation metalsmiths shop at NATTC Norman, Oklahoma: Waves at Work." February 1943; NATTC, Norman, Okla.;
Lt. Wayne Miller; 80-G-471490

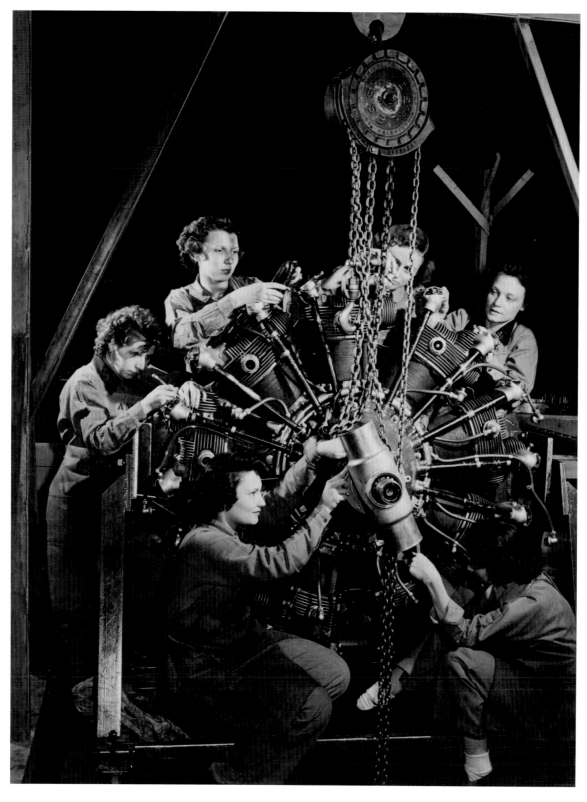

"WAVES receive practical instructions for aviation metalsmith at NATTC, Norman, Oklahoma." February 1943;
NATTC, Norman, Okla.; Lt. Wayne Miller; 80-G-471496

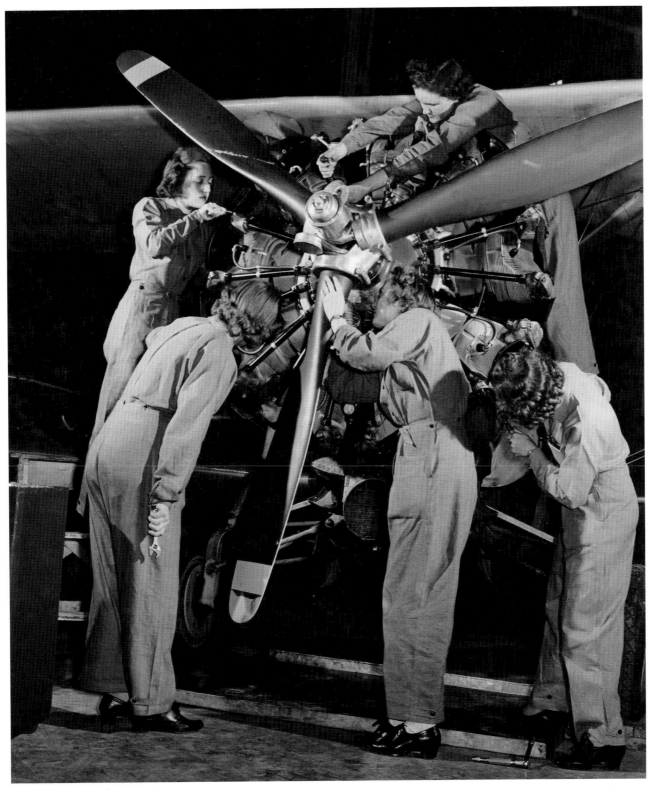

"Lucille Henderson, Darline Wagner, Phoebe Swan, Ruth Potter, and Juanita Hess working on plane in assembly and repair shop at NATTC, Norman, Oklahoma." February 1943; NATTC, Norman, Okla.; Lt. Wayne Miller; 80-G-471478

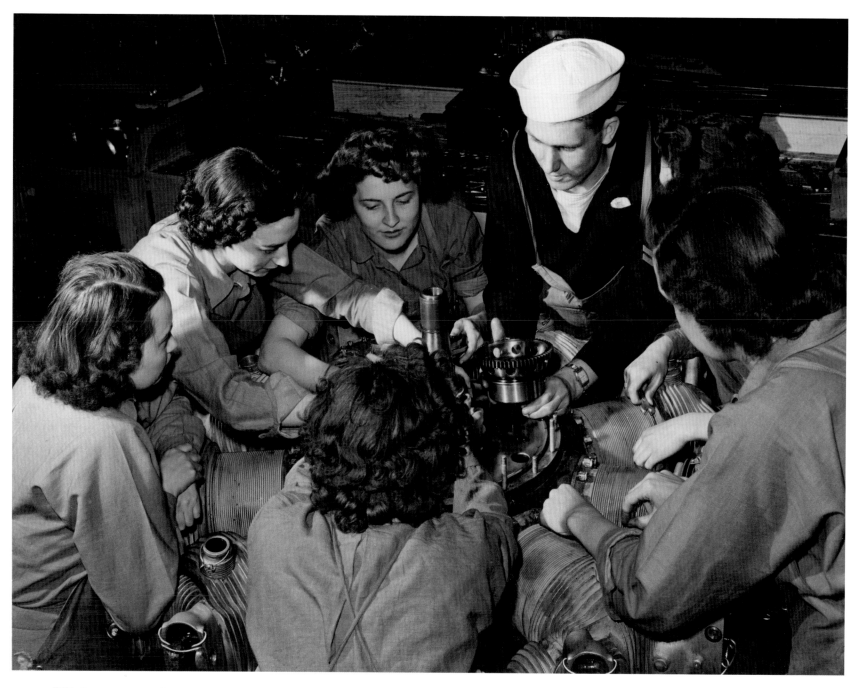

"WAVES receive practical instructions for aviation metalsmith at NATTC, Norman, Oklahoma." February 1943; NATTC, Norman, Okla.; Lt. Wayne Miller; 80-G-471497

"WAVES working on airplanes at NATTC, Norman, Oklahoma: Learning how to take planes apart as well as to put them together." February 1943; NATTC, Norman, Okla.; Lt. Wayne Miller; 80-G-471502

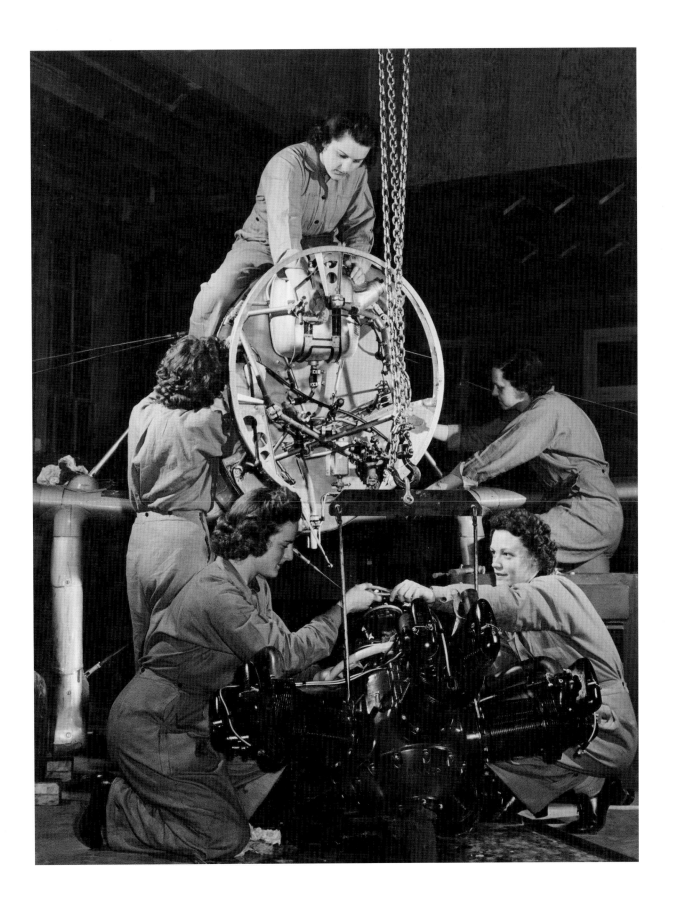

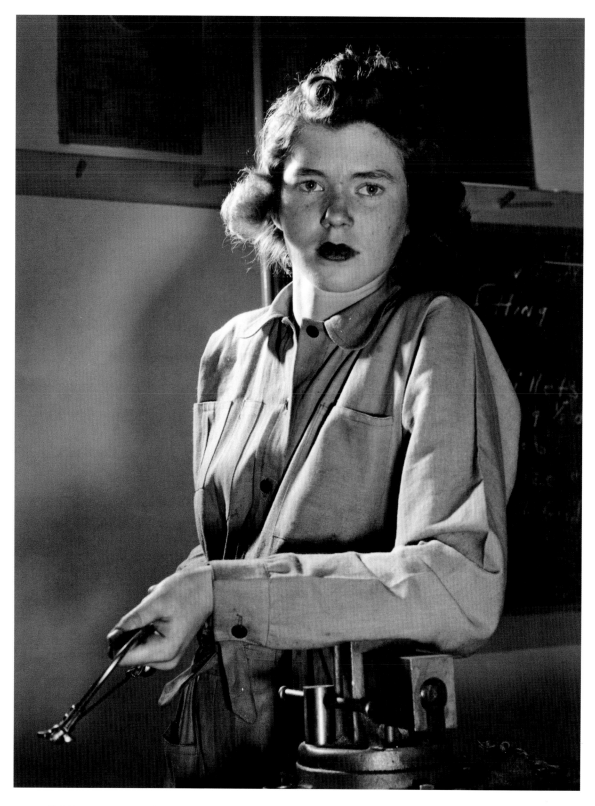

"WAVE trainees at Naval Air Technical Training Center, Norman, Oklahoma: Edna E. Baker, AMM." March 1943; Norman, Okla.; PH2 Howard Liberman; 80-G-471669

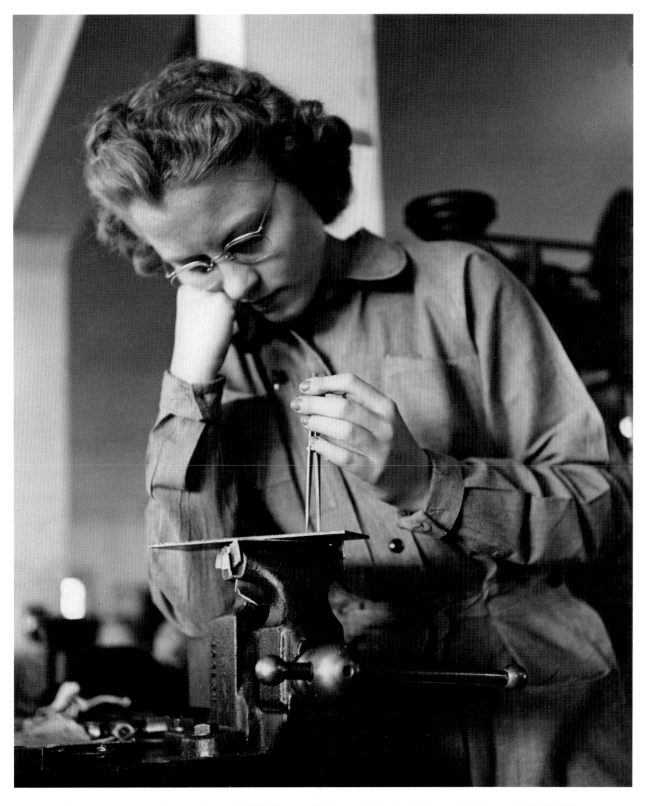

"WAVE in aviation machinist shop at NATTC, Norman, Oklahoma: Helen Capaldi at work." February 1943; NATTC, Norman, Okla.; Lt. Wayne Miller; 80-G-471506

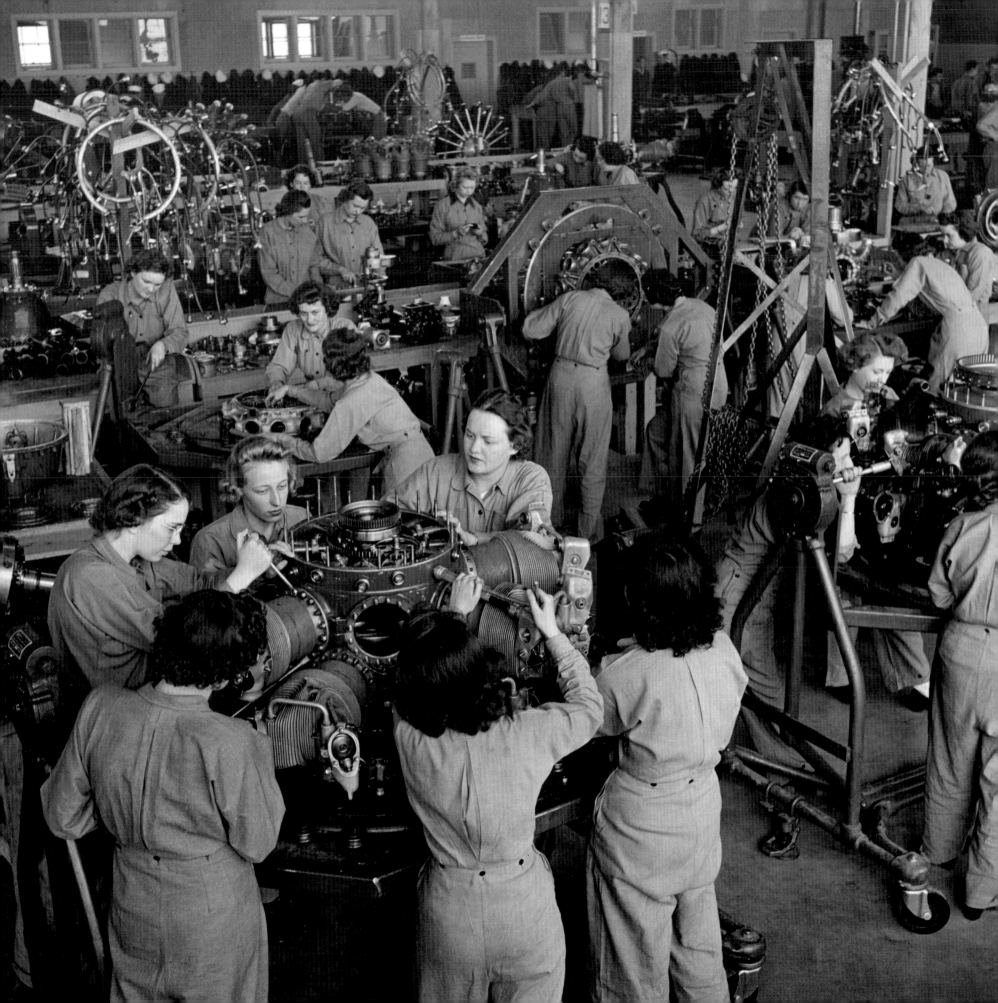

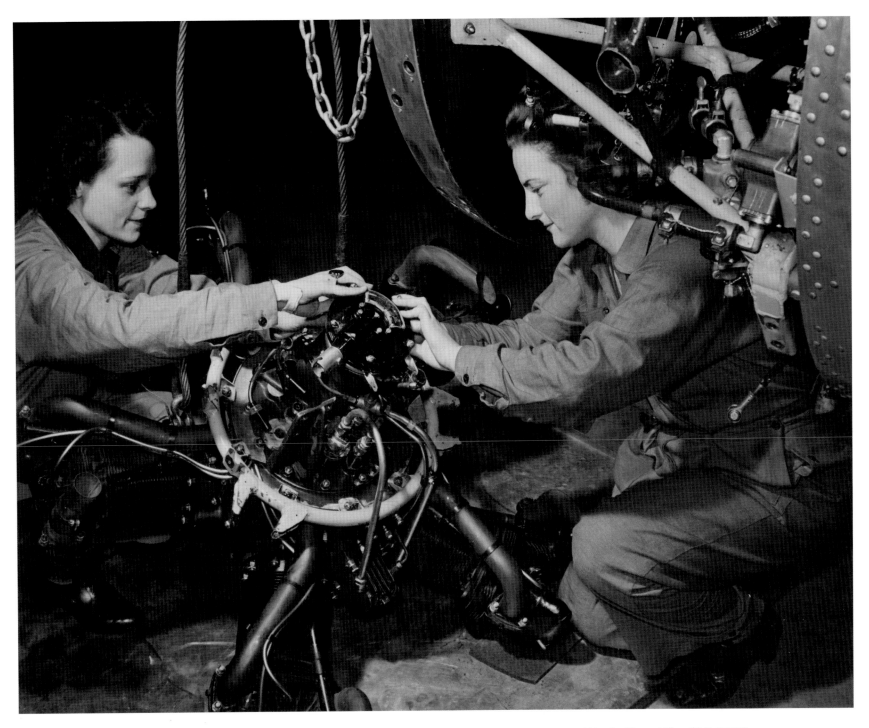

"WAVES working on airplane parts at NATTC, Norman, Oklahoma." February 1943; NATTC, Norman, Okla.; Lt. Wayne Miller; 80-G-471548

"WAVES working on airplanes at NATTC, Norman, Oklahoma: Learning how to take planes apart as well as to put them together." February 1943; NATTC, Norman, Okla.; Lt. Wayne Miller; 80-G-471503

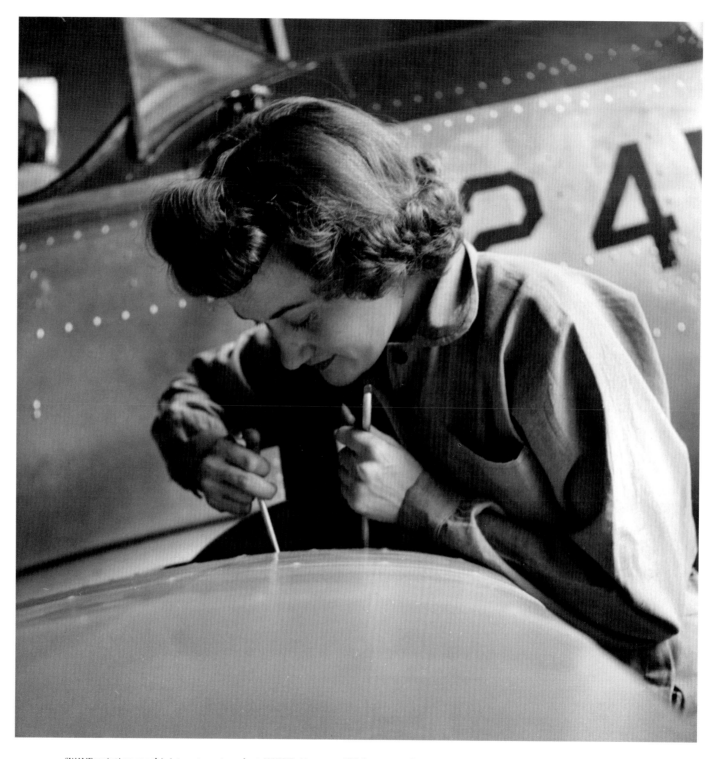

"WAVE aviation machinist mates at work at NATTC, Norman, Oklahoma: Working on plane." February 1943; NATTC, Norman, Okla.;
Lt. Wayne Miller; 80-G-471520

"WAVE activities at Jacksonville, Florida: Bernice Sansbury, AMM, adjusts spark plugs of SNJ training plane." September 1943;
NAS, Jacksonville; Lt. Victor Jorgensen; 80-G-471686

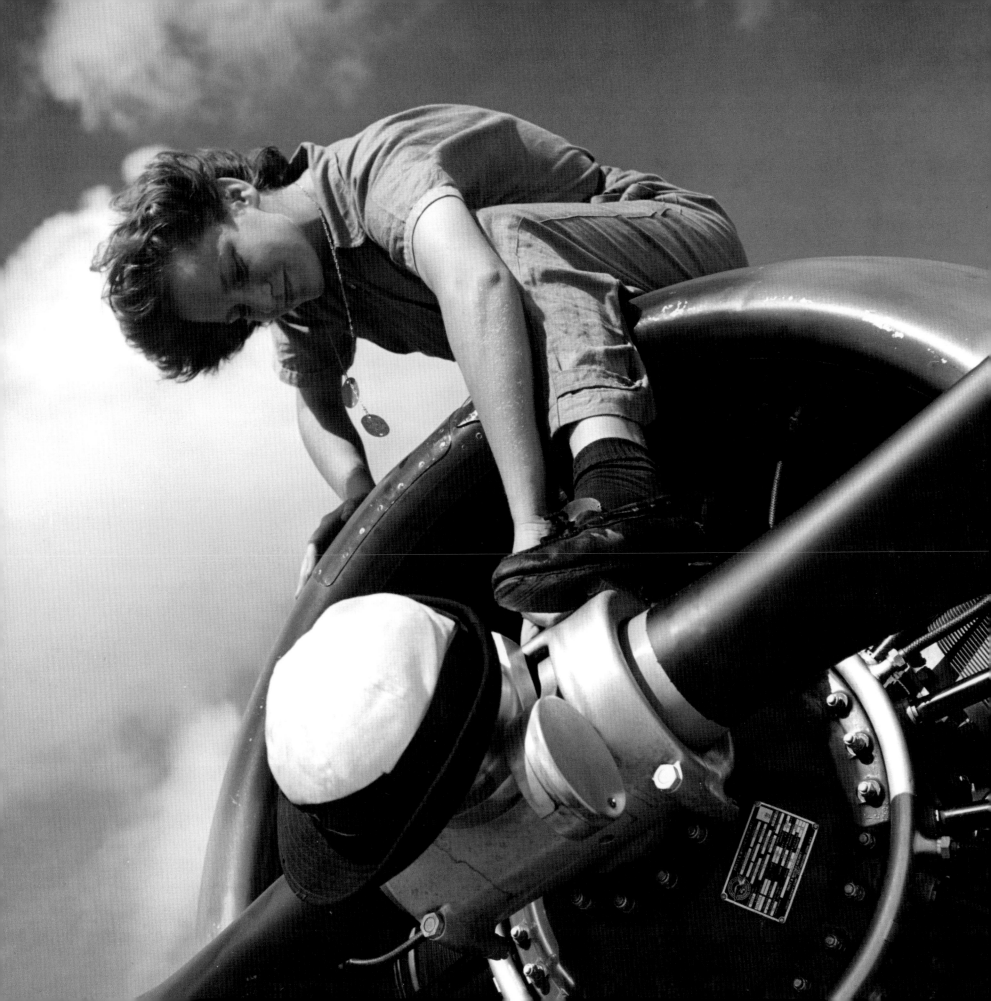

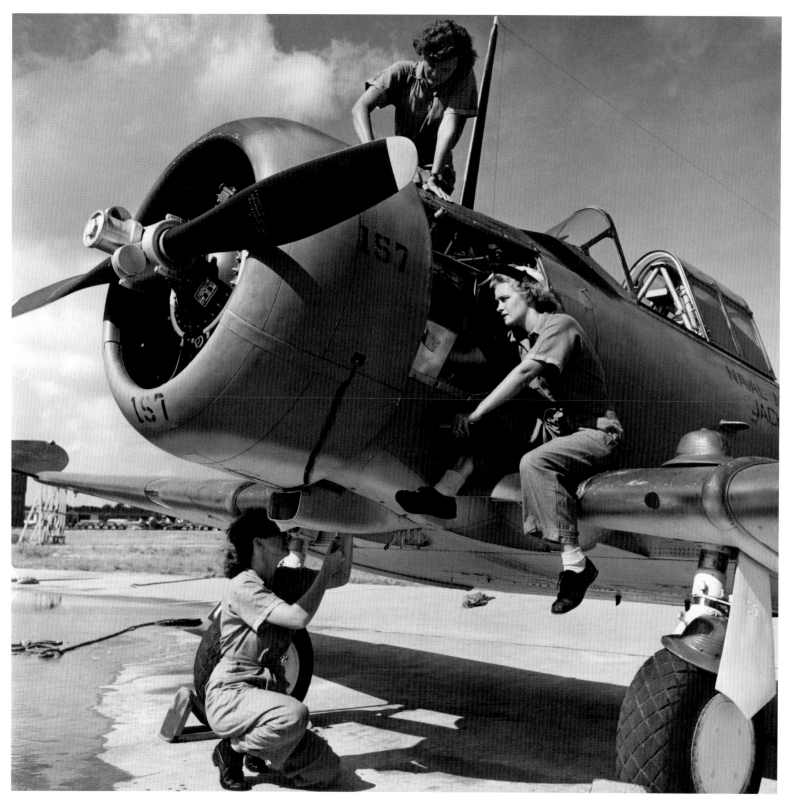

"WAVE activities at Jacksonville, Florida: Mary Arnold, AMM, on fuselage of SNJ; Violet Falkum, AMM, on wing; and Bernice Sansbury, AMM, on air intake of training plane." September 1943; NAS, Jacksonville; Lt. Victor Jorgensen; 80-G-471690

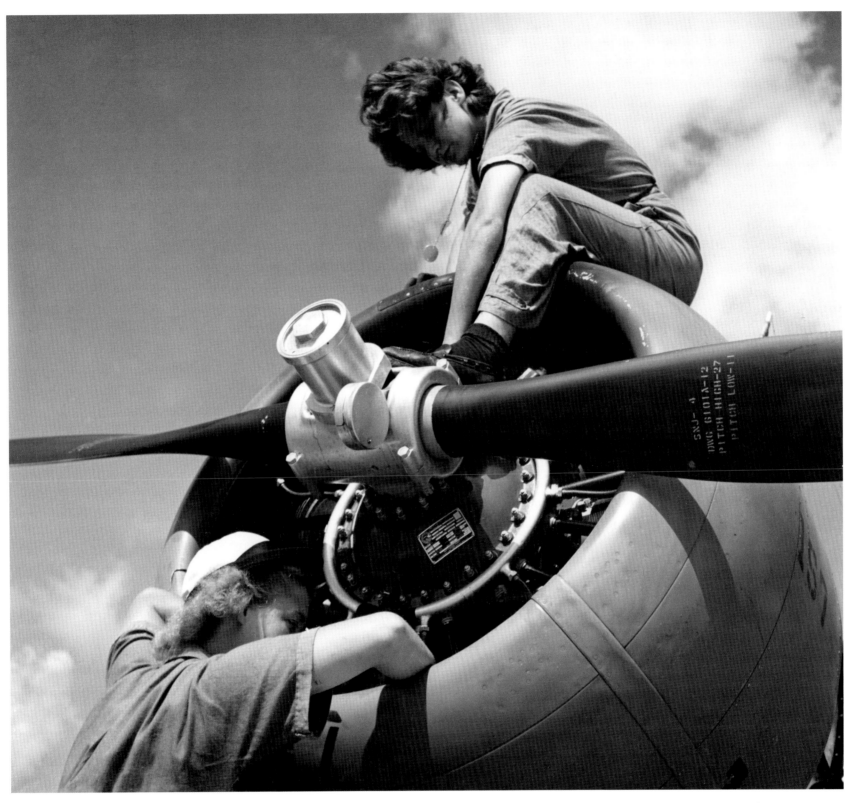

"WAVE Bernice Sansbury (above), and Violet Falkum, NAS, Jacksonville, Florida, working on engine of an SNJ." September 1943; NAS, Jacksonville, Fla.; photograph unattributed; 80-G-471708

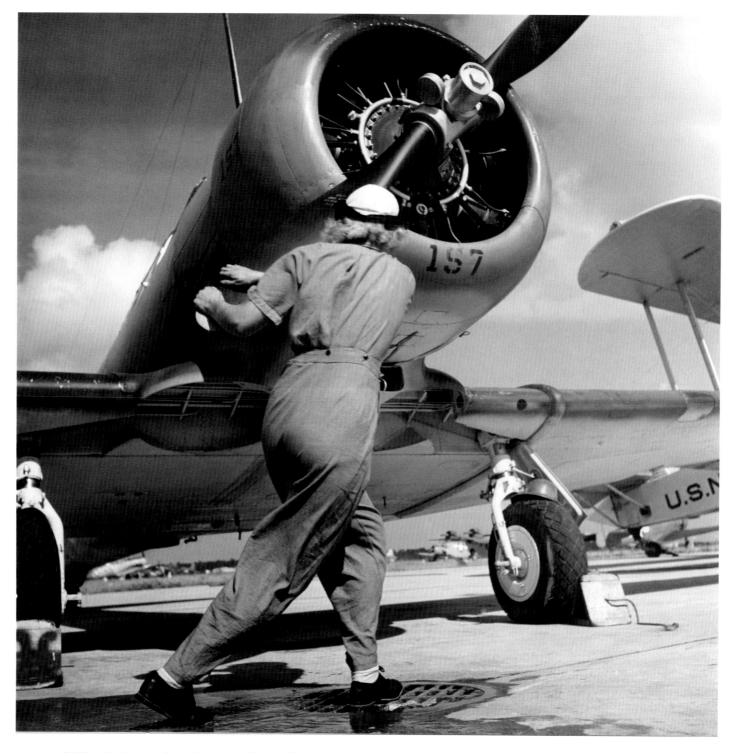

"WAVE activities at Jacksonville, Florida: Violet Falkum, AMM, spins prop of SNJ training plane." September 1943; NAS, Jacksonville; Lt. Victor Jorgensen; 80-G-471688

"WAVE activities at Jacksonville, Florida: Violet Falkum, AMM, perches on wing of SNJ training plane." September 1943; NAS, Jacksonville; Lt. Victor Jorgensen; 80-G-471685

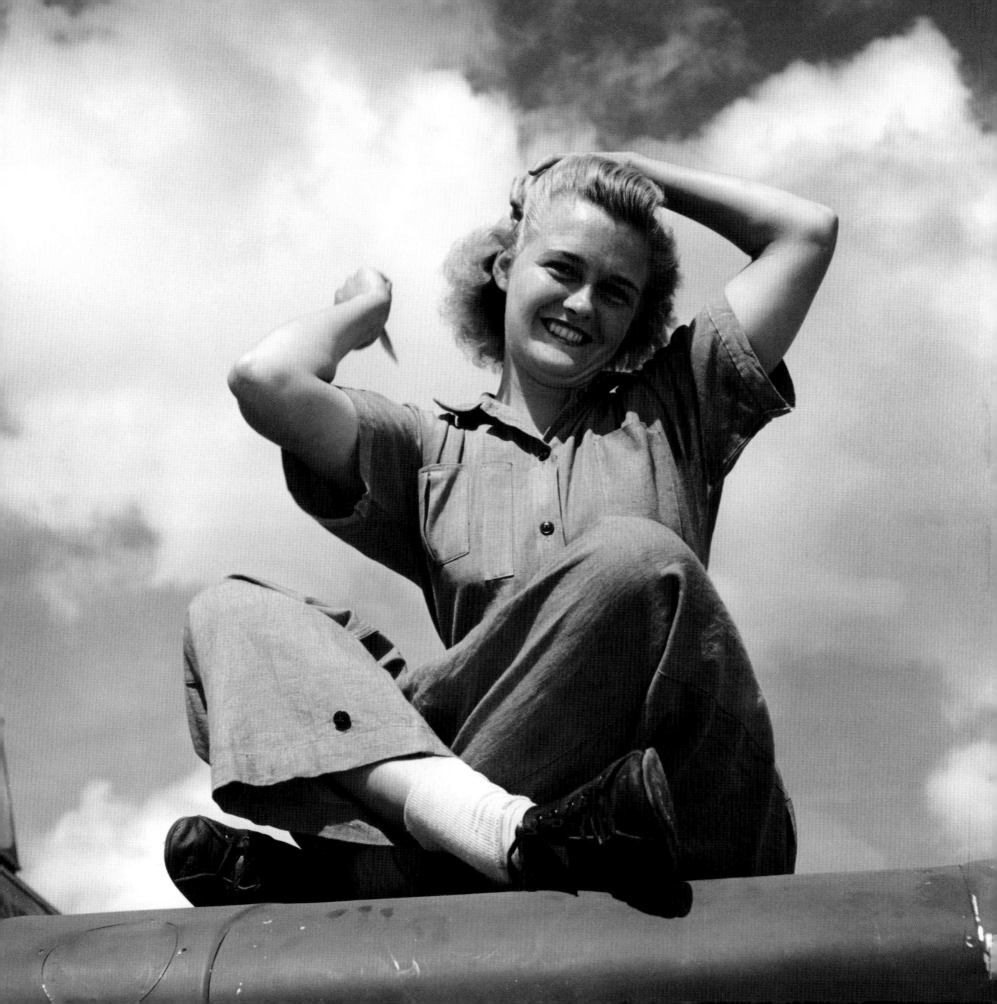

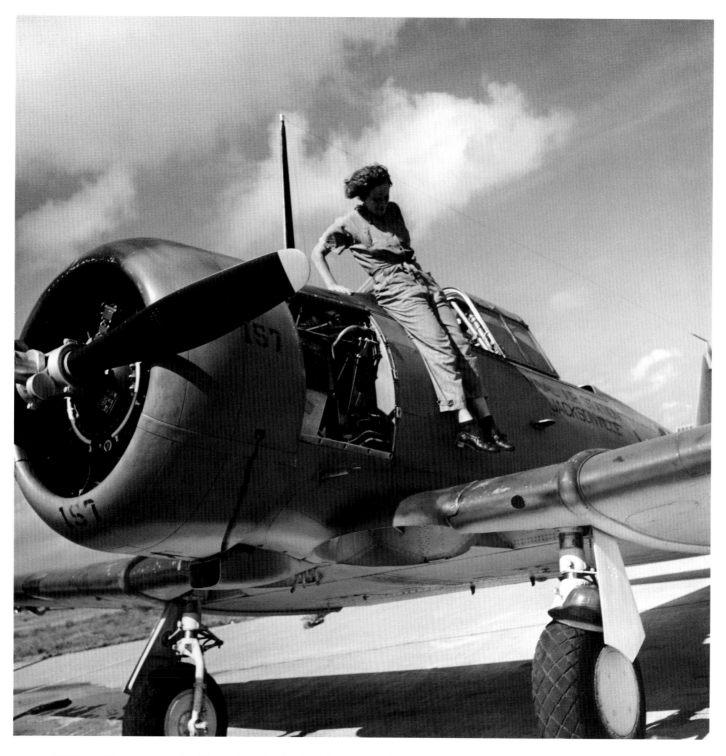

"WAVE activities at Jacksonville, Florida: Mary Arnold, AMM, jumps down from SNJ training plane." September 1943; NAS, Jacksonville; Lt. Victor Jorgensen; 80-G-471687

"WAVE Mary Arnold, NAS, Jacksonville, Florida, removing the cowling of an SNJ." September 1943; NAS, Jacksonville, Fla.; photograph unattributed; 80-G-471709

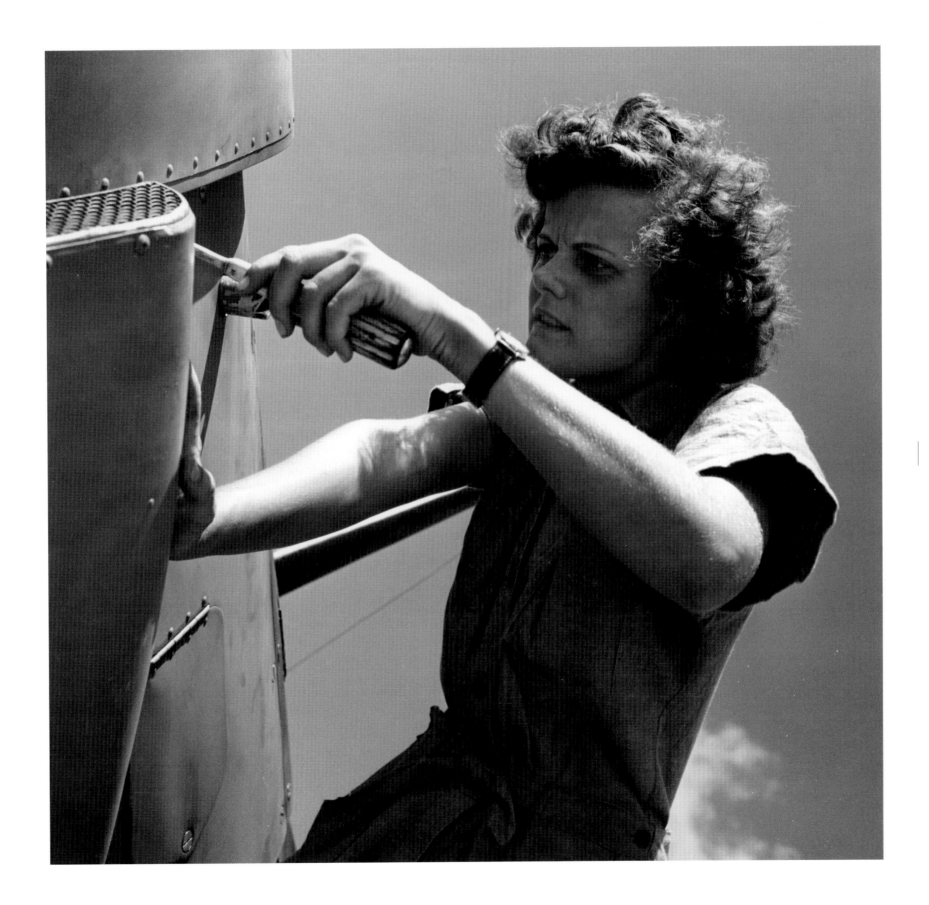

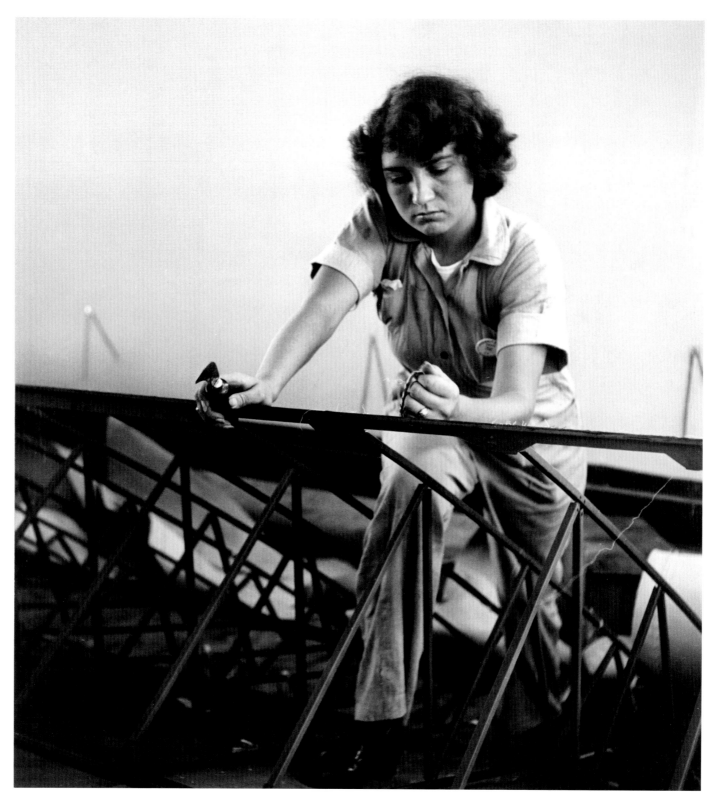

"WAVE activities at Jacksonville, Florida: Lydia Mumpower, AMM, strips down an airelon section of PBY." September 1943; NAS, Jacksonville; Lt. Victor Jorgensen; 80-G-471694

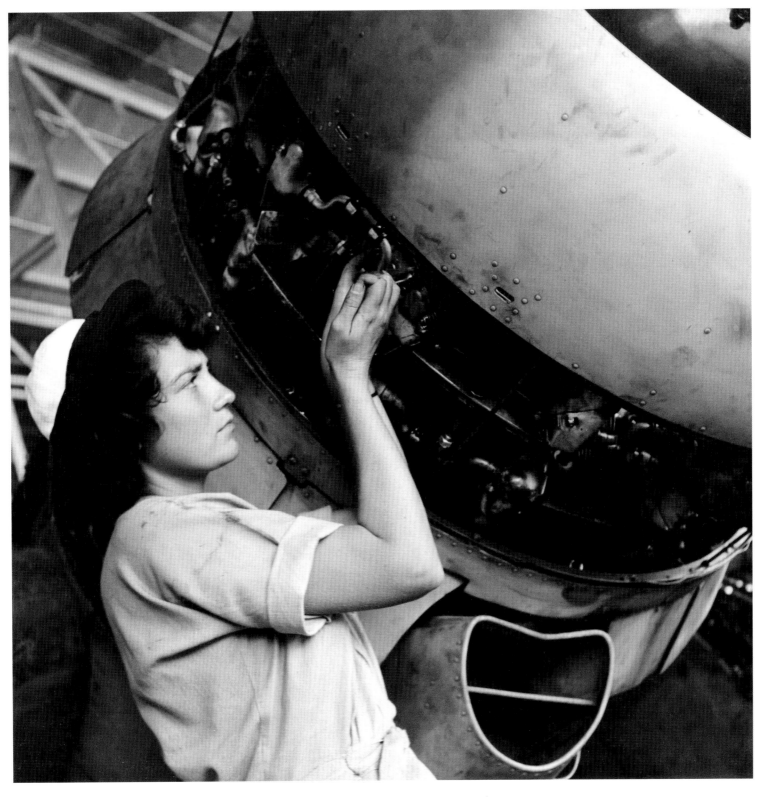

"WAVE activities at Jacksonville, Florida: Lydia Mumpower, AMM, works on engine of a PBY, Patrol Bomber." September 1943; NAS, Jacksonville; Lt. Victor Jorgensen; 80-G-471695

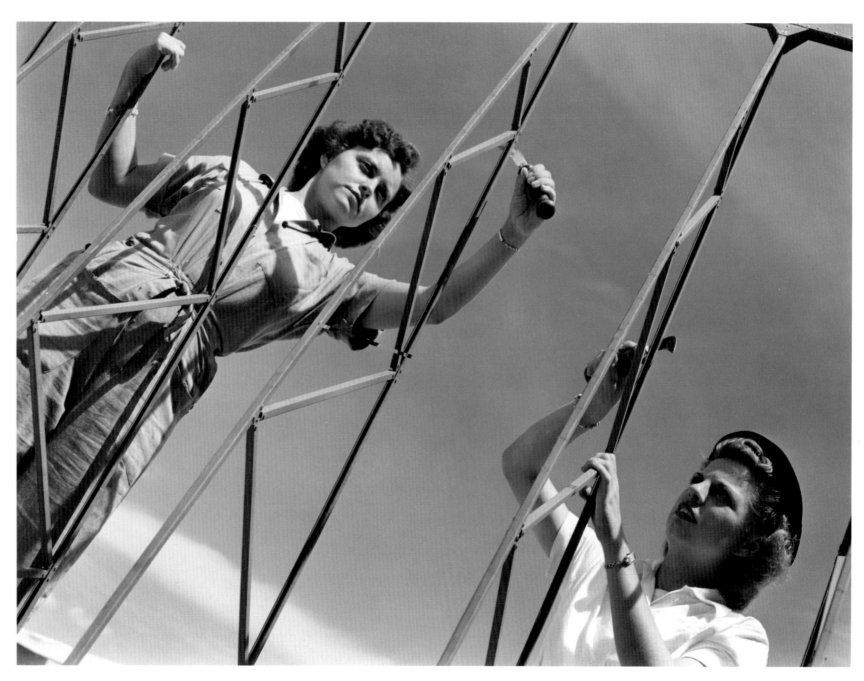

"WAVE activities at Jacksonville, Florida: Doris Brooks, AMM (left), and Nikki Foster, AMM, scrape struts of PBY airelon section." September 1943; NAS, Jacksonville; Lt. Victor Jorgensen; 80-G-471692

"WAVE Sophie Kobzik, NAS, Jacksonville, Florida, working on cables, which operates the tail controls." September 1943; NAS, Jacksonville, Fla.; photograph unattributed; 80-G-471717

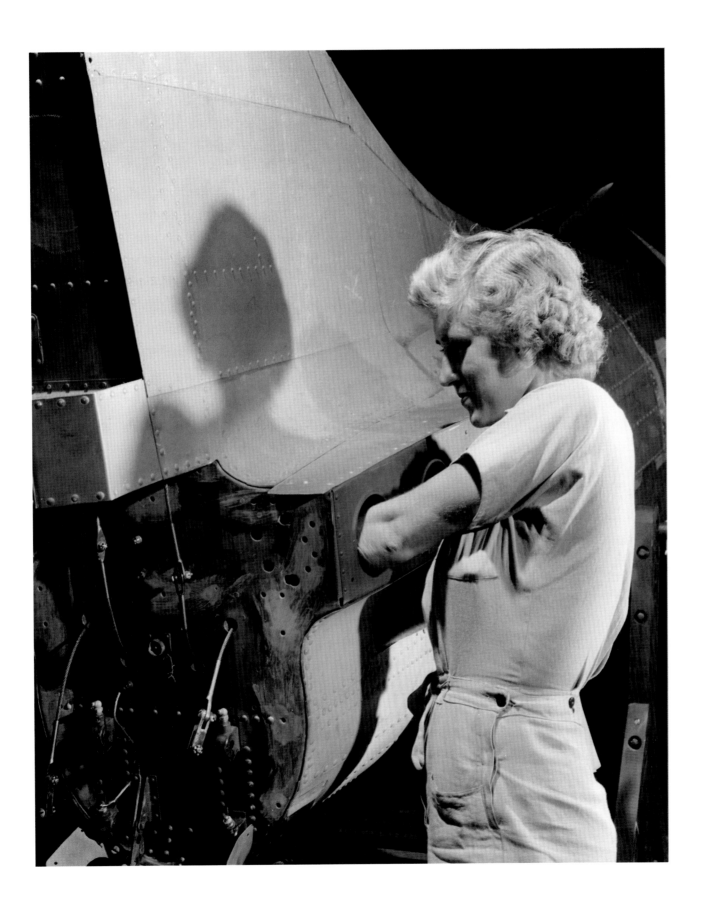

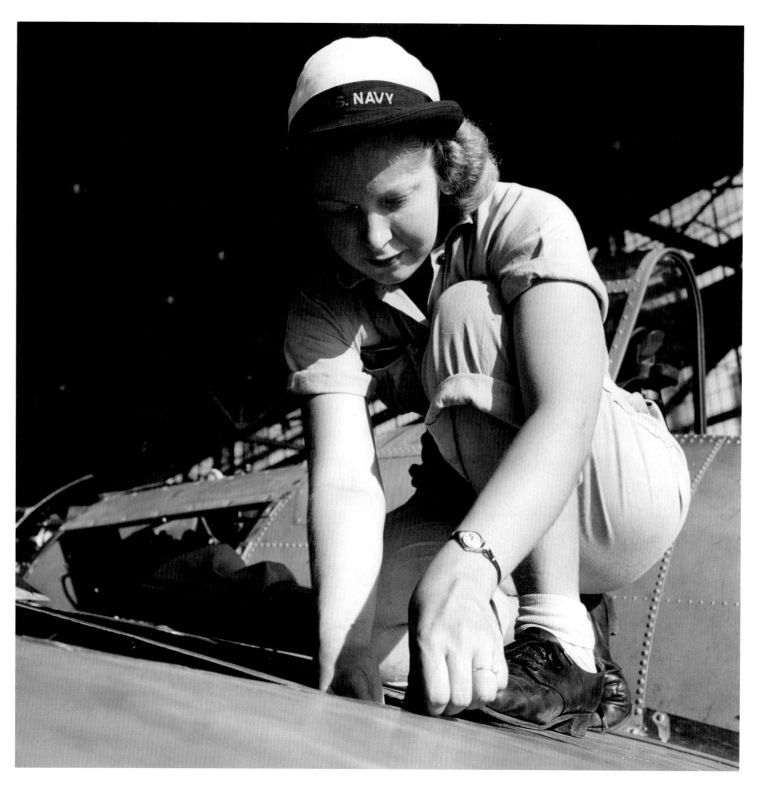

"WAVE Ann Garman working on control cables in the wing of an F4F." September 1943; NAS, Jacksonville; Lt. Victor Jorgensen; 80-G-471704

"WAVE Ann Garman talking to a seaman guard in the O and R building at NAS, Jacksonville, Florida." September 1943; NAS, Jacksonville; photograph unattributed; 80-G-471705

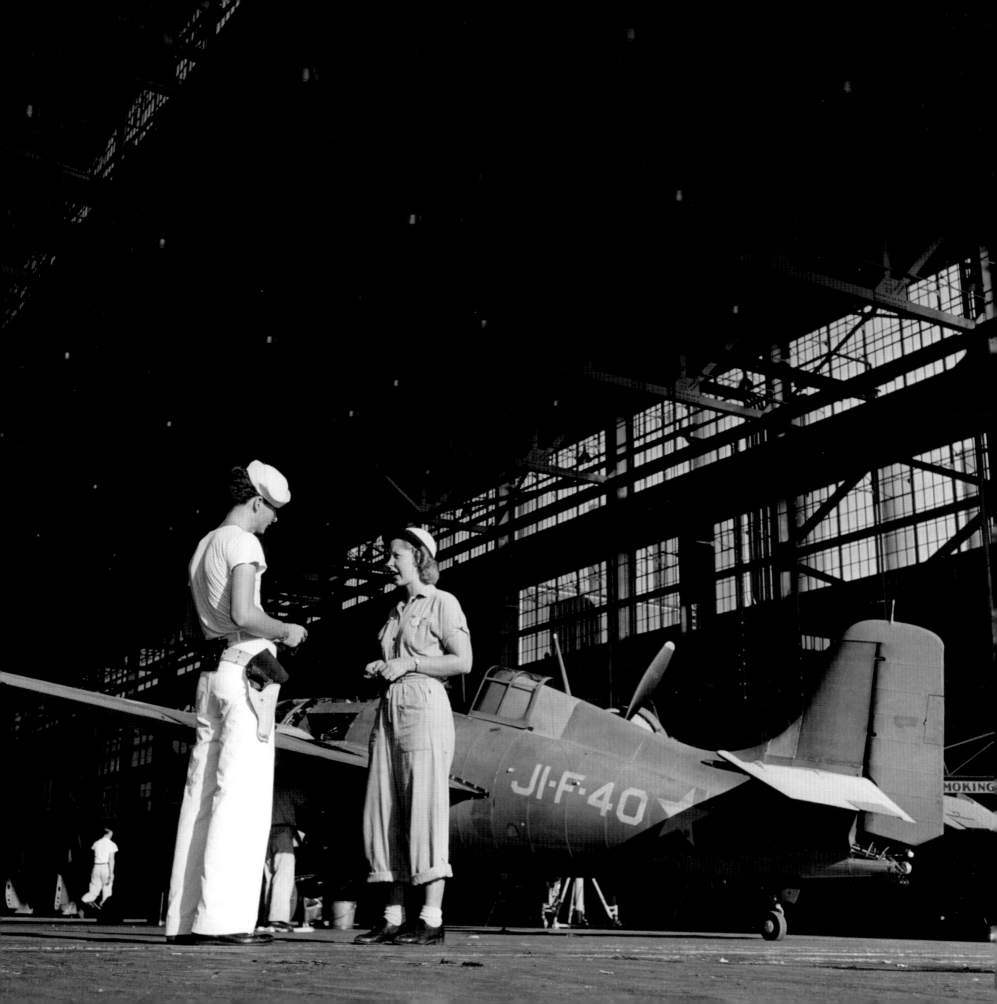

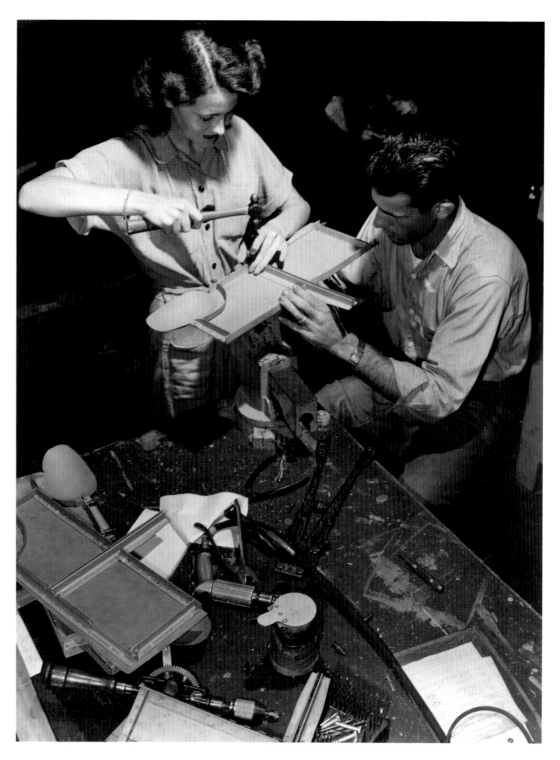

"WAVE Virginia Burns and Melvin Whitwell, AM3, NAS, Jacksonville, Florida, assembling ducts and metal units."
September 1943; NAS, Jacksonville, Fla.; photograph unattributed; 80-G-471716

"Cpl. Andren Loschiave, USMCR, explaining airplane magnets to Pvt. Anna Smith, USMCR. Both marines are
stationed at Cherry Point, North Carolina." November 1943; Cherry Point, N.C.; Lt. Paul Dorsey; 80-G-471902

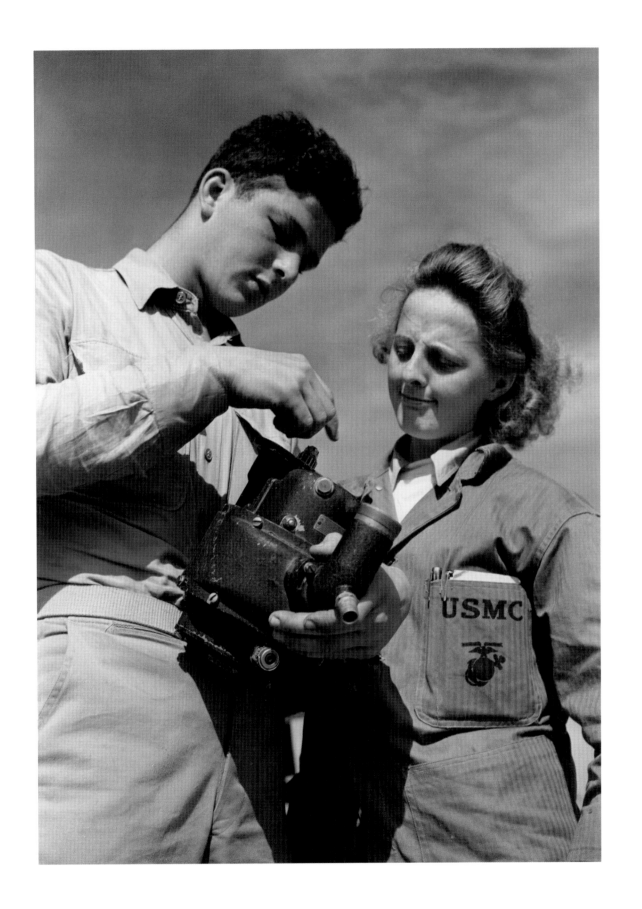

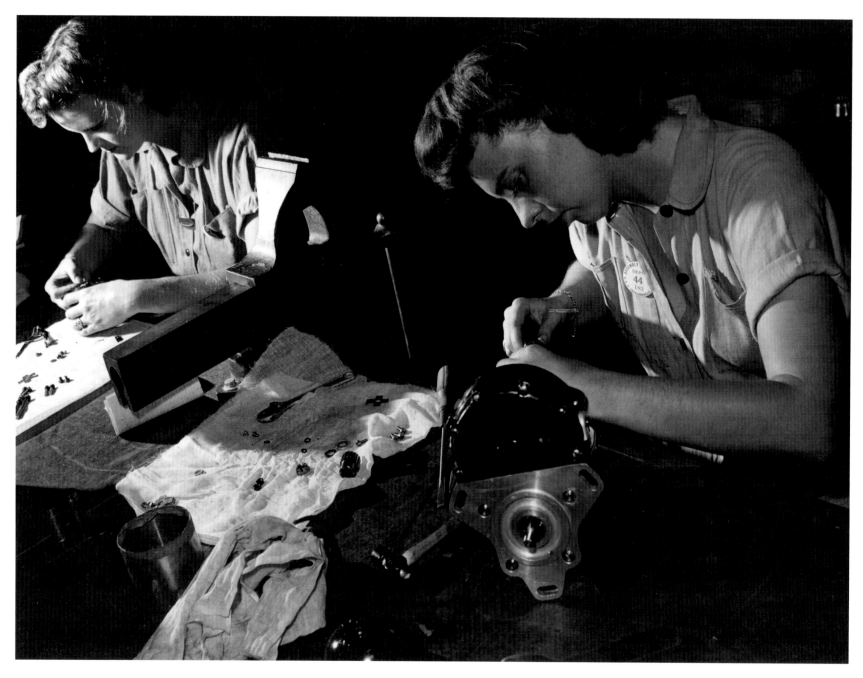

"WAVES Lucille Henderson and Gladys Densford, NAS, Jacksonville, Florida, cleaning generator parts." September 1943; NAS, Jacksonville, Fla.; photograph unattributed; 80-G-471715

"WAVE Mary Ann Gasser, NAS, Jacksonville, Florida, assembles a generator that has been cleaned and overhauled." September 1943; NAS, Jacksonville, Fla.; photograph unattributed; 80-G-471714

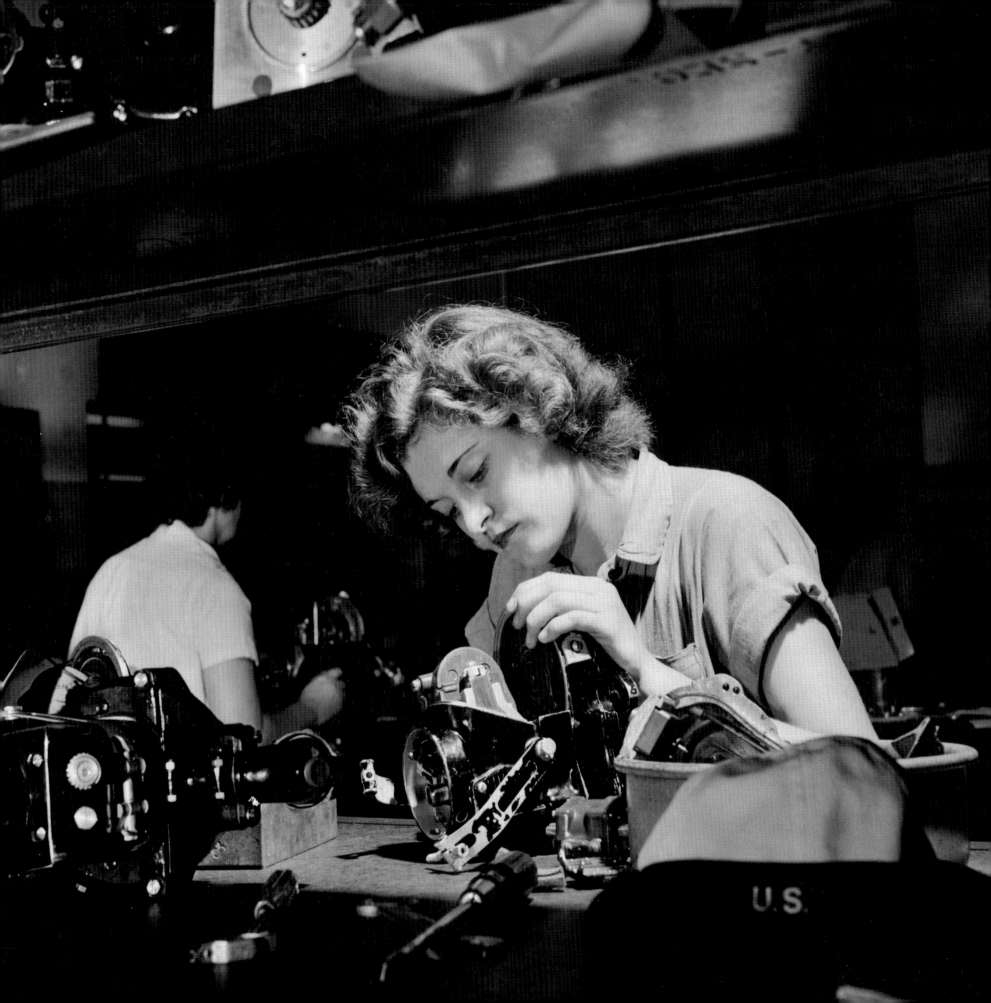

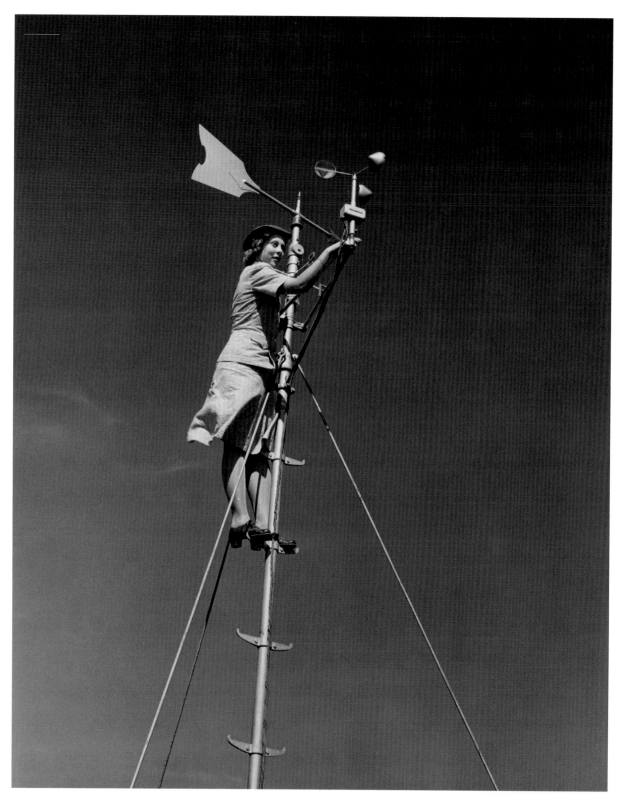

"Pvt. Margaret Thorsen, USMCR, goes aloft to take a reading on an anemometor at Cherry Point, North Carolina."
November 1943; Cherry Point, N.C.; Lt. Paul Dorsey; 80-G-471904

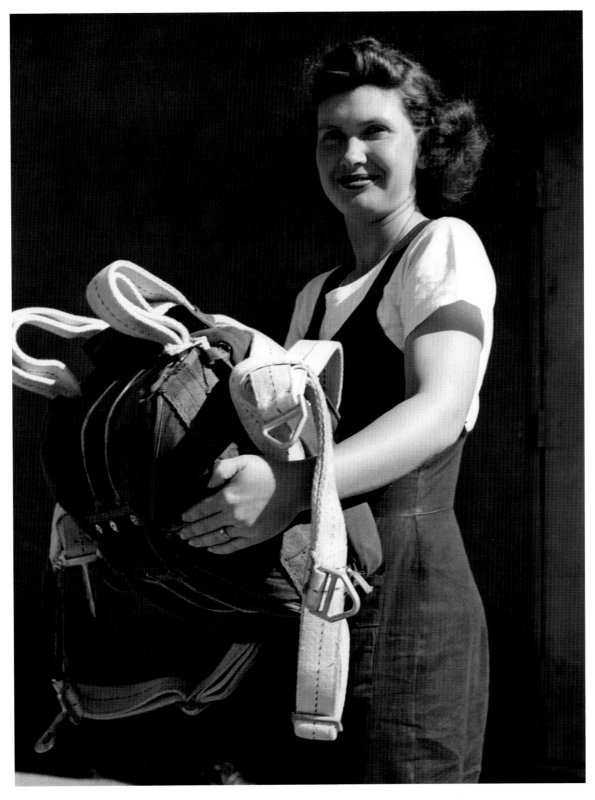

"Pfc. Phyllis Peterson, USMCR, parachute rigger at Cherry Point, North Carolina. carrying her parachute out to make a test."
November 1943; Cherry Point, N.C.; Lt. Paul Dorsey; 80-G-471919

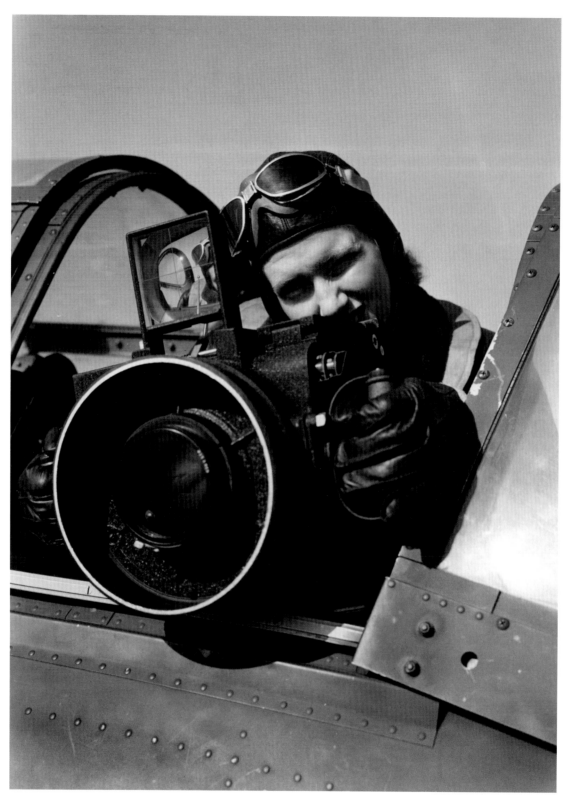

"Pvt. Grace Louise Wyman, USMCR, Using F-56 aerial camera. She is stationed at Cherry Point, North Carolina."
November 1943; Cherry Point, N.C.; Lt. Paul Dorsey; 80-G-471907

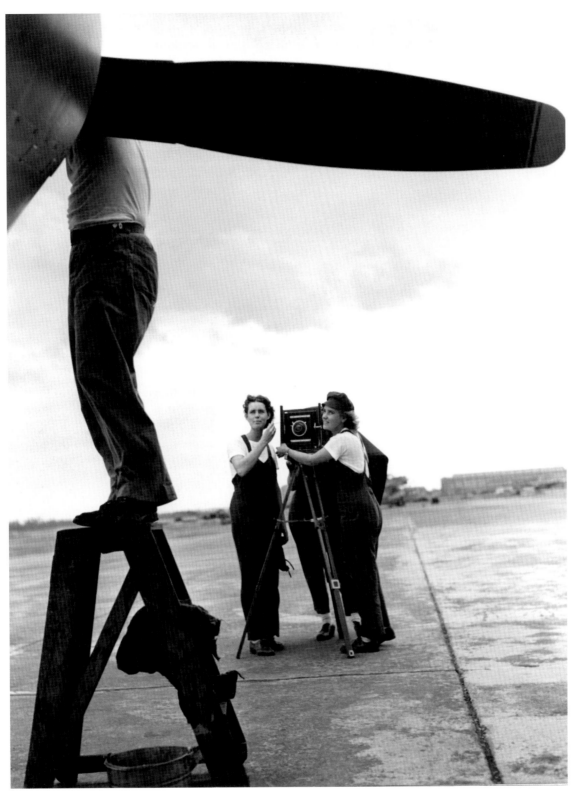

"Pvt. Jacqueline, USMCR, and Pfc. Dorothy Parmelee, USMCR, learning photography at Cherry Point, North Carolina."
November 1943; Cherry Point, N.C.; Lt. Paul Dorsey; 80-G-471923

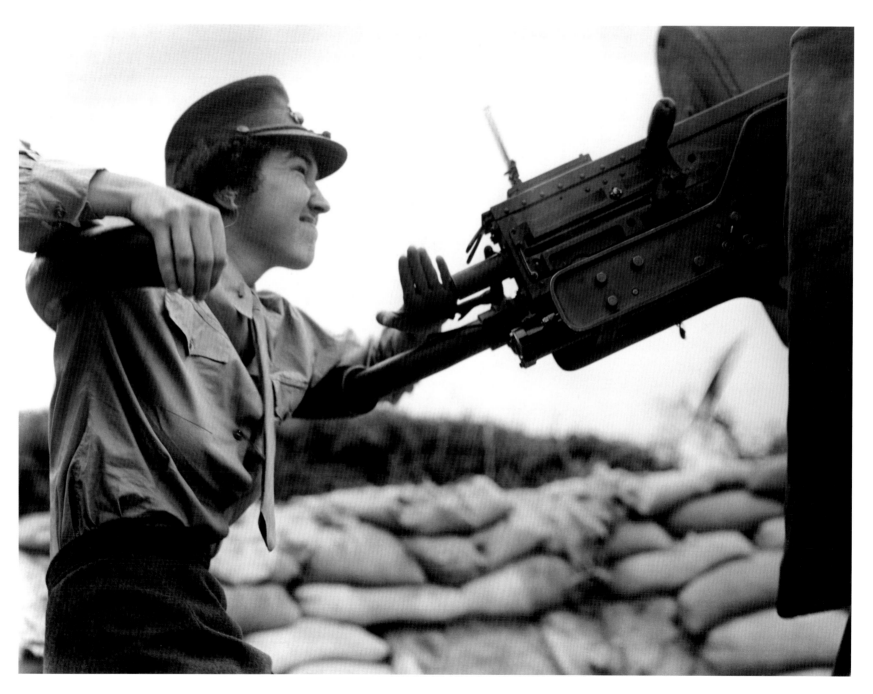

"2nd Lt. Jane Greenough, USMCR, operating a 50 calibre machine gun at Cherry Point, North Carolina." November 1943; Cherry Point, N.C.; Lt. Paul Dorsey; 80-G-471918

"Pvt. Marie Mitchell, USMCR, learning aircraft engine maintenance at Cherry Point, North Carolina." November 1943; Cherry Point, N.C.; Lt. Paul Dorsey; 80-G-471920

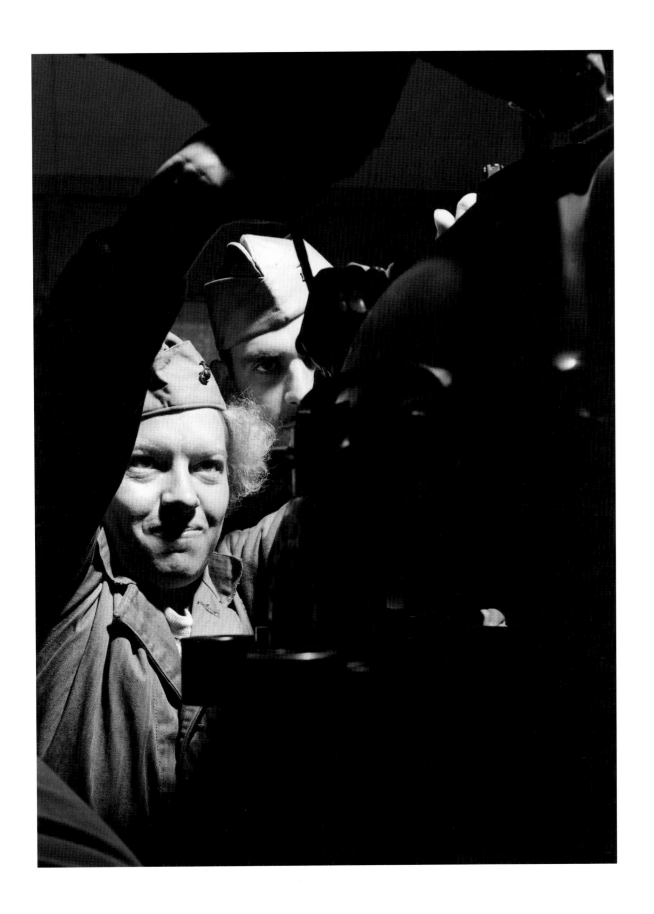

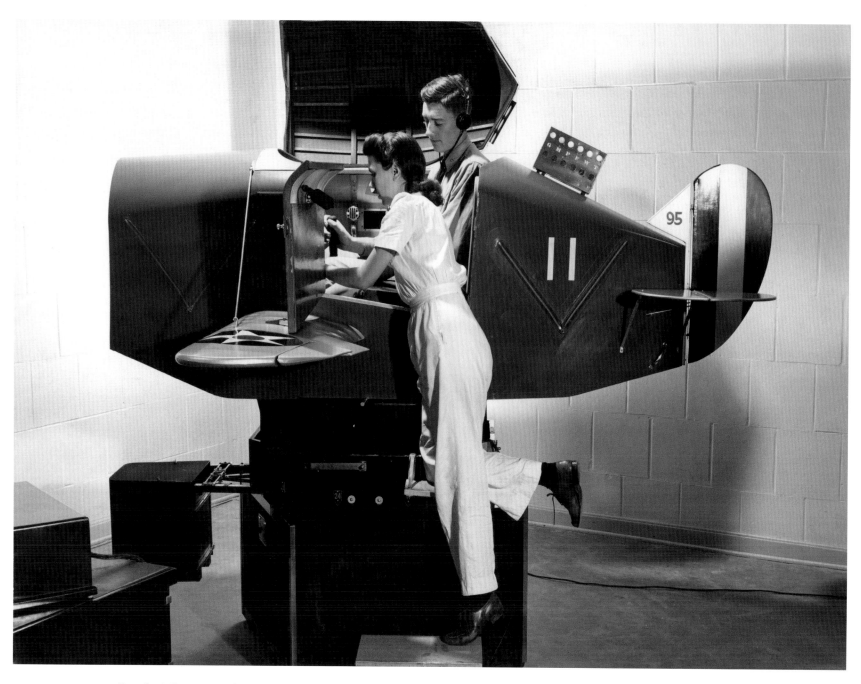

"Female civil service employee instructs aviation cadet on use of link trainer controls at NATC, Corpus Christi, Texas." November 1943;
Corpus Christi, Tex.; LCdr. Charles Jacobs; 80-G-475285

"Lucilee McClure of Huntington Park, California, measures for drilling on SNV wing in Consolidated Vultee Plant, Downey, California." August 1943;
Downey, Calif.; LCdr. Charles Jacobs; 80-G-475922

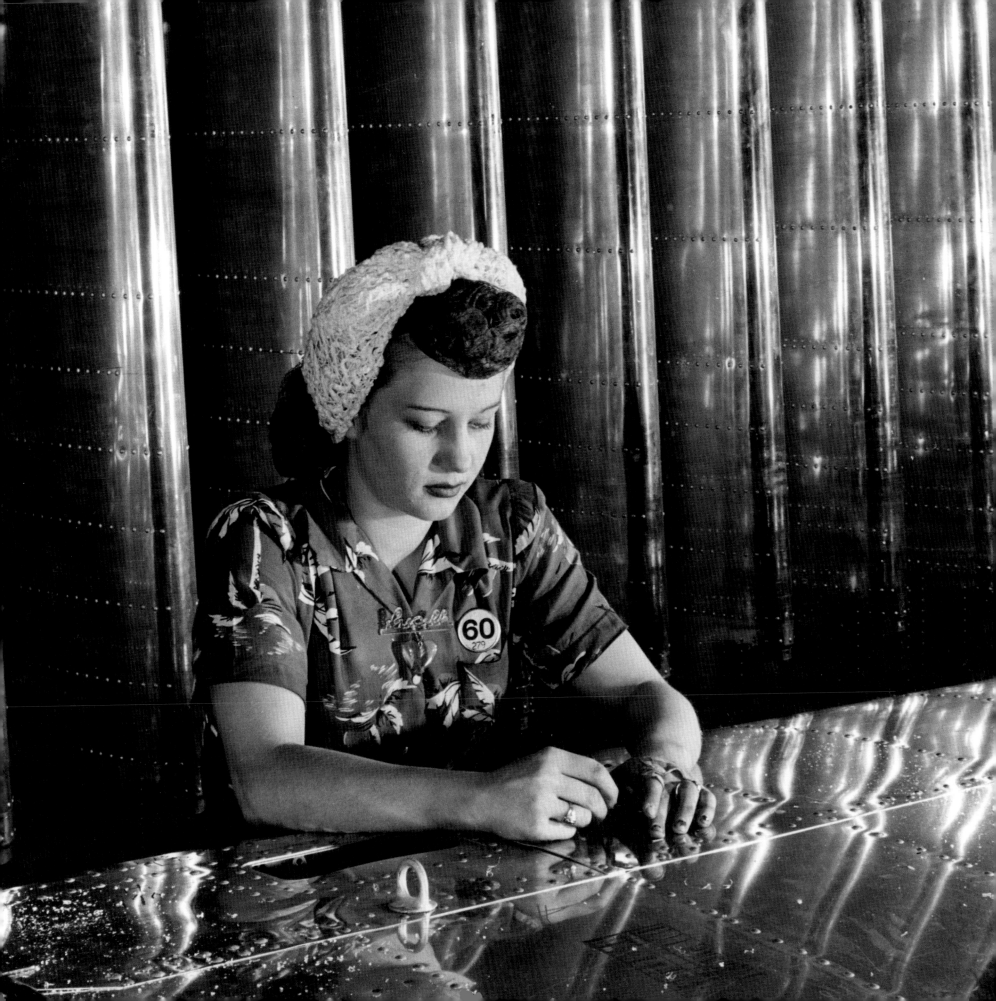

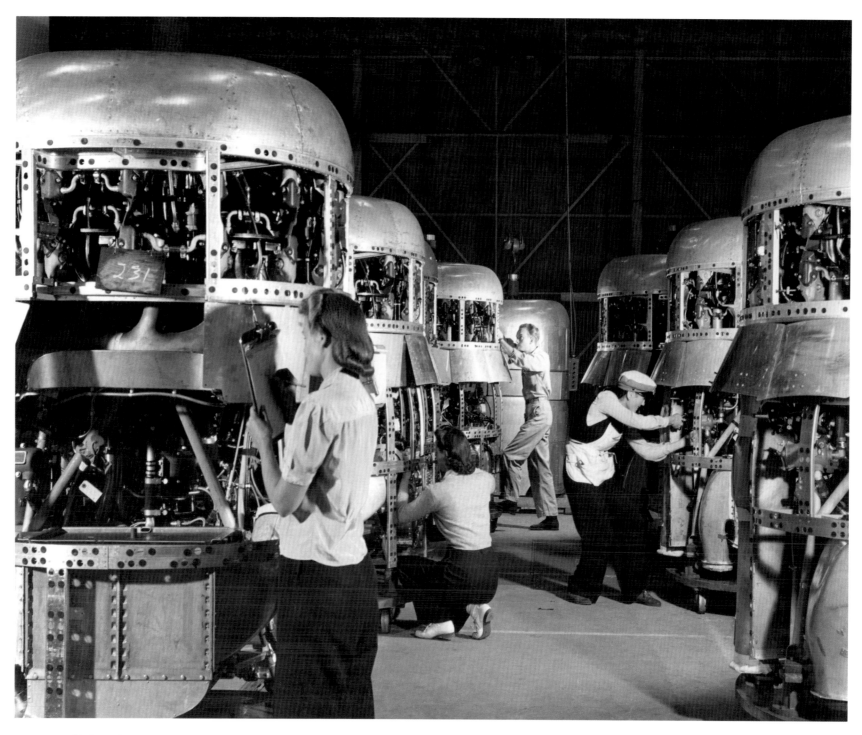

"Assembly line of engines for B-24s is pictured at Consolidated Vultee Aircraft Plant, Downey, California." August 1943; Downey, Calif.; LCdr. Charles Jacobs; 80-G-475900

"Betty Marshall of Belle Gardens, California, makes adjustment on B-24 engine at Consolidated Vultee Aircraft Plant, Downey, California." August 1943; Downey, Calif.; LCdr. Charles Jacobs; 80-G-475903

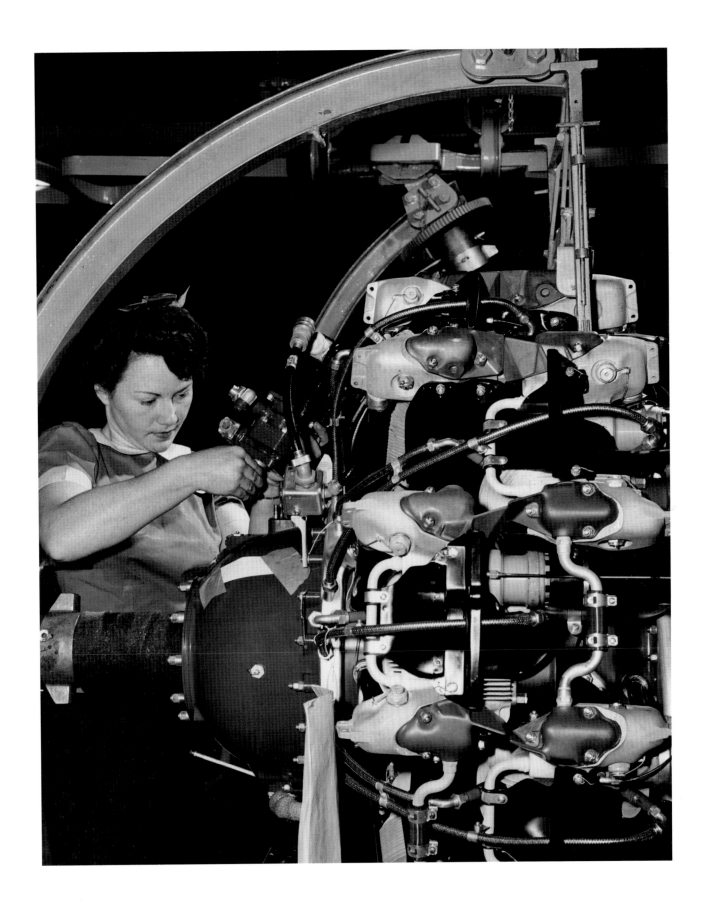

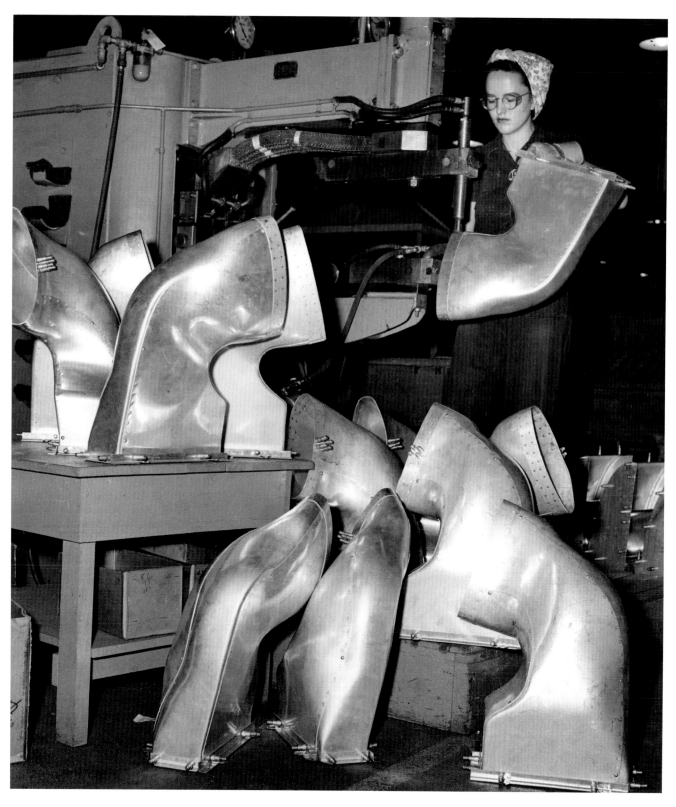

"Air ducts for B-24s are spot-welded in Consolidated Vultee Aircraft Plant, California." August 1943;
Downey, Calif.; LCdr. Charles Jacobs; 80-G-475904

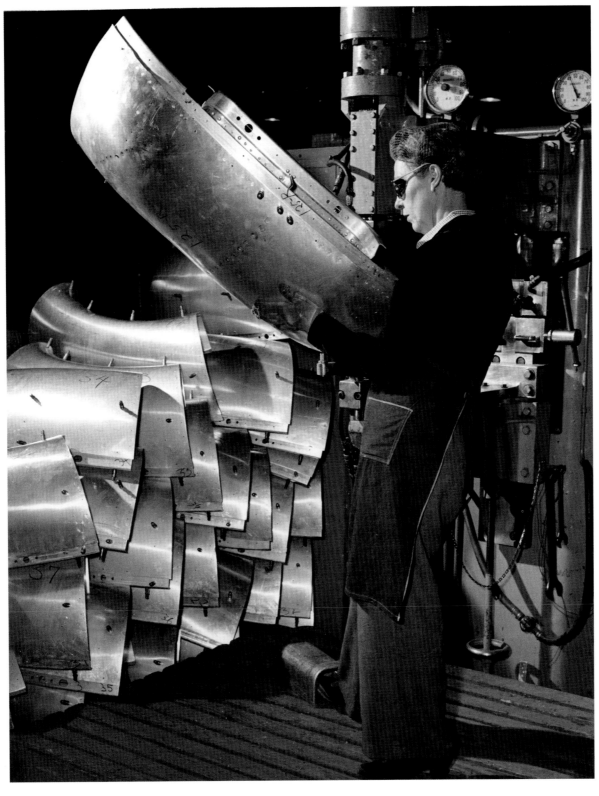

"Engine cowlings for B-24s are spot-welded at Consolidated Vultee Aircraft Plant, Downey, California." August 1943;
Downey, Calif.; LCdr. Charles Jacobs; 80-G-475905

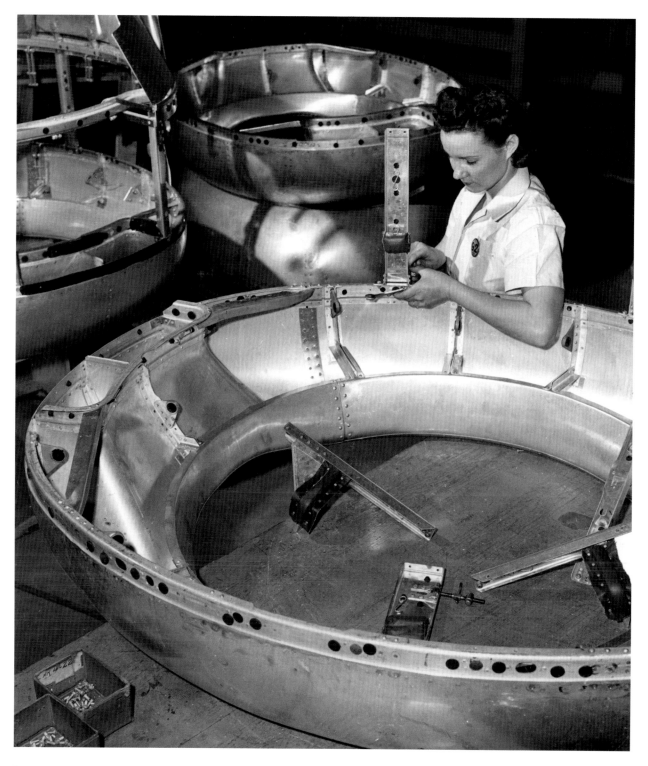

"Margaret Marwin of Los Angeles, California, fastens strut to engine cowling of B-24 at Consolidated Vultee Plant, Downey, California."
August 1943; Downey, Calif.; LCdr. Charles Jacobs; 80-G-475906

"SNVs are assembled on line at Consolidated Vultee Aircraft Plant, Downey, California." August 1943; Downey, Calif.; LCdr. Charles Jacobs; 80-G-475907

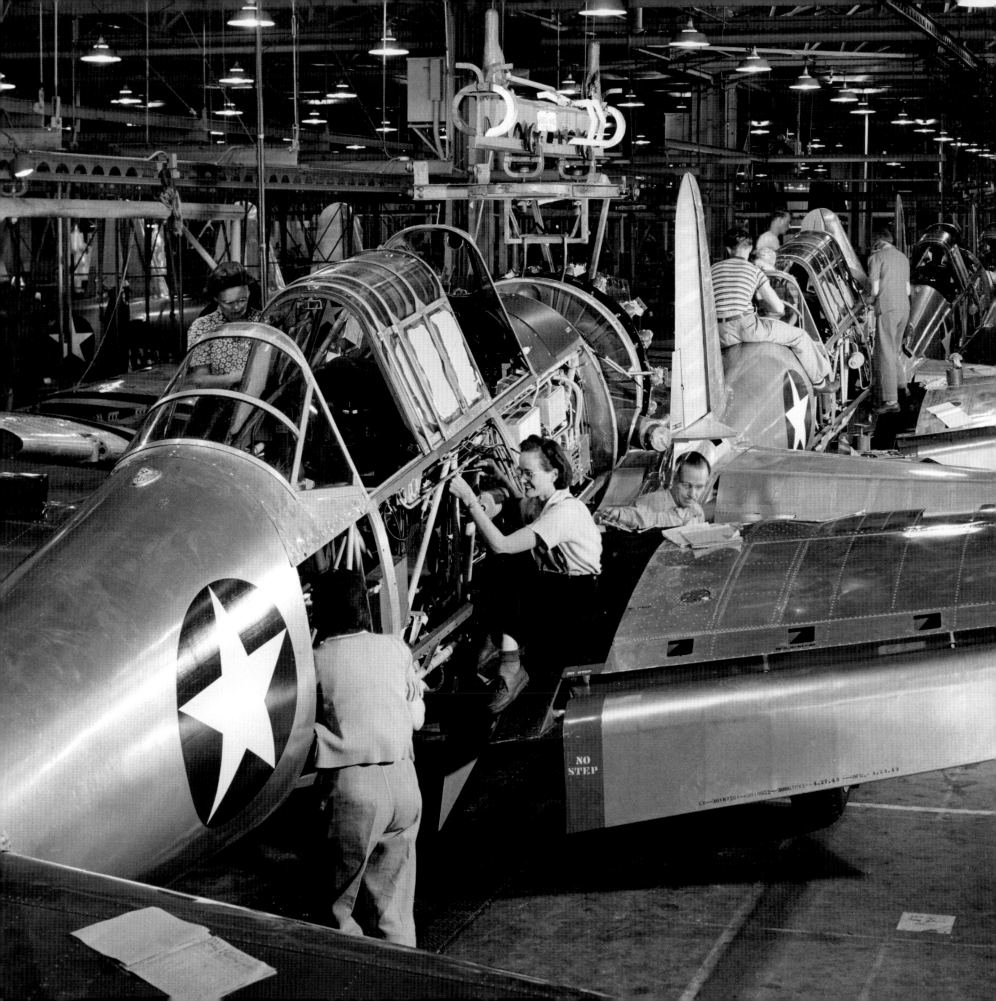

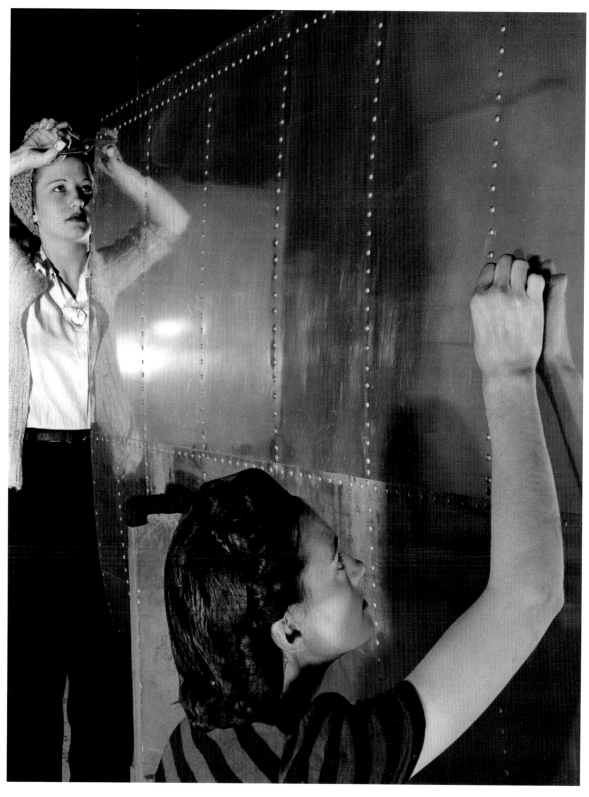

"Woman inspector checks rivets on SNV wing while another worker makes minor adjustment at Consolidated Vultee Plant, Downey, California." August 1943; Downey, Calif.; LCdr. Charles Jacobs; 80-G-475908

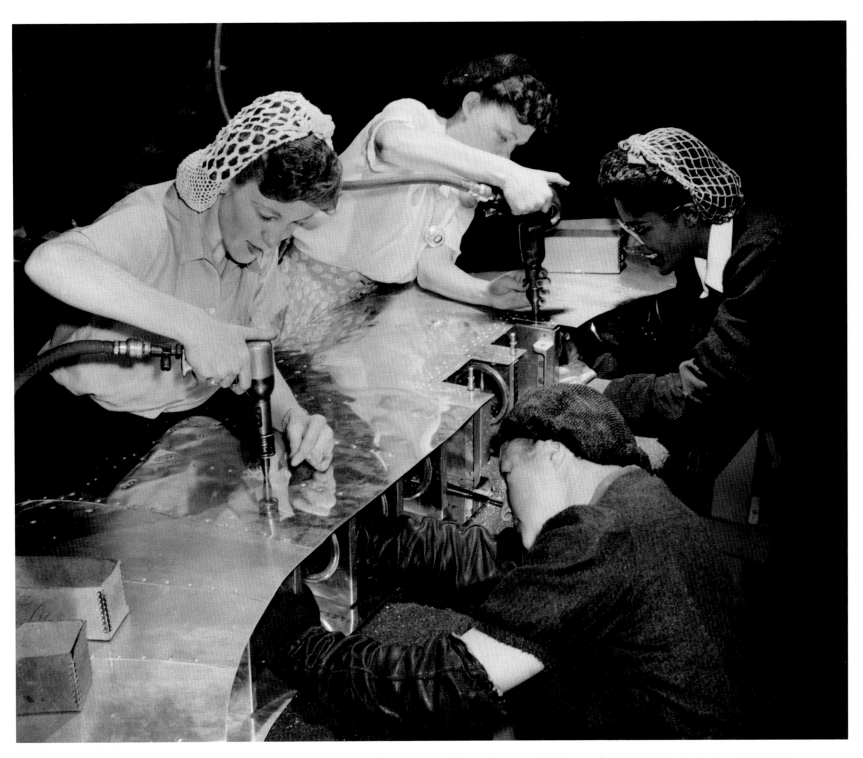

"Women riveters work on tail fin for B-24 in Consolidated Vultee Plant, Downey, California. " August 1943; Downey, Calif.; LCdr. Charles Jacobs; 80-G-475913

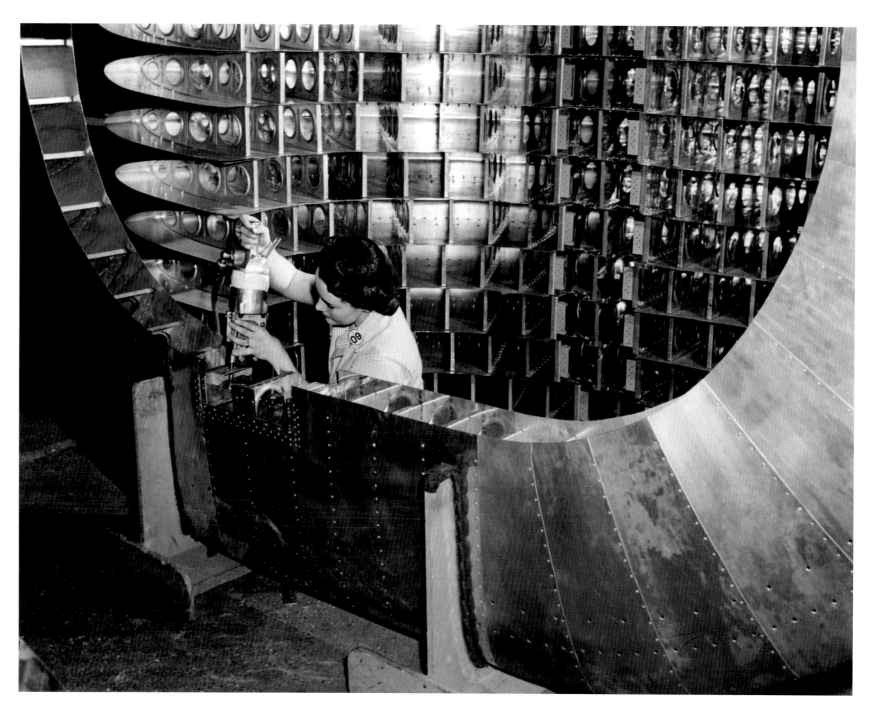

"Oval fin for B-24 is spot-welded at Consolidated Vultee Plant, Downey, California." August 1943; Downey, Calif.; LCdr. Charles Jacobs; 80-G-475914

"Arlene Hampton of Downey, California, checks landing gear shock absorbers for SNVs at Consolidated Vultee Plant, Downey, California."
August 1943; Downey, Calif.; LCdr. Charles Jacobs; 80-G-475911

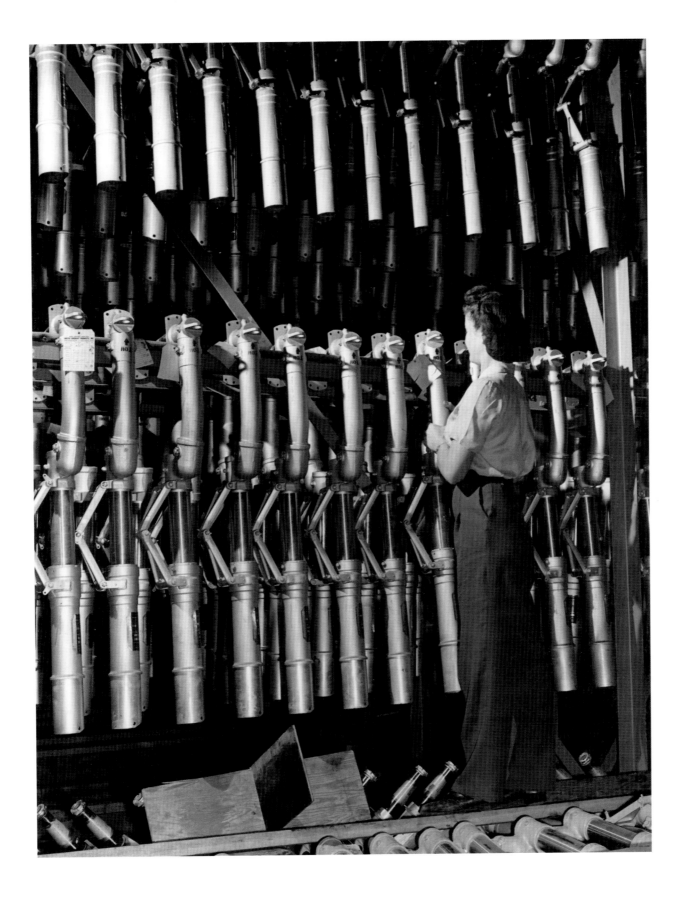

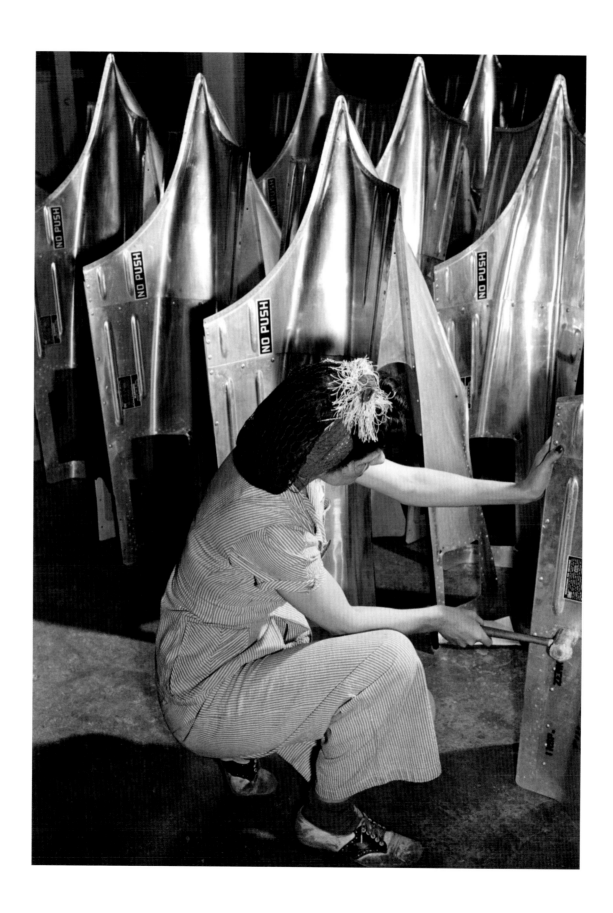

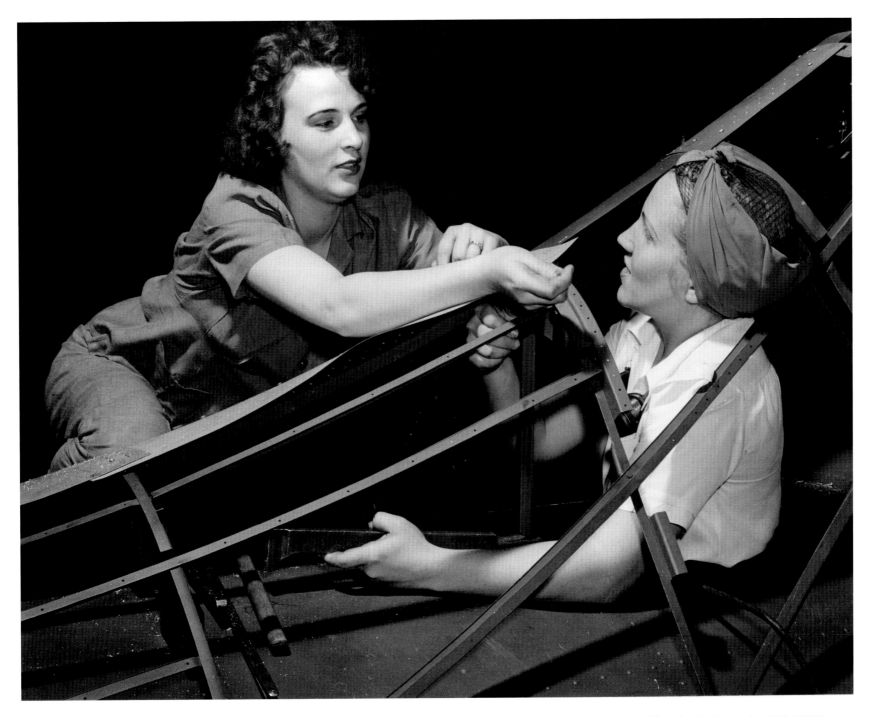

"Instruction panels are fastened to tail cones of SNVs at Consolidated Vultee Plant, Downey, California." August 1943; Downey, Calif.; LCdr. Charles Jacobs; 80-G-475912

"Skin for tail of PBY is riveted on at Consolidated Vultee Plant, San Diego, California." August 1943; San Diego, Calif.; LCdr. Charles Jacobs; 80-G-475917

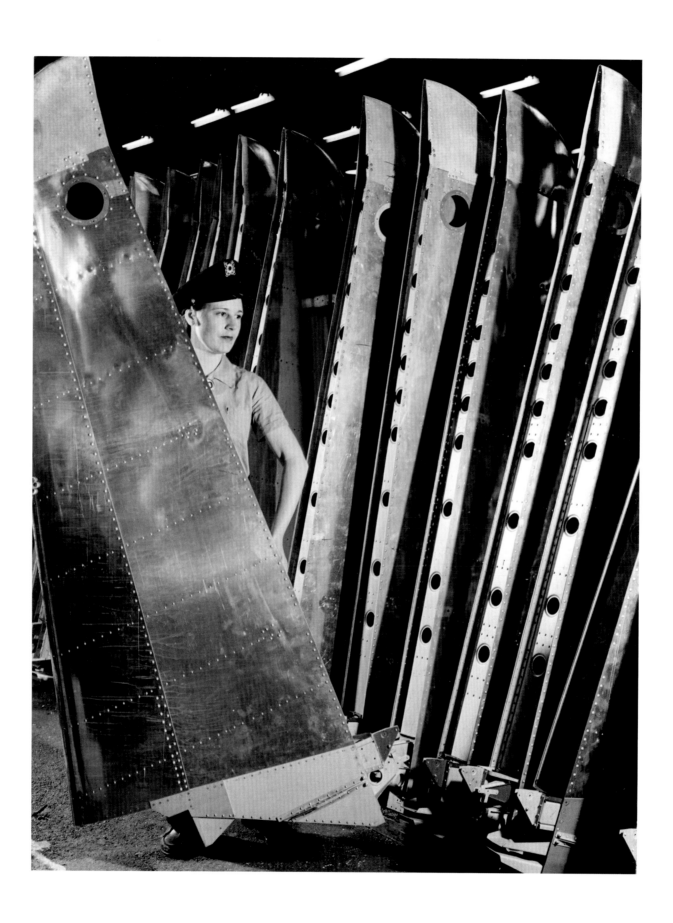

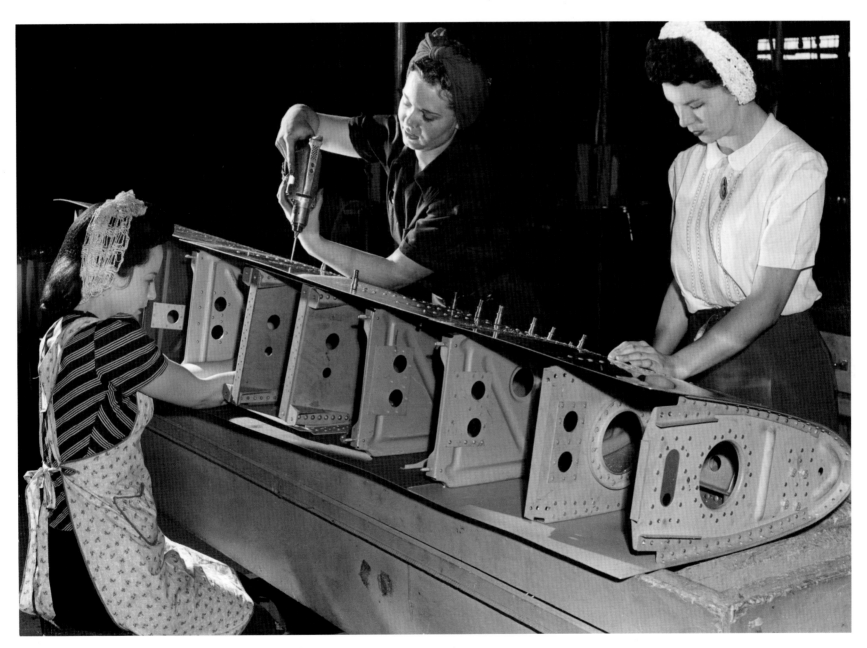

"Women worker carries tail fin for SNV from storage rack at Consolidated Vultee Plant, Downey, California." August 1943; Downey, Calif.; LCdr. Charles Jacobs; 80-G-475921

"Skin is riveted to leading edge of SNV wing at Consolidated Vultee Plant, Downey, California." August 1943; Downey, Calif.; LCdr. Charles Jacobs; 80-G-475927

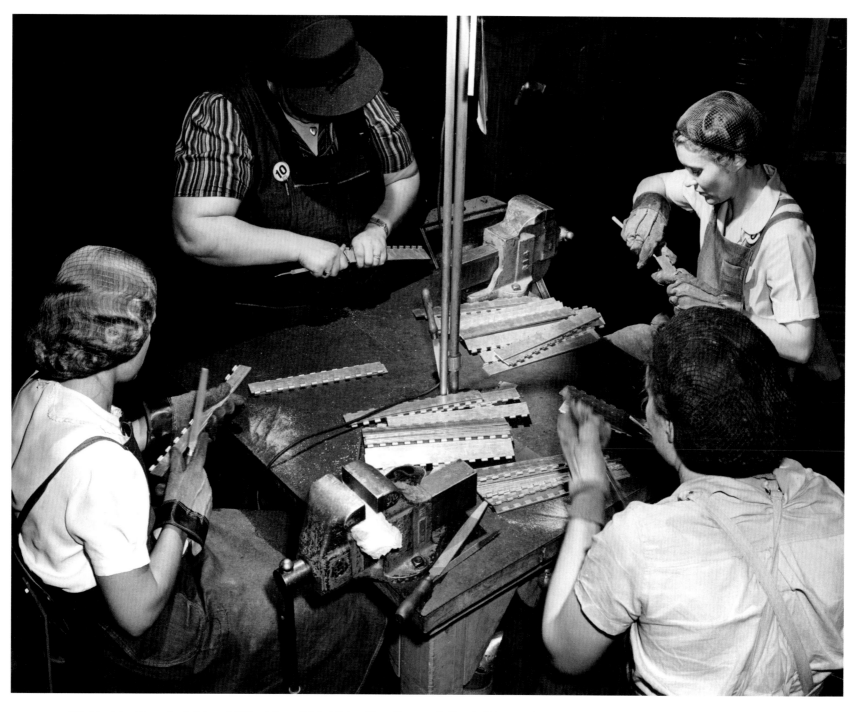

"Workers trim hinges for hatches of SNVs at Consolidated Vultee Plant, Downey, California." August 1943; Downey, Calif.; LCdr. Charles Jacobs; 80-G-475925

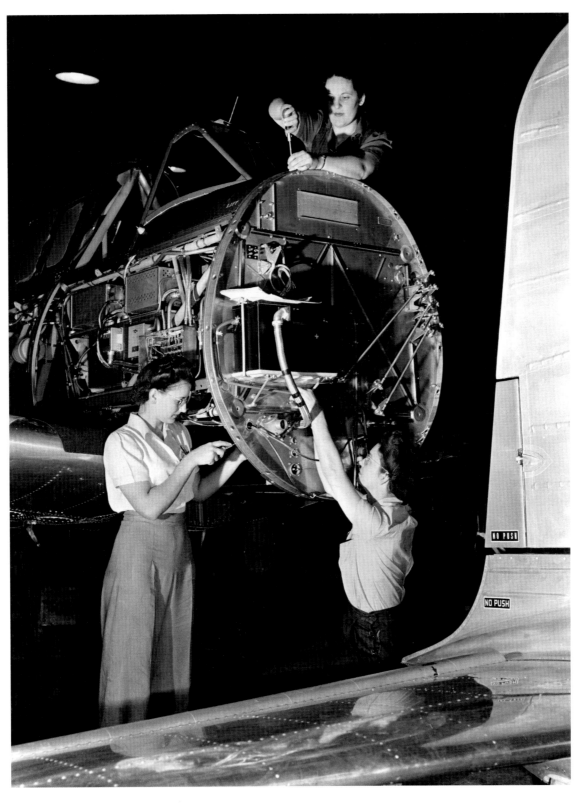

"Women workers help assemble SNV at Consolidated Vultee Plant, Downey, California." August 1943; Downey, Calif.; LCdr. Charles Jacobs; 80-G-475935

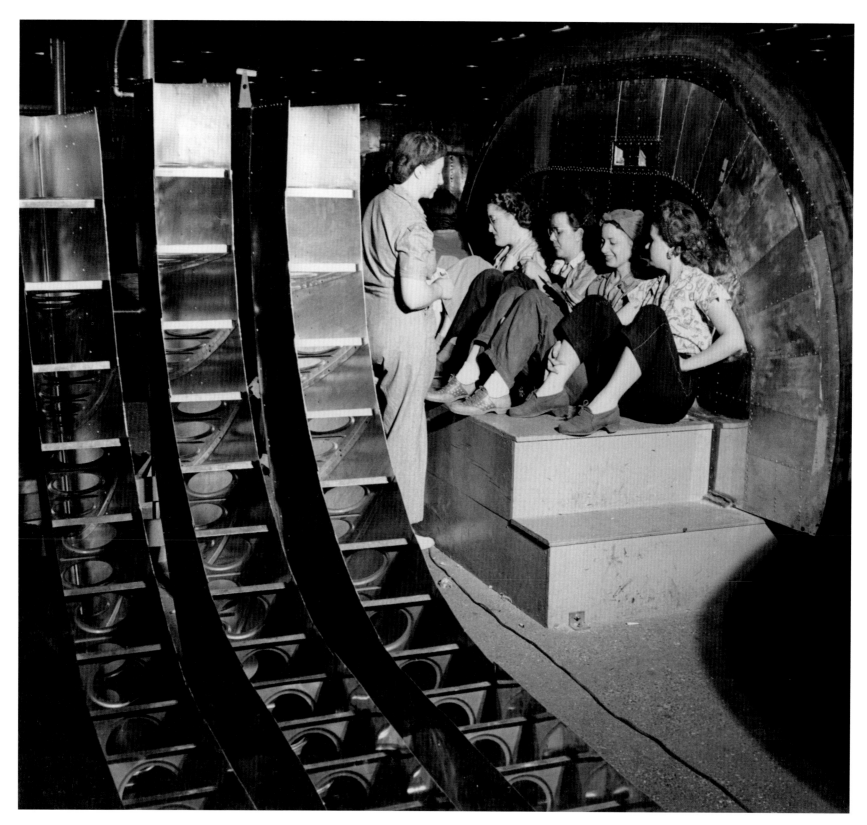

148

"Women workers take rest period by B-24 fin in Consolidated Vultee Plant, Downey, California." August 1943; Downey, Calif.; LCdr. Charles Jacobs; 80-G-475929

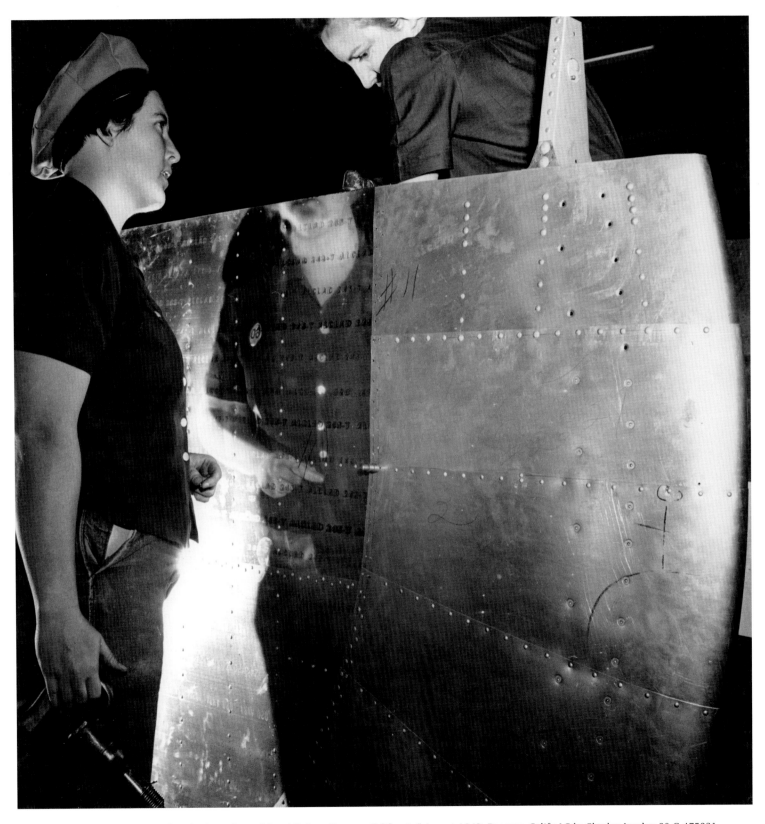

"Riveting team works on fin of B-24 at Consolidated Vultee, Downey, California." August 1943; Downey, Calif.; LCdr. Charles Jacobs; 80-G-475931

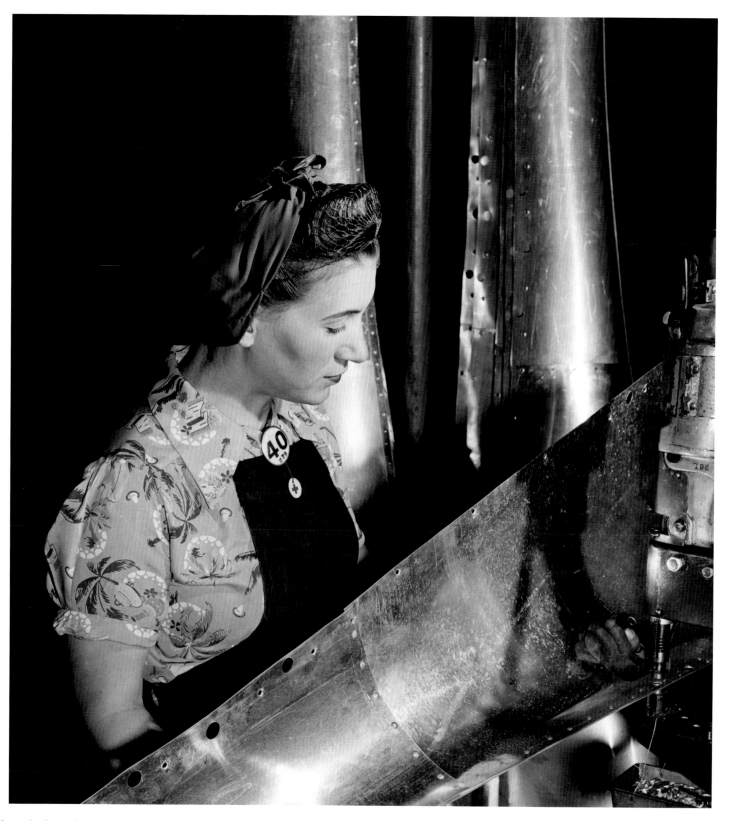

"Holes in leading edge of SNV wing are punched at Consolidated Vultee Plant, Downey, California." August 1943; Downey, Calif.; LCdr. Charles Jacobs; 80-G-475926

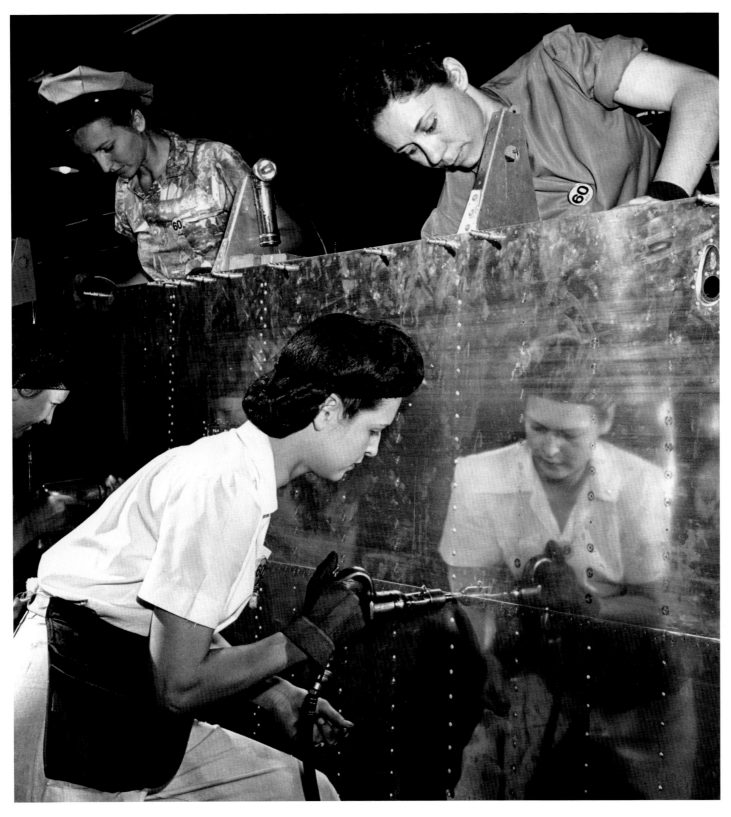

"Women riveters work on tail fins of PB4Y1 at Consolidated Vultee Aircraft Plant, Downey, California." August 1943; Downey, Calif.; LCdr. Charles Jacobs; 80-G-475979

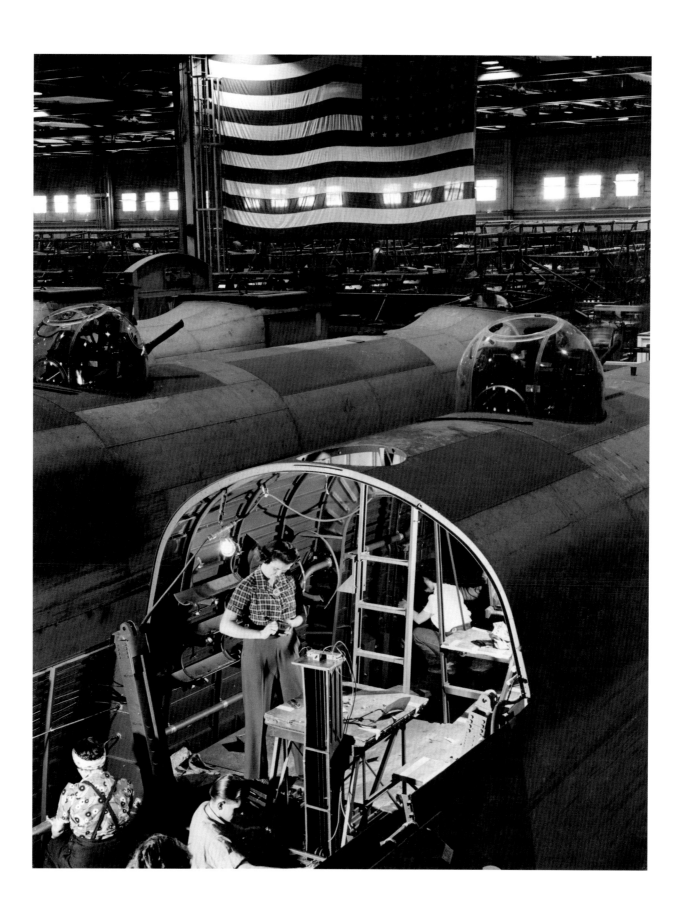

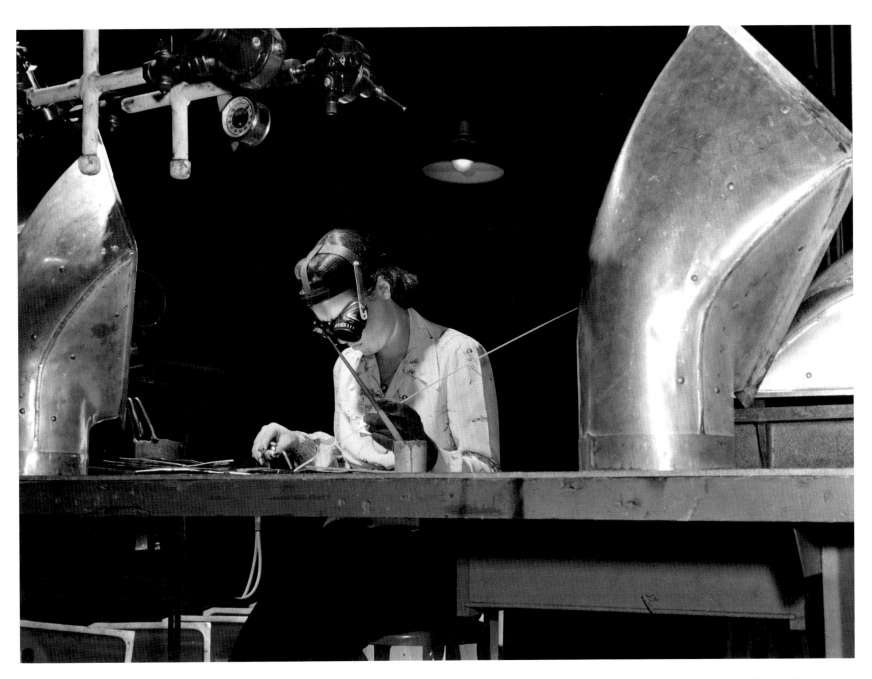

"Fuselage assembly line for PB2Ys at Consolidated Vultee Aircraft Plant, San Diego, California." August 1943; San Diego, Calif.; LCdr. Charles Jacobs; 80-G-475951

"Small parts for SNVs are gas-welded at Consolidated Vultee Plant, Downey, California." August 1943; Downey, Calif.; LCdr. Charles Jacobs; 80-G-475936

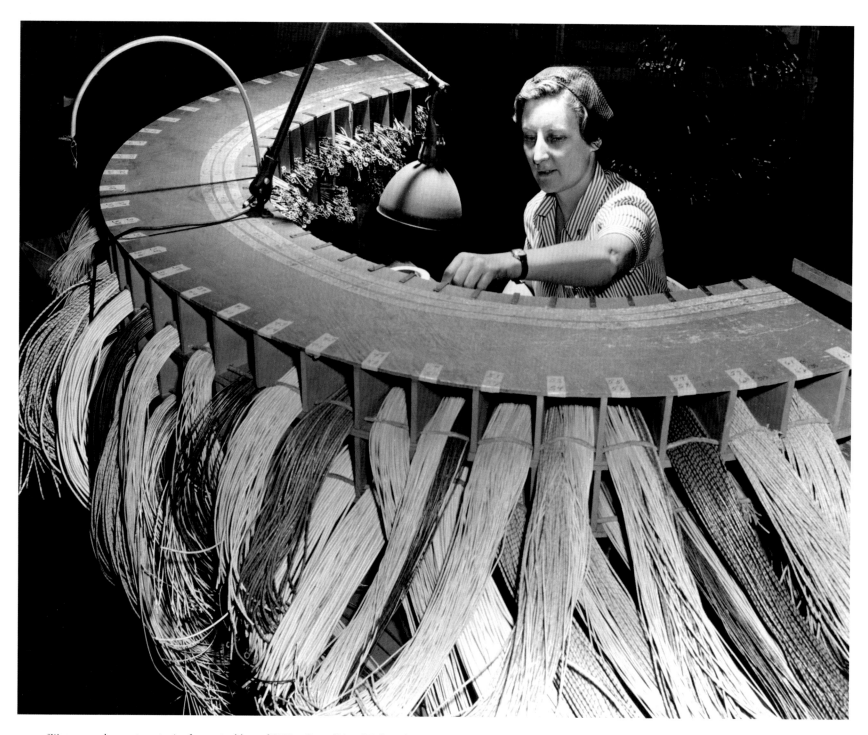

"Woman worker sorts out wire for control box of SNV at Consolidated Vultee Plant, Downey, California." August 1943; Downey, Calif.; LCdr. Charles Jacobs; 80-G-475938

"Women workers during rest period at Consolidated Vultee Aircraft Plant, Downey, California." August 1943; Downey, Calif.; LCdr. Charles Jacobs; 80-G-475978

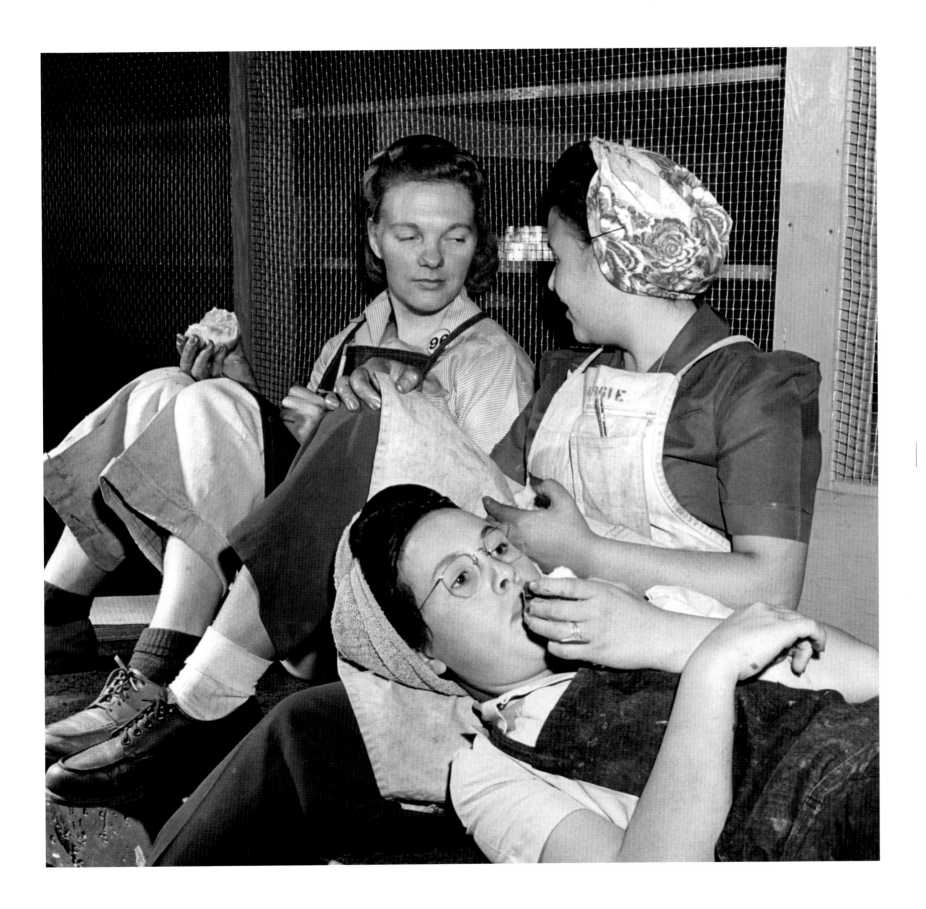

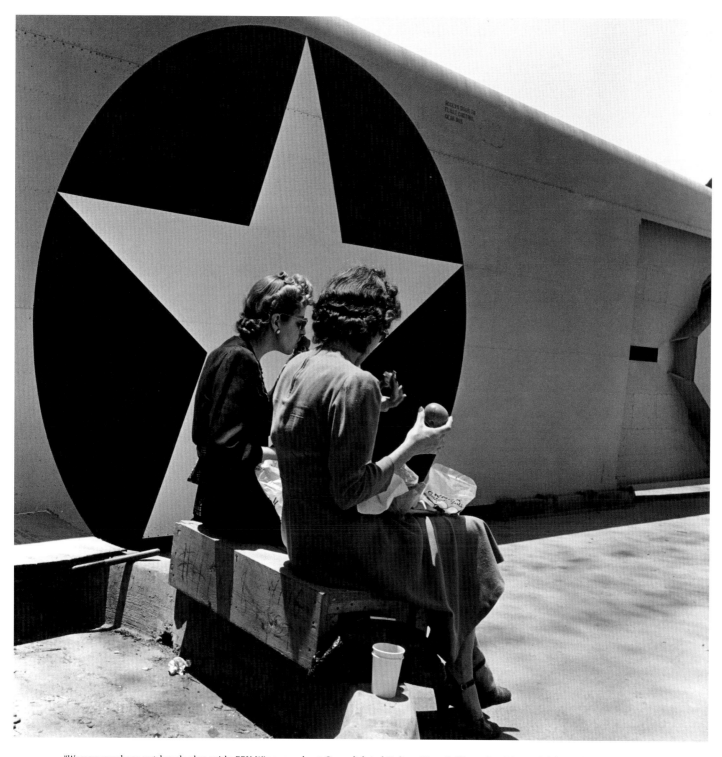

"Women workers eat lunch alongside PBY Wing panels at Consolidated Vultee Aircraft Plant, San Diego, California." August 1943; San Diego, Calif.; LCdr. Charles Jacobs; 80-G-475996

"Workers eat lunch under PB2Y at Consolidated Vultee Aircraft Plants, San Diego, California." August 1943; San Diego, Calif.; LCdr. Charles Jacobs; 80-G-475991

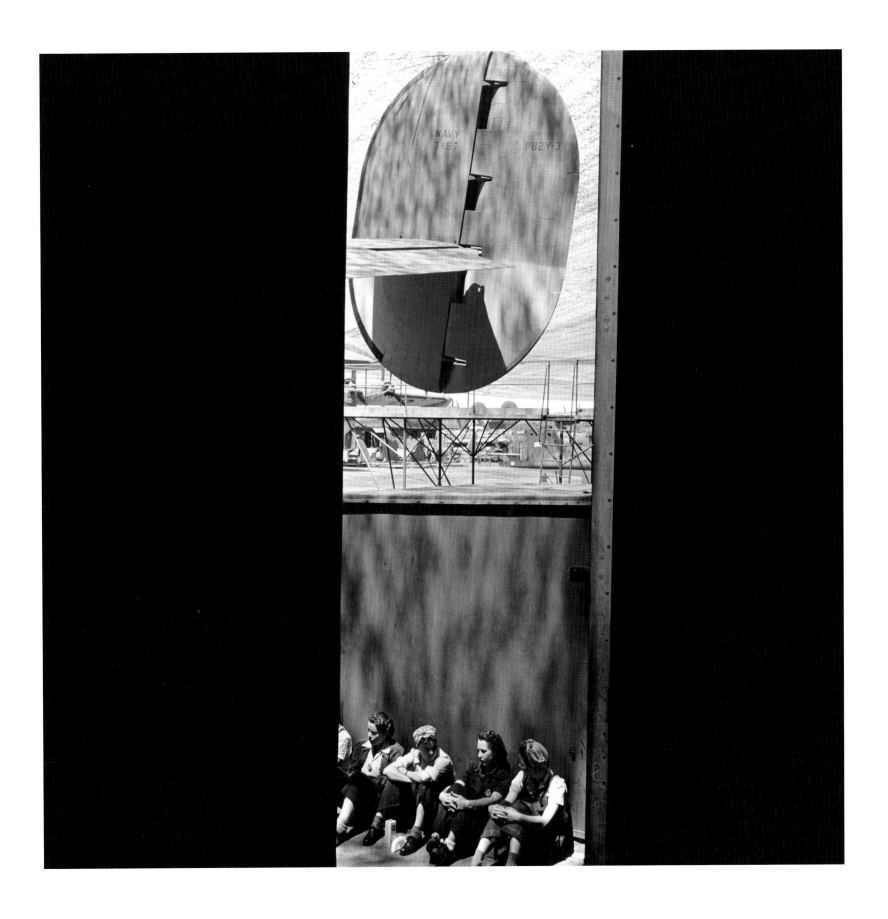

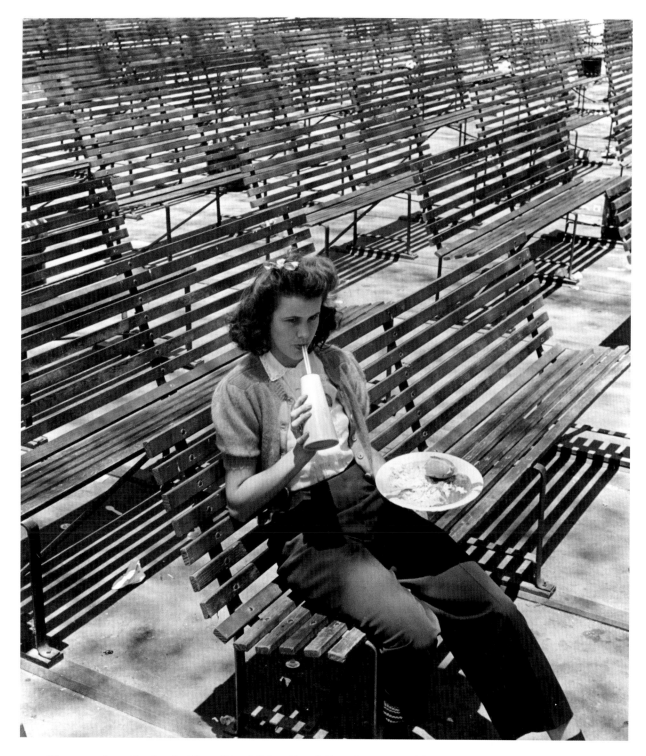

"Woman worker eating lunch at Consolidated Vultee Aircraft Plant, San Diego, California." August 1943; San Diego, Calif.;
LCdr. Charles Jacobs; 80-G-475999

"Bicycles and motor scooters such as these are used to transport visitors and workers around Consolidated Vultee Plant,
San Diego, California." August 1943; San Diego, Calif.; LCdr. Charles Jacobs; 80-G-476017

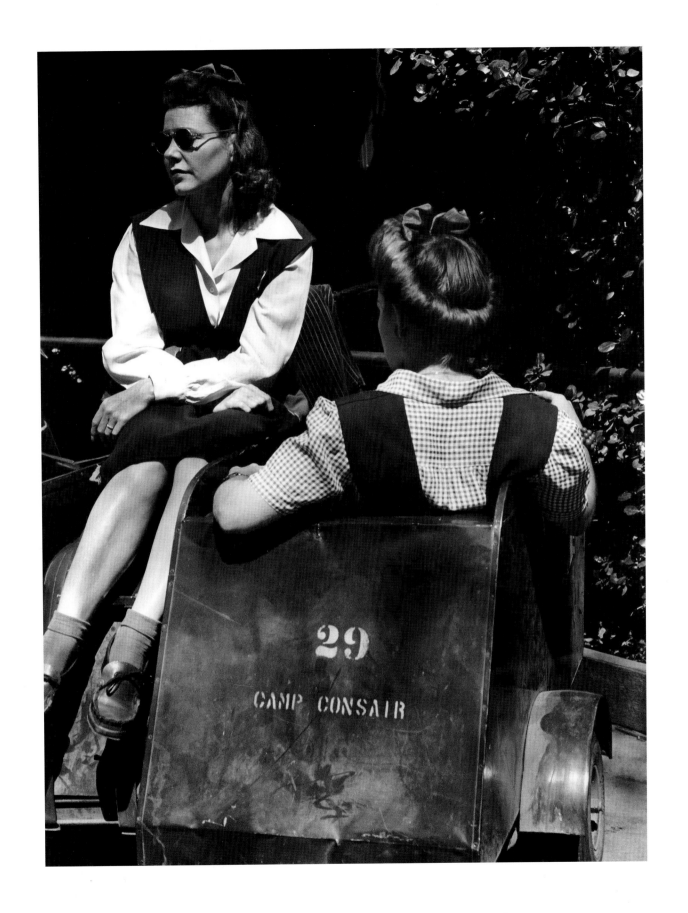

## ACKNOWLEDGMENTS

*Making Waves* is the end result of a ten year project, which earlier produced *At Ease: Navy Men of World War II* and *Men of WW II: Fighting Men at Ease.* My editor at Harry N. Abrams, Inc., Howard Reeves, took a chance on an untested writer and subject six years ago. I thank him for the opportunity and able guidance over the years. The designer of all three books, my friend Ed Miller, created and sustained the visual narrative across all three books. They look very handsome next to each other on the shelf. Additional thanks to the many others at Abrams who worked to produce these three books. My thanks to my friend Matthew Montelongo, who organized the captions for this book.

The staff members at the Still Pictures Branch of the National Archives in College Park, Maryland, were invaluable in their assistance. They oriented me at the beginning and helped me through what could have been an overwhelming experience. The librarians at the New York Public Library were very helpful in assisting me in finding historical background information.

I've been lucky to have a group of friends who've shared this adventure with me, or at least listened to me when I went on and on about the project; many thanks to Carrie Michaelis, Luke Doles, Dan Evans, Bruce Temkin, Danni Michaeli, Ivan Quintanilla, Thom Ronk, Arielle Rittvo, Mark Drooks, Noah Glassman, Joe Hepworth, Steve Golembiewski, Mariella Diaz, Debbie Seaman, Brett Roper, and Joshua Black. Special thanks to Ben Michaelis and Dave Adox, who took on the difficult role of my personal project managers.

My parents, Arthur and Selma Bachner, my sister Sindy Liben, and her family, provided love and support for these books. They treated them as if they were their own history. In the case of my father, they were. If their encouragement is any guide, I would have published three books in three weeks.

I come from a family of women where service and work are a given. My love and thanks to all of them, especially to my mother and late grandmother, Regina, for raising me in an environment where I never thought twice about undertaking this work. The effort they brought to everything, and that my mother continues to bring to her life, are an inspiration and a reminder of how lazy I am in comparison.

My husband, Ed Rivera, provides love, support, knowledge, a critical eye, and the spark which usually sets me off on project after project. He started this one. As I've written before, this has been as much his project as mine.

Editor: Howard Reeves
Designer: Edward Miller

Library of Congress Cataloging-in-Publication Data

Bachner, Evan.
  Making WAVES : Navy women of World War II / by Evan Bachner.
     p. cm.
  Includes photographs chiefly taken by the Naval Photographic Unit and housed at the National Archives.
   ISBN-13: 978-0-8109-9523-9
   ISBN-10: 0-8109-9523-9
  1.  United States. Naval Reserve. Women's Reserve—Pictorial works.
  2.  World War, 1939–1945—Naval operations, American—Pictorial works.
  3.  World War, 1939–1945—Photography. 4.  War photography—United States—History—20th century. 5.  Women sailors—United States—Pictorial works. I. United States. Naval Aviation Photographic Unit. II. United States. National Archives and Records Administration. III. Title.
   D769.597.B33 2008
   940.54'5973082—dc22
                    2007036127

Text copyright © 2008 Evan Bachner

Printed and bound in China

10 9 8 7 6 5 4 3 2 1

▲ **Abrams**

Harry N. Abrams, Inc.
115 West 18th Street
New York, N.Y. 10011
www.hnabooks.com

Abrams is a subsidiary of

**HNA** ▪▪▪▪▪
harry n. abrams, inc.
a subsidiary of La Martinière Groupe